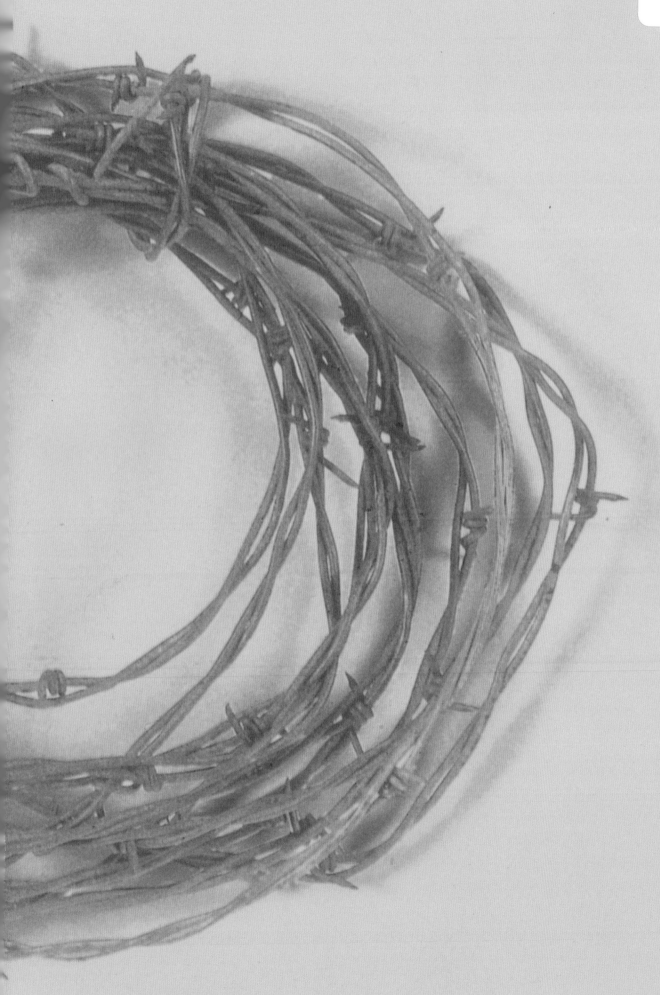

WHITFIELD LOVELL

KIN

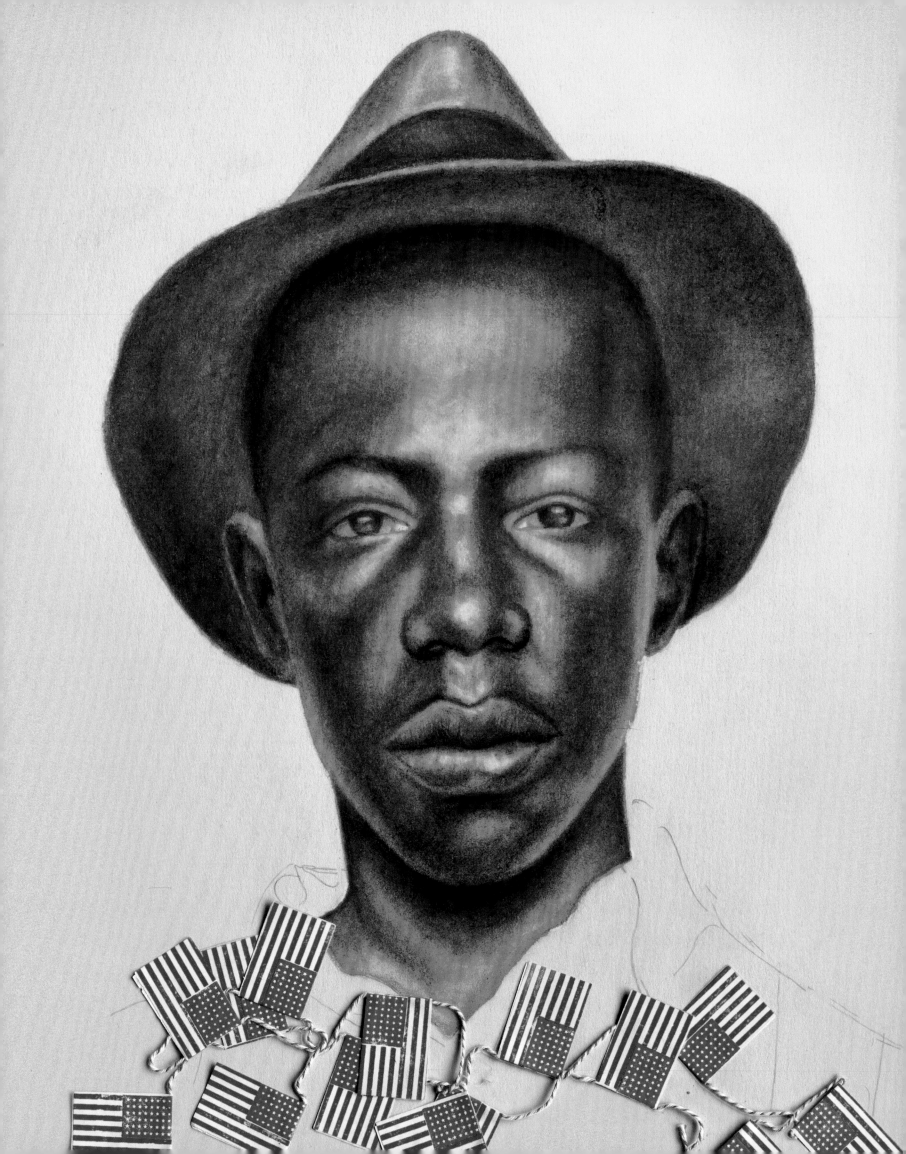

WHITFIELD LOVELL
KIN

Introduction by Irving Sandler

Essays by Sarah E. Lewis, Julie L. McGee, Klaus Ottmann, Kevin Quashie,
and Elsa Smithgall, with an interview of Whitfield Lovell

Skira *RIZZOLI*
NEW YORK

in association with The Phillips Collection, Washington, DC

Published on the occasion of the exhibition WHITFIELD LOVELL: *The Kin Series & Related Works*,
organized by The Phillips Collection, Washington DC, October 8, 2016–January 8, 2017.

Page 157 (right): art © The Joseph and Robert Cornell Memorial Foundation/
Licensed by VAGA, New York, NY;
Page 159 (left): © Rauschenberg Foundation/Licensed by VAGA, New York, NY;
Page 159 (right): © Man Ray Trust ARS-ADAGP;
Page 160: digital image © The Museum of Modern Art/License by SCALA/Art Resource, NY;
Page 162: © Kienholz. Courtesy of L.A. Louver, Venice, CA.

Library of Congress Control Number: 2016945567
ISBN: 978-0-8478-5824-8

First published in the United States of America in 2016 by
Skira Rizzoli Publications, Inc., 300 Park Avenue South, New York, NY 10010, www.rizzoliusa.com

in association with The Phillips Collection, 1600 21st Street NW, Washington DC, 20009

with the support of DC Moore Gallery, New York

A Lyon Artbook

For Skira Rizzoli Publications, Inc.:
Charles Miers, Publisher
Margaret Rennolds Chace, Associate Publisher
Loren Olson, Assistant Editor

Editor: Christopher Lyon
Design: Hans Werner Holzwarth, Berlin

Front cover: Whitfield Lovell, *Kin XLV (Das Lied Von Der Erde)*, 2011 (detail);
Front endpapers: *Kin XXXII (Run Like the Wind)*, 2008 (detail);
Back endpapers: *Kin III (Canto)*, 2008 (detail);
Frontispiece: *Kin I (Our Folks)*, 2008 (detail);
Pages 4 and 5: *Kin XXIV (Cross the River, Round the Bend)*, 2008 (detail);
Page 6: *Kin XXI (De-Dah)*, 2008 (detail).

2016 2017 2018 2019 / 10 9 8 7 6 5 4 3 2 1
Printed in Italy

Contents

Director's Foreword

In 2008 the noted American artist Whitfield Lovell began what has become a defining body of work in his distinguished career and in the history of contemporary art, the deeply resonant *Kin* series. In each masterfully arranged composition, Lovell carefully juxtaposes an exquisitely drawn African American face with timeworn objects from everyday life. His rendering of such detailed, vivid faces and selection of objects to accompany them require countless hours of meticulous drawing and sustained contemplation as Lovell connects with the lives of anonymous individuals inscribed in old photographs. From the first image in the series, featuring the riveting gaze of an African American male wearing a fedora with small paper U. S. flags arrayed below the head, to *Kin LX* (*Le Rouge et le Noir*) (p. 145) with a male African American figure whose elegant, slightly tilted face peers out from behind a thicket of branches, Lovell mines the breadth and depth of human experience to reveal common bonds that transcend racial, gender, cultural, or religious differences.

At a time in our history when we confront the faces of Syrian refugees risking their lives to escape oppressive conditions or those of individuals who have suffered violent attacks abroad or in this country, the power of Lovell's art lies in its ability to connect us with the past and its ongoing reverberations in the present through the expression of the human spirit. Rather than steer away from troubled history, Lovell's art brings it gracefully forward, prompting us to consider "the markings that the past has made—and continues to make—on who we are."

The Phillips Collection is especially proud to be a part of this publication and its in-depth study of Lovell's *Kin* series. This monograph accompanies our focused exhibition featuring selections from the series in dialogue with related works; three of Lovell's *Kin* have enriched our permanent collection since their acquisition in 2014. Essays by Phillips curators Klaus Ottmann and Elsa Smithgall and by esteemed scholars Sarah E. Lewis, Julie L. McGee, Kevin Quashie, and Irving Sandler offer a rich array of perspectives that expand the context for exploring the work of a singular artist who is a leader in contemporary art today.

Dorothy Kosinski
Director, The Phillips Collection
Washington, DC

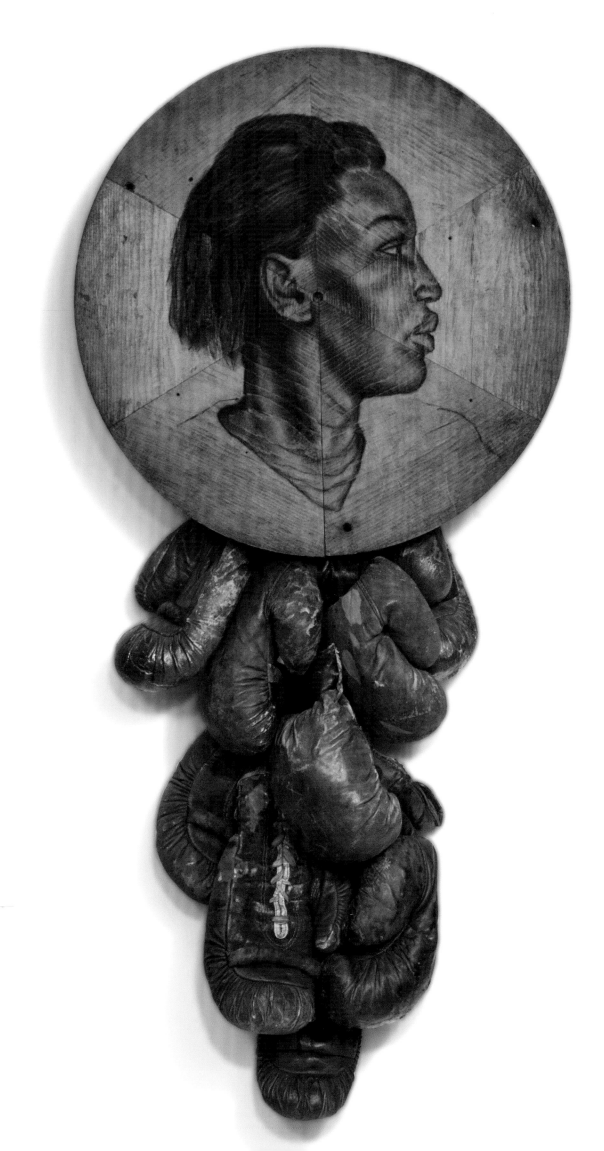

Introduction

Irving Sandler

Whitfield Lovell's *Kin* series consist of sixty Conté crayon drawings of close-up heads of unidentified African Americans. The photographs on which they are based were culled from unretouched black-and-white passport photos, police mug shots, and work identification cards dating from the 1940s, which the artist found in secondhand shops. Accompanying each drawing is a found object; these range from a bouquet of flowers or a piece of rope to a revolver or an arc of playing cards. Lovell's use of vintage photographs reveals his interest in the history of African Americans, but instead of momentous past events or persons, he depicts ordinary black individuals who lived some seven decades ago, rendered with a vividness that gives the impression that you might encounter them on the street today.

Lovell's anonymous African Americans are distinguished by their dignity, indicating his regard for them as "Our Folks"—the parenthetical title of the first entry in the *Kin* series. He also considered calling the series "Our People" and "Kinfolk"—by extension, humankind. Though Lovell does not know the identities of the subjects of the photographs, their images called out to him. It was as if something in them reminded him of himself, whether the photo was of a worker, a middle-class citizen, or even a criminal. As he told Julie L. McGee in the interview included in this volume (p. 183), he sought to reveal "qualities that make us human, regardless of how we behave."

Lovell is a straightforward humanist. Uncompromising in the face of long-term and widespread belittling of humanism in modern art, he has reinvigorated American realism. Prior to the late 1960s, recycling social realism would have been spurned as academic and retrogressive, but in the postmodern era, the rehabilitation of pre-modern styles is acceptable as long as an artist adds something fresh and authentic, which is precisely what Lovell has done.

Lovell's work causes the viewer's attention to fluctuate between photographic image and Conté crayon drawing, the mechanical look of the one and the handwork of the other. There is no mistaking that the images are based on photographs, but the drawing—the quality of the drawing—makes itself strongly felt, so much so that Lovell's works are more accurately described as drawings of heads than as photorealist portraits.

If Lovell's works are in the American tradition of realist art, the objects that accompany them suggest the modernist tradition ushered in by Marcel Duchamp's ready-mades. Combining the two, Lovell juxtaposes the two-dimensional and three-dimensional, the illusory space of the drawn image and the physical space of objects and paper, the monochromatic drawing and the color of the objects. There is an implied narrative connection between the drawn head and the object or objects in each work, implied because it is ambiguous and open to varied interpretations. The interaction reveals hidden aspects of both the drawings and the objects. A string of beads could direct one's attention to courtship. A revolver, knife, cartridge belt, piece of rope, or coil of barbed wire might evoke the violent oppression of African Americans in our history. In conversation with McGee, Lovell said, "Certainly the effect of slavery is something I can feel in my bones; it's a feeling I understand because I felt it coming off of my parents and emanating from my grandparents. ... You can't just shake all that stuff off. ... Our cultural memory and our identities are intertwined with a difficult history."

Lovell's subjects transcend nation and race. But they are African Americans, and race plays a critical role in Lovell's art. He finds the issue burdensome, but as he has said, he cannot avoid the question of whether his art is "'of,' 'for,' 'by,' and 'about' black folks" (a question that would not be raised for a white artist). Lovell has chosen to present images of African Americans in a positive light, to celebrate them, in order, as he said, "to pay homage to the lives of ordinary people whose existence has been overlooked and unrepresented historically." His approach reminds me of something Elaine de Kooning used to say, "When you're in love, you don't rhapsodize, you itemize." Lovell avoids sentimentality, the Achilles heel of figurative art, by portraying his subjects factually and refusing to idealize them. His depictions are deeply felt and genuine.

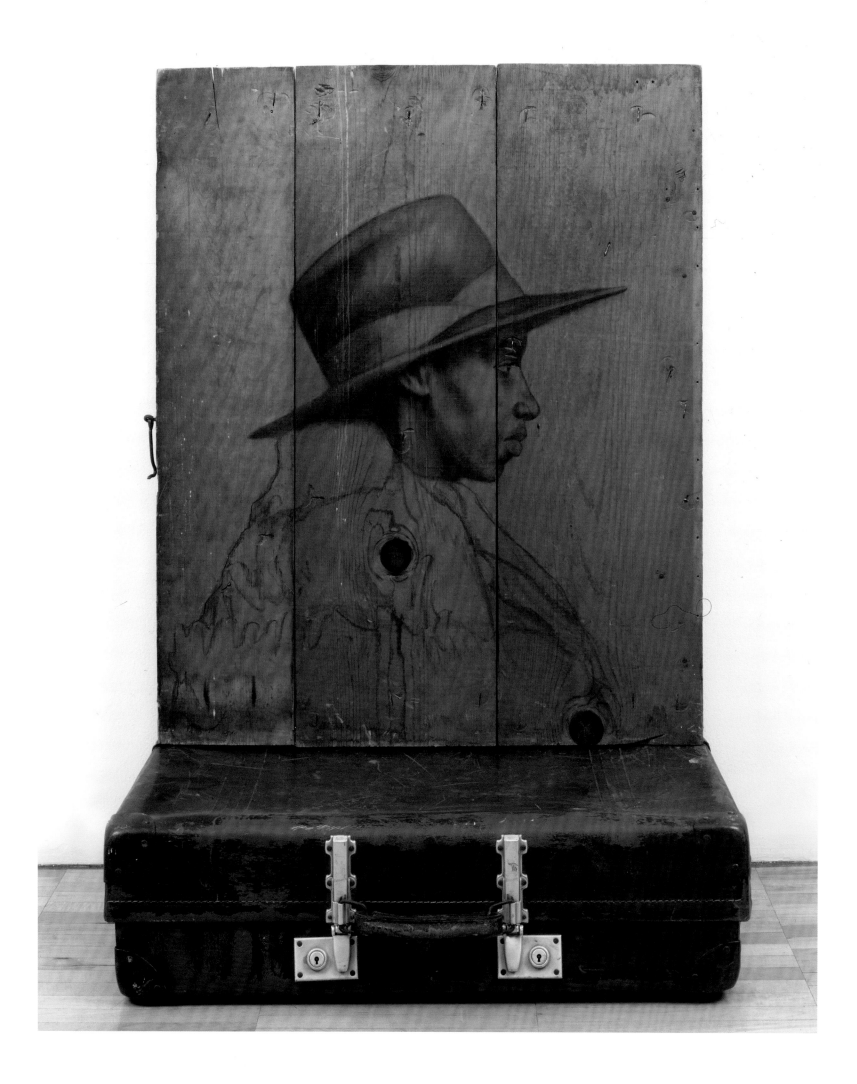

More than You Know:
The Quiet Art of Whitfield Lovell

Kevin Quashie

It is the use of juxtaposition that one might notice first. Almost all the pieces in the *Kin* series of Conté drawings on cream paper—and many of the earlier charcoal figures on a wooden support—incorporate an artifact, a found object from everyday life (a figurine, a bit of rope, a chain, a knife, a fabric bouquet). The composition is clean, as if image and artifact are located near each other without abrasion or overlap.

The pairing of artifact and image doesn't really create a sense of doubleness because the depicted figure is intended to be prominent. But there is tension there, a conversation between subject and object placed so carefully near each other. Proximity is contagion, and the artifact insinuates itself on the drawn image. Indeed, the artifact sometimes becomes part of the subject's body, marking the place where one might expect a shirt collar, a piece of jewelry, the outline of a chest. Localized and domesticated, the artifact's randomness is exchanged for specificity, a result of it being ordained with a bold, beautiful black face.

And the subject is clarified by the artifact. Look, for example, at *Kin VII (Scent of Magnolia)*, 2008 (p. 39): Are these flowers from his room, a private and unusual explosion of color? The flowers he gave to a date or the ones he brought to a funeral? We might pick up the title's reference to Billie Holiday's luscious voice on "Strange Fruit" ("scent of magnolia sweet and fresh / the sudden smell of burning flesh"), which might lead to a more ominous reading—his killed body marked by a wreath—but it is unsatisfying to be so singular and definitive with this image. Because of the flowers, he is a more a subject than an emblem; we can wonder if he loved pink and purple tones without ignoring the possibility of racist violence. Whatever the story, the flowers are a surprise; they interrupt the dominant narratives that might be ascribed to the profile of a black man of that age.

The foreboding is there in Lovell's work—the chain, the barbed wire, the target, the rope—as it would be, often is, for a black person in the United States, but the specter of threat should not overwhelm the subject's humanity. It is only part of their story. Lovell seems to aim for a balance between the social or public meaning of a person (or object), and the intimacy, the human relevance that the individual has. Where his earlier work created tableaux using full-bodied figures, the aesthetic of juxtaposition in these pieces is what evokes narrative, as if we are seeing the unfolding of a scene of human life, as if more and more of the image will manifest if you look long enough. (This is especially true of Lovell's drawings that lack a corresponding artifact, such as *Kin XV (Seven Breezes)*, 2008 [p. 55].) The key is to let the unexpected be possible.

The power of the narrative turns on these faces, which are stunning evidence of Lovell's skill in drawing. The figures in his earlier tableaux (for example, those in exhibitions including *Whispers from the Walls* [1999; pp. 22–23] and *SANCTUARY: The Great Dismal Swamp* [2002; pp. 151–53]) were made from anonymous posed studio portrait photographs found at flea markets or in town archives, while identification photographs and mug shots are among the sources for his more recent work, especially the *Kin* series. In all the work, Lovell renders the subjects with terrific clarity—the intensity in the eyes, the relaxedness around a mouth, the tautness of the curled hair. His use of shadow is astute, and the result is images of people who look like people—not symbols but every-day people, wary and resolute, alive. They look familiar to us even if it is rare to see black faces represented in such a studied, elegant way. The quality is consistent even with the images made from identification photographs, where there is an intimacy, a sense of agency, as if the face reveals something particular about the ambition and ethic of the subject.

The artifacts, and their juxtaposition with the images, are a tribute to Lovell's conceptual intelligence. More than a master of neoclassical portraiture, he is a gifted conceptual artist who works in a third dimension and engages (postmodern) theoretical principles (disparateness, disorder, multiplicity, ambivalence). But the

Page 8: **Bleck,** 2008.
Conté on wood, gloves;
44 ¹/₂ x 21 x 11 inches

Page 10: **North,** 2000.
Charcoal on wood, suitcase;
40 ¹/₂ x 33 x 17 inches
Greenville County
Museum of Art, Greenville,
South Carolina

**Visitation:
The Richmond Project,**
2001. Installation view
(detail of woman and piano)

astuteness of his juxtapositions seems to refuse the noisiness that is so often a part of modern art: These compositions are not put together violently, even if they sometimes suggest violence; they are not arranged harshly, even as harshness is part of the story they tell. There is elegance here, a delicacy of tone, because, after all, these are human lives and human lives are as delicate as they are sturdy. Furthermore, the conceptual aspect of this work is not abstract. Instead, Lovell's images rely on explicit concreteness—a portrayal of a person who once lived on this earth, the presence of an object once used by a person who lived on this earth. These pieces are steeped in concreteness, as if to remind us that everyday life is full of fancy and whimsy and passion, desperation and displacement—all the elements of art.

Quiet is the prevailing quality of this work, not silence but quiet. The word *quiet* here is intended as a metaphor for the interior, for the full range of one's inner life—one's desires, ambitions, hungers, vulnerabilities, fears. The interior is hard to describe and even harder to represent, but it is potent in its ineffability and is essential to being human. The interior is full of motion and energy, expressive and dynamic, which is why *silence* is not an appropriate synonym—*silence* is too loaded a term, too readily associated with the absence of motion or sound. *Quiet* is ravishing and wild.

Quiet is also antithetical to how we think about black culture and, by extension, black people. So much of the discourse of racial blackness imagines black people as public subjects with identities formed and articulated and resisted in public. (In fact, the notion of resistance, so important to black life, is tethered also to this notion of publicness.) Such blackness is dramatic, symbolic, never for itself, its own vagary; it is always representative and engaged with how it is imagined publicly. These characterizations are the legacy of antiblackness, and they become the common way we understand and represent blackness, a lingua franca.

The idea of quiet, then, can shift attention to what is interior. This shift can feel like a kind of heresy if the interior is thought of as apolitical or inexpressive, which it is not: one's inner life is raucous and full of expression, if we can remember to distinguish the term *expressive* from the notion of public. Indeed the interior could be understood as the source of human action—that anything we do is shaped by the range of desires and capacities of our inner life.

This is the agency in Lovell's pieces, the way they imply a full range of human life. We don't know the subjects just by looking at them or noticing the artifacts. Their lives are wide-open and possible, and they are more than familiar characterizations of victimization by or triumph over racism. For sure, the threat and violence of racism is one story, as is grace and the necessity of the fight. But what else is there to black humanity, these pieces seem to ask? The question is an invitation to imagine inner lives on the broadest terrain.

What sustains this invitation is the spare quality of the composition and the aesthetic of juxtaposition. Lovell's work is pure visual poetry: slim images enjambed and aligned, meaning left open. Who is that woman, that man? What was she thinking then, and what was the taste she liked the most? Did she revel in words, or did she prefer the lilt of a soft piano? These questions can only be asked if we remember that these people are human beings, and whatever partial answers we might come up with cannot be seen through a public lens. The interior lives of these people are largely inaccessible to us. Many critics have noted that Lovell's pieces are haunting, which makes sense given how exposed and vulnerable these subjects are (exposed and vulnerable not just to violence but to life itself). But maybe they are also ghostly in the way that sociologist Avery Gordon uses the term to describe bodies of wild agency that are not fully commensurate with our social and political language.

It is a remarkable thing for a black visual artist working with black subjects to be able to slip away from easy politicization, from the narrowness of representation, and to reach toward the expression of black humanity. It is remarkable, also, to make the argument that Lovell makes so well with his work—that what is black is at once particular and universal, familiar and unknowable.

Oh, the dignity here, the absence of spectacle, the precise elegance of the poses. The grace and moral clarity. Oh, these images that are more than we know, more than we ever can know.

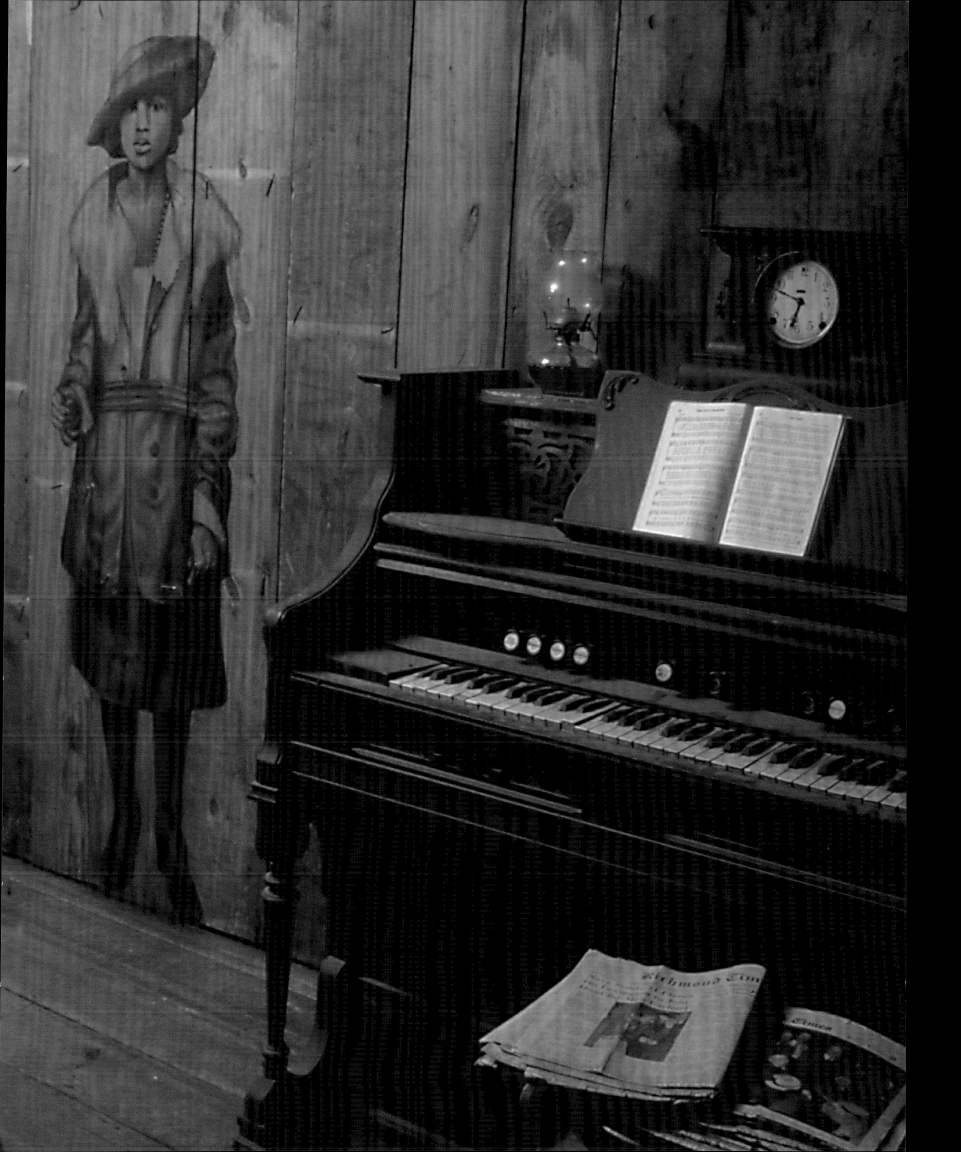

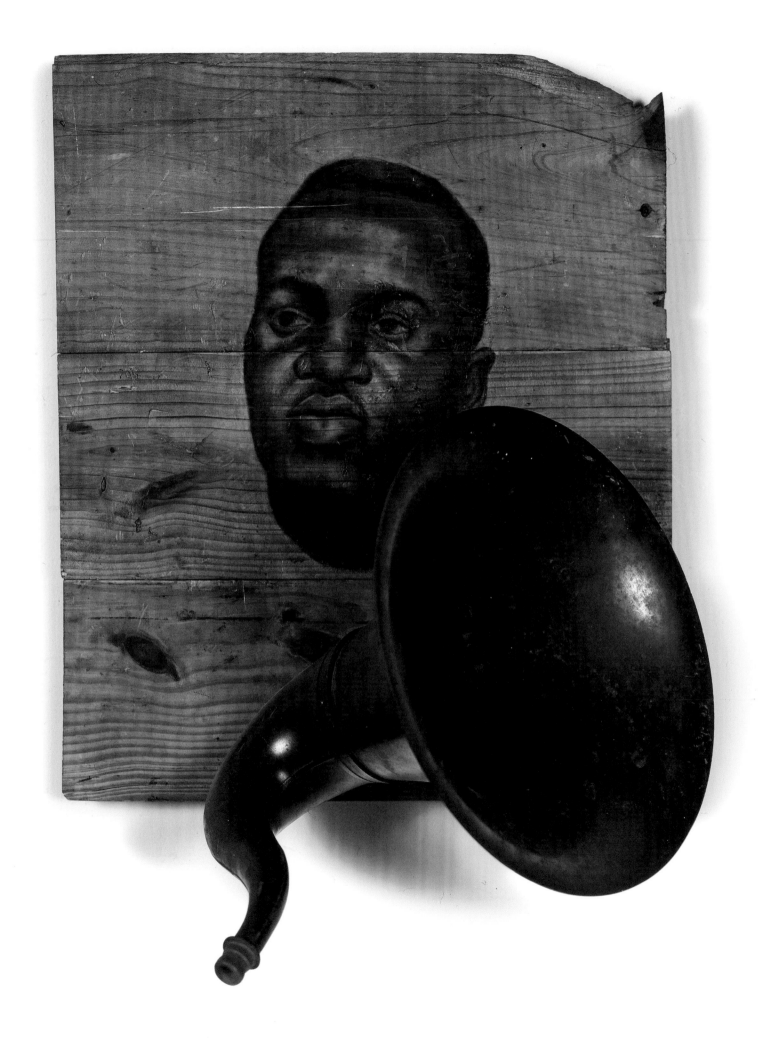

Whitfield Lovell:
A Reverence for Ordinary People

Sarah E. Lewis

I walked into Whitfield Lovell's studio one night for a soirée, heard a woman's voice rising, and, after I thought she had reached the limit of the human vocal range, go higher still. In the room were kin gathered, men and women whom Lovell had known, affirming with their smiles and tears the power of the promised performance—the voice of Alicia Hall Moran accompanied by Jason Moran on piano, sounding out the pathos of Lovell's *Kin* series, a new body of work that surrounded them, based on photographs of anonymous African Americans taken in the 1940s. For this musical "happening" in Lovell's studio loft converted from a piano factory, Hall Moran sang six songs that resonated with his selected pieces.

It seems appropriate that the *Kin* series, then still in process, would inspire an auditory dimension. In much of Lovell's oeuvre, the music is, in fact, audible. In *After an Afternoon*, 2008 (p. 182), nearly forty radios are piled as if to create one magnum instrument, playing four separate tracks simultaneously—Billie Holiday singing "Yesterdays" and "Strange Fruit," a Walter Winchell World War II news broadcast, and an excerpt from the classic 1940s radio program, *The Beulah Show*. Through music, we often connect with a time before our own, "the world that came just before you were born, and which is really so hard to know," Lovell had told me.[1] Perhaps, I thought later, the evening occurred because even when there is no audio in the *Kin* works, "the pieces have a sound that you can almost hear."[2] In an earlier work, *Call*, 2001 (opposite), a gramophone horn is juxtaposed with the contours of a man's image, rhyming in scale and shape as if the descent of the instrument suggests a depth of human spirit.

Yet what I came to see is that simply because of the evocative power of Lovell's works, one woman *sang*. I emphasize this encounter to underscore that Whitfield Lovell's *Kin* series does not require my words. Perhaps it does not require anyone's, and this is not because his works need no explanation. James Agee felt that his pen could not match the lived realities of American tenant families in the photographs by Walker Evans reproduced in their 1941 book *Let Us Now Praise Famous Men*.[3] As he put it:

> If I could do it, I'd do no writing at all here. It would be photographs; the rest would be fragments of cloth, bits of cotton, lumps of earth, records of speech, pieces of wood and iron, phials of odors, plates of food and of excrement....A piece of body torn out by the roots might be more to the point. As it is, though, I'll do what little I can in writing. Only it will be very little. I'm not capable of it; and if I were, you would not go near it at all. For if you did, you would hardly bear to live.[4]

So, too, might anyone recognize the near impossibility of prose conveying the visceral power of Lovell's *Kin* series of assemblages—a set of sixty works in Conté crayon on paper coupled with found objects, "pieces of wood and iron."[5] Like Evans, Lovell has trained his gaze on a moment before mid-century in American culture. He expands Evans's scope by selecting images of anonymous African Americans seen in identification photographs, from mug shots to photo-booth pictures.[6] The syntax of Lovell's resulting compositions, juxtaposing drawn images with found objects, creates synoptic narratives that help us to understand the significance and complexities of African American lives.

The *Kin* series began after Lovell looked at a photo-booth picture of a man, his wide-brimmed hat tilted slightly off-center framing his withdrawn frontal stare, and saw him as family. Bodily expression revealed inner life. "There was something about the emotion in his eyes that immediately spoke to me. I was compelled to draw that young man's face at a certain life-like scale, and to capture as much of his expression as I could," Lovell said. This photograph inspired him to create *Kin I (Our Folks)*, 2008 (p. 27), the first in the series that emerged as he continued to look at a set of identification images. The intensity of these mostly classification-based photographs compelled Lovell to create more work as he considered those jailed, measured, arranged, documented, and categorized folk as what they are—kin.

Anthropogenie, 1988–89.
Oil stick and charcoal on
paper; 86 x 50 inches

Page 14: **Call,** 2001.
Charcoal on wood, found
object; 24 x 20 x 15 inches
Private collection

of the photograph down to the level of the hair strands—communicates his grasp of this connection and his care. He exalts her profile by partially framing it with a wooden chain, creating a contour like that of a cameo—an object reserved for images of intimate importance. "The thing that touched me most of all is the way that her bottom lip curls out and down," he said. He recalled affectionately that an older relative had such a lip and often held her mouth a certain way so that her lips weren't protruding. The work's title, *Nobody*, refers to a song written by Bert Williams and Alex Rogers, performed by Nina Simone, which comments on the prevailing insight of Lovell's overall practice: transforming an anonymous visage into a significant image worthy of honor.

Many subjects in Lovell's series read as reluctant sitters, men and women with withdrawn, downcast, or defiant expressions—a residue, one wonders in the case of mug shots, of their initial context?[7] While prior to the *Kin* series, Lovell had engaged with source images by commercial photographers from the twentieth century, in which sitters had representational authority, as Patricia Hills has observed, the *Kin* series makes use of institutional, often classification-based, images for which the subject was required to relinquish control.[8] He was attracted to these images because some display the subject in profile, one way that these images bear the trace of a correctional setting or police precinct. Such institutional photographs often intrigue us, as Katy June-Friesen has pointed out with regard to the captivating quality of the mug shot. "We look hard at their faces…and then look harder."[9]

The source images of frontal and profile portraits that so gripped Lovell were part of a representational system for presenting criminal types that is rooted in racial science and anthropometry. Dr. Alphonse Bertillon codified the profile convention for police photographs in the late 1880s in Paris. The son of a statistician, Bertillon built a classification method on the aesthetics of racial science; he applied anthropometrical measurements, from the length of the head to characteristics of the teeth, to the task of tracking and identifying criminals.[10] A precursor of Bertillon was Francis Galton, whose *Portraits and Combinations of Portraits of Violent Criminals* (c. 1878) used photographic portraiture as a technique to index the so-called criminal mind. In these images, external appearances were meant to correspond with different mental

"I didn't plan to do the series," Lovell told me slowly, deliberately, as he went through the *Kin* series drawings in sequence with me one afternoon, beginning with the first image. "I simply reacted to a number of really intense photos that were made mostly for identification purposes."

The subjects "were not posing per se, they were just being who they were, and so there was a rawness that was very intimate and arresting. I couldn't stop thinking about them," he said. "As I was working from them, I felt like I was seeing these individuals in the way that you only see your family members, or those you live with. Like when you wake up in the morning, and you're completely unselfconscious. I recognized how familiar the faces I was drawing all seemed, and I thought, 'These people are almost, well, they *are* just like family.'"

Kin VI (*Nobody*), 2008 (p. 37), the sixth work in the series, began when Lovell looked at one image of a woman set in profile and saw her as someone whom he seemed to innately know. He was struck by her short, cropped hair, straightened but with curly natural hair showing at the roots. It reminded him of his older sister, who struggled to get her hair straightened with a hot comb. The meticulous precision of his drawing—stylistic mimesis

Villa Val Lemme, 1993.
Installation detail

characteristics. Yet Galton noted that in his composites, "[t]he special villainous irregularities in the latter have disappeared, and the common humanity that underlies them has prevailed."[11] Galton recognized the dual nature of identification portraits as Lovell would; works meant to signal deviance often resulted in portrayals that express positive human qualities.

Many of Lovell's assemblages suggest a radical re-visioning of the aesthetics of racial classification. In *Kin XXI* (*De-Dah*), 2008 (pp. 6 and 67), Lovell placed a ruler next to the rendering of a man, as if calling into question its historic function of measuring bodies. The ruler, used to draw a straight line, also echoes the man's upright, proud posture. His upturned chin, too, alludes to the triumphant sound of the work's parenthetical title, *De-Dah*, the name of a Clifford Brown composition, which connotes a sense of contentment. Yet in the context of the source images, the measuring stick evokes a tightly regulated system of classification, one that transforms the camera into an instrument of measurement.[12] The contrast between the dignified illusionistic portrayal and the tactile object of judgment has the force of a detonation.[13]

In *Kin XXXI* (*Island of My Skin*), 2008 (p. 87), as another example, Lovell places a facial image at the apex of a miniature tree as if to encode the arbor-like hierarchy once used by racial science to diagram human development. Herbert Spencer had envisioned evolution not as a "great chain of being," as Charles Darwin had, but as a development schematically akin to the contours of a tree, an ancient symbol with genealogical associations. Spencer's tree branches spatialized time: races once considered to be "earlier" on the evolutionary time line are seen in the lower branches; more "advanced" races are placed above. The stylized sculpture of an artificial tree seems to underscore the artificiality of supposed racial hierarchies. The branches jut out unnaturally at jaunty, near-geometric angles. A line drawn on the pot perhaps emphasizes its false roots. *Kin XXXI* (*Island of My Skin*) was not the first work in which Lovell presented his viewers with what seems to be an evocation of the false foundations of racial science. In *Anthropogenie*, 1988–89 (opposite), he diagrammed racial hierarchies. In place of a face is a drawing of three primates—a chimpanzee, an orangutan, and a gorilla—and a "neger," a black man sitting in a tree, borrowed from a German magazine illustration. Yet in *Kin XXXI* (*Island of My Skin*), he inverts the conventional order of these false hierarchies: the African American man is seen at the apex of the

tree. Is it too much to wonder if the compositional placement and suggested critique is part of the meaning that Lovell intends? To view Lovell's work means lingering with such questions.

Here we arrive at the product of Lovell's work—not declarations or assertions, but questions. One often feels as Hills did when she was in Lovell's studio, pondering, "What meaning was Lovell attempting to provoke…What was Lovell communicating?" with his evocative tableaux.[14] Lovell's compositional mood is the interrogative.

Lucy Lippard has called Lovell a visual "historian of memory," yet the *Kin* series suggests that he has become a chronicler of imagined or proposed alternate futures.[15] The deft choices of objects in his work seem to ask: do we imagine this life this way, or that way? The effect is deliberate, as Lovell made clear in response to a collector's interest in knowing more about *Kin III* (*Canto*), 2008 (p. 31), picturing a young black man above a semi-circle of bullet casings, a work that suggests multiple readings about violence, power, and harm all at once: "I could say that it is about the Scottsboro Boys, or Emmett Till, or lynchings, or the aftermath of Katrina or Abner Louima," he said, "but it isn't about any one thing, it is about all of these things. I could go on and on about all of this, but…the pieces are meant to be evocative, not to tell any particular story."

Forty years after Martin Luther King Jr.'s assassination, on the eve of the election of President Barack Obama, Lovell found himself creating the *Kin* series. At first, he focused on America's emblematic cloth, our national flag. In *Kin II* (*Oh Damballa*), 2008 (p. 29), he

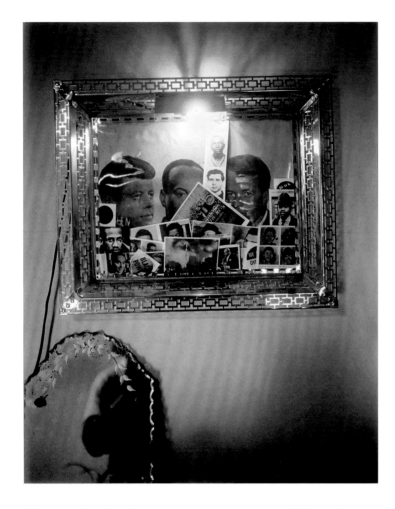

Kerry James Marshall,
Mementos, 1998. C-print
photograph; 24 x 20 inches

fashioned the flags' connecting string in an undulating line to rhyme with the contours of African continental geography, a metaphor for the diaspora that roots American history. The flag garlands a woman's profile with nearly cartographic clarity. The sitter's distant gaze suggests she is with us, yet far away. In *Kin VIII* (1619), 2008 (p. 41)—a reference to the date on which the first twenty enslaved Africans were brought to American shores—Lovell precisely placed gauzy crumpled flags under the childlike face of a woman whose focused, almost steely gaze seems fixed on a moment of profound importance. Yet after making these two works, Lovell stopped using flags. "When I think of the U.S. flag, I'm aware of how loaded it is, and I don't employ it simply to evoke notions of patriotism," Lovell told me. "It's not that I don't love this country, but it certainly does bring up very mixed emotions."

Nevertheless, Lovell let the colors of the American flag remain a sublimated, symbolic motif. He sensed that star-spangled banner–decorated African American portrayals might be viewed as a triumphant declaration of a new American moment after the election of Obama instead of the more complex signification Lovell intended. A red, white, and blue target affixed below a stoic woman depicted in profile becomes a bull's-eye in *Kin IV (One Last Thrill)*, 2008 (p. 33). Her elegant white earring, set directly above it, becomes a foil against the brutality of that symbol, transforming aggression into grace. "You have to be willing to be a target," the singer and composer Bernice Johnson Reagon once told those of us gathered in 2010 in the Highlander Civil Rights School in Knoxville, Tennessee. "You have to be willing

to come under attack when you are fighting for something much larger than yourself. You have to be willing to have vitriol fired at you." This is the sense of being fired at to which Lovell refers, the sense that "someone's always taking shots, whether it be literally or figuratively."

Lovell's career began in the wake of the "aesthetic funerals," as they have been called, of the civil rights movement, the tributes created after King's death, which unfurl images, ideas, and epic visions of African American culture, as if to secure a horizon line that felt suddenly in doubt.[16] For some, spreads of memorabilia became a study of memento mori. Many artists drew on personal archives of signs, photographs, posters, and postcards, such as the one we see in an a 1998 photograph by Kerry James Marshall, *Mementos*: into the illuminated metal picture frame of a tribute to the slain Kennedys and King are wedged many photos and slogans evoking the civil rights and Black Power movements. Below it is a partial view of a mirror, with an engraved wreath, in which we glimpse Marshall taking the picture.

In January 2010, to honor Martin Luther King Jr., the *New York Times* published "The Dream Described," a pictorial op-ed piece by Lovell, accompanied by a reproduction of *Kin II (Oh Damballa)*:

> The Rev. Dr. Martin Luther King Jr., whom we honor today, talked about the disparity between promise and reality in America. This work—a Conté crayon drawing with garlands of American flags—is meant to explore those themes, too. It juxtaposes a black woman's face with the flag to conjure the complex relationship between African-Americans and patriotism. The tension grows out of the contradiction of living in a country that did not afford my ancestors basic human rights—while at the same time being fully aware and proud of the contributions those very ancestors made to our history and culture. [17]

Lovell's use of flags and then his backing off from them enacts this paradox of patriotism and disenfranchisement. The controversy surrounding the response to Michelle Obama's 2008 Milwaukee rally comment—"For the first time in my adult life, I am proud of my country, because it feels like hope is finally making a comeback"—reminded us of the difficulty in expressing both a critique of democracy and a sense of patriotism. Lovell's *Kin* series is a collective expression of universal humanism, yet it is also a commentary on the difficulty of achieving equality under the law.

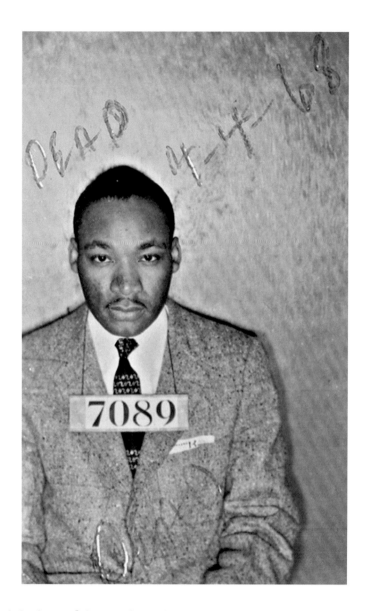

The paradox of patriotism was famously argued by Frederick Douglass in a speech that relied upon the rhetoric of pictures. In Rochester, New York, in 1852, he spoke about the conflict of celebrating the independence of America with its history of bondage. With "scorching irony," he asked his rhetorical question: "What to the slave is the 4th of July?" The question became the title of the speech that answered it: "A day that reveals to him, more than all other days in the year, the gross injustice and cruelty to which he is the constant victim."[18] Douglass described the landscape of injustice, laying out his argument about the irony of patriotism through a new pictorial language of the day—the panorama.[19] He reminded his audience of "the distance between this platform and a slave plantation, from which I escaped" and the comparative youthfulness of the seventy-six-year-old country, whose destiny, he said, might still be directed by the "high lessons of wisdom, of justice and of truth." He could have summarized his message easily enough without the pains he took, but it would have blunted the force of his sweeping imagery. Through this panoramic, synoptic vision, he shifted the focus of his talk from Independence Day back to American slavery and even to biblical times to paint a "dark picture" of the state of America.

Douglass elaborated on these ideas in his Civil War–era speech, "Pictures and Progress," in which he spoke at length about the importance of photographs for racial reconciliation.[20] From the orator and abolitionist came one of the earliest articulations of how the private function of aesthetic force operates in public life. Not only is the force of pictures, as Douglass defined it, evident in the work of many artists creating today, including Lovell's own, but his Kin series cannot be fully understood without first placing it within the history of photography.

Lovell's work is in the tradition of Douglass, who argued that ennobling portraits of African Americans, particularly ones based on historical documents, are a kind of evidence, and that our engagement with them is an often perspective-altering act. "I'm always amazed at how many people are taken aback when they see the dignity of the individuals that I'm depicting," Lovell has said. "I did a piece based on the photograph of a maid from around 1910. Very well tucked-in and groomed. I thought it was quite funny that in a review she was referred to as a 'well-dressed African-American.'"[21] As Lovell told Julie L. McGee, in the interview in this volume, "if my work may have made more

real the lives of the people in those old photographs in the eyes of history, then I would feel really good about that."

As Lovell makes plain in a 2006 interview, his work is, however unintentionally, "in service to" the photographic imagery:

The way that I've been working certainly over the past several years is that I feel that I'm sort of dodging the history of painting in a lot of ways. I'm not particularly interested in making paintings. I'm not particularly interested in making drawings or that whole dialogue. But the fact that I'm doing this with my hand, and that it's a hand-drawn image, is very important to me. I love the act of drawing. Of course I love drawings and paintings. But in my current work I'm mostly interested in the people and the imagery, so that my drawings are more in service to the imagery than being about "drawing."[22]

In the more recent interview with McGee, he expands on this view:

I think we all owe so much to those people who went out to have their pictures taken, and the photographers who posed and shot them. They are the ones who made the most profound contribution by just making the images and leaving them behind. That's why I feel it's important to respect their images, to be careful how they are used. They weren't making them for any grandiose purposes, aside from saying, "This is who I am—this is who I was, and I was here."

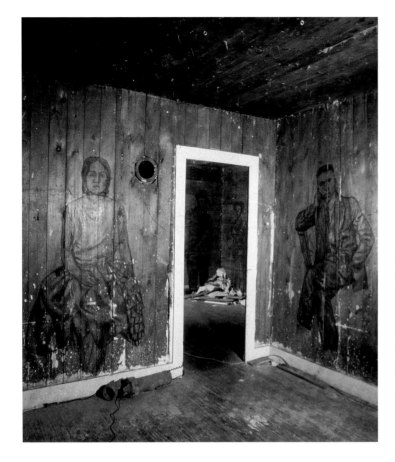

If, in reflecting the conventions of portrait photography, Lovell's *Kin* series almost seems to be part of that genre's history—as McGee suggested during her conversation with Lovell, "the history of photography would be incomplete without a reference to [Lovell's] work or that of other artists for whom photographic source material matters deeply"—it is partially because Lovell's own family had given him a keen sense of the important role of photography for marking moments in African American heritage. From his grandmother, who lived to be ninety-seven, he learned about the Great Migration and segregation, asking her about her inherited collection of photographs from the 1920s and 1930s, from which he made drawings. His maternal grandparents were part of the Great Migration, coming to Harlem in the 1930s from South Carolina. He grew up surrounded by a trove of inherited photographs in his home documenting his family—from the rural South in South Carolina and the Caribbean—and he also spent hours with his father in a darkroom in his childhood home. His father's work as a self-taught photographer influenced him long before he went on to study with photographer Larry Clark at Cooper Union. As his father's darkroom assistant, he was impressed by how an image emerges in the developing tray—at once invisible and then seemingly fixed—and it began his engagement with both the materiality and the ephemerality of a photograph.

With a deep interest in African American life, Lovell began to develop installations after a residency at an artists' retreat in 1993 in Capriata d'Orba, Italy, in the Villa Val Lemme, a mansion built in the mid-nineteenth century by a slave trader. As Lovell contemplated the significance of his own presence there, the meditation affected his practice; he felt compelled to create "dignified images of black people" in that space and left a self-portrait on a wall of the villa (p. 17). Two years later, in 1995, during an experience at Project Row Houses in Houston as an artist-in-residence, he used vintage photographs of African Americans as source imagery for his work. He has continued to use them ever since.

The force of Lovell's tableaux lies in the fact that they display a sensibility found in the tradition of early African American photographers, whose work was a way to "serve, and preserve, their communities and the individuals who sat for portraits," as Deborah Willis states.[23] Like Lorna Simpson and Radcliffe Bailey, who integrate actual vintage photographs into their work, Lovell accents his engagement with image-making and de-emphasizes his engagement with painting and sculpture.

Lovell deploys the plane of paper for compositional effect as a photographer might, with objects added not to pin down a potential narrative for each subject, but to call it into question and open up new possibilities. Caught and surrounded, the man in *Kin XI (Play It a Long Time)*, 2008 (p. 47), shows Lovell's preternatural ability to evoke the American landscape as a stage for racial violence through a few expertly selected pieces. The toy soldiers on the blank page surround a smooth-looking cigar-smoking man, seemingly unassailable. The subject's serene expression is a stark juxtaposition to his sculptural companions—miniature lead soldiers, each with a rifle poised close to him as if he is under attack. It is as if Lovell has conjured the visual narrative of the Confederate "Last Stand"—couching a Civil War narrative in terms of defending the western frontier. The blankness surrounding Lovell's subjects thus reads not as unused or unfinished but as a volumetric space in which his selected objects may convey inner narratives. His play with illusion and scale of the blank page—not stark and bright white but tan paper, as if it has aged, reading as an index of time passed—creates out of the plane of the sheet a sense of topography, an environment.

Yet while Lovell draws out the suggestive expressions in the *Kin* faces with sculptural cues, we are left with no hint about the actual histories of the images. Gone are any inscriptions or contextual information on the images, as there is on one of the most famous institutional images of all, Martin Luther King Jr.'s mug shot with the handwritten note: "DEAD 4-4-68"—a curt synopsis

America, 2000.
Charcoal on wood, flags;
89 x 53 ¹/₂ x 20 inches

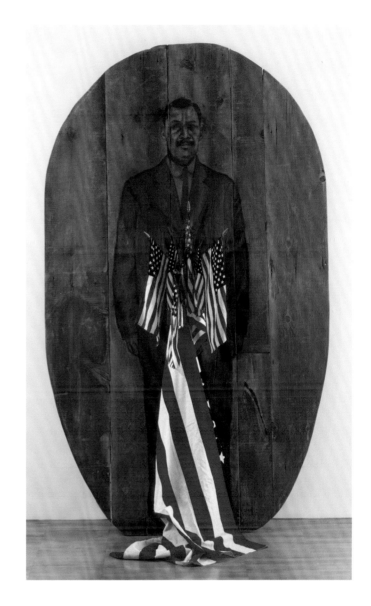

of his assassination and life (p. 19). King's killing on April 4, 1968, was a critical event in the artist's life; it impacted both his artistic practice and personal perspective by undergirding his work with a sense of the history of the freedom movement for African Americans. Recalling that King was photographed by the Alabama police following his arrest during the Montgomery bus boycott in 1956 reminds us to consider the context for police mug shots in the most expansive way. Lovell's sitters, too, could have been protesting laws that would soon be deemed unjust. The circumstances are not known.

The *Kin* series is inspired by African American men and women; the *Kin* series is about us all. "The series touches upon many aspects of the human experience. At one time I was expected to draw solely from African American culture as if the black experience were an insular entity, and therefore unaffiliated with the rest of the world. I feel the *Kin* series transgresses cultural or racial boundaries because of the emotional charge they all have." As we discussed the issue, Lovell recalled the scene in Akira Kurosawa's 1950 film *Rashomon* when Ravel's *Boléro* is heard. The effect had turned the specific to the universal. "It's not music from eleventh-century feudal Japan. That twentieth-century Western composition draws us into the story line because suddenly it's part of an even larger picture. We see how broad the human experience really is, and the characters become our sisters and brothers…our kin." Then he slowed his cadence, and our eyes turned to *Kin XII (Fakarouni)*, 2008 (p. 49), its title the signature song of the famous Egyptian singer Umm Kulthum, as Lovell asked rhetorically:

> *So you see what I mean when I say that I'm looking for the global implication in all the most ordinary of things, and the beauty and the significance of the most average of people? By relating the emotion of a classic Egyptian song to the qualities in that piece, to the humanity of the individual, I'm saying that this woman's being exists in the world, and not just a small sliver of one particular culture. Whether we are alike or different on the surface, doesn't the reality of one person reflect the human condition that we're all part of and responsible for?*

Perhaps Lovell sensed it all along: song could approach the evocative power of the series in a way that words may not.

Lovell's humanistic aim is for the *Kin* series to have the function of both a *sacra conversazione*, a holy conversation among the blessed, and a memento mori, "to evoke a sense of place, to be able to feel the spirit of the past for a moment, to feel the presence of these people."[24] Lovell achieves this through a compositional syntax that questions his sitters' states of bondage and fleeting freedom. The result is works that put "ordinary people in a context of reverence"—portraits transformed into a rite of honor.

[1] Lovell, personal interview with the author, June 12, 2009, New York City. All quotes are taken from this interview unless otherwise indicated.

[2] Lovell quoted in Bartholomew F. Bland, "Whitfield Lovell: All Things in Time," in *Whitfield Lovell: All Things in Time* (Yonkers, NY: Hudson River Museum, 2008), 29.

[3] In 1936 James Agee and Walker Evans were assigned by *Fortune* magazine to prepare an article about "cotton tenantry in the United States," a verbal and photographic depiction of "the daily lives and environment of an average white family of tenant farmers." At the time, Evans was on furlough from what was then called the Resettlement Administration (later the Farm Security Administration). The article was ultimately rejected but became the basis for their landmark book first published in 1941. For more about the dating of images and the reasons for the rejection, see Judith Keller, *Walker Evans: The Getty Museum Collection* (Malibu, CA: The J. Paul Getty Museum, 1995), 132, 187.

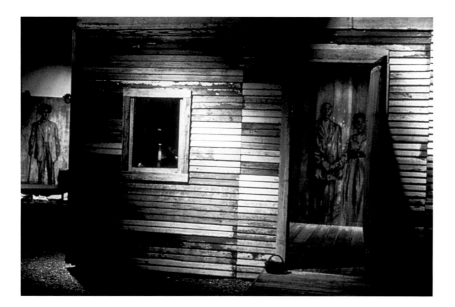

Left and right: **Whispers from the Walls,** 1999. Installation views

4 James Agee, *Let Us Now Praise Famous Men: Three Tenant Families* (Boston: Houghton Mifflin Company, 1960), 13.

5 Lovell considers the *Kin* series works to be assemblage and notes Robert Rauschenberg and Edward Kienholz as precedents.

6 It is a move that enlarges the tonal range of "hardship and resignation" found in the Evans, photographs, as Jennifer Ellen Way put it in "Redeeming Art World Mythologies: Working (Ex)change, or, the House Whitfield Lovell Built," in *The Art of Whitfield Lovell: Whispers from the Walls,* ed. Diana Block (Denton, TX: University of North Texas Press, 1999), 37.

7 Timothy Welsh explored the difference between commercial photography and the mug shot in his exhibition, *Reluctant Sitters,* at Studio@620, St. Petersburg, Florida, in February 2007.

8 Patricia Hills, "Notes on Whitfield Lovell Tableaux," in *Whitfield Lovell* (New York: DC Moore Gallery, 2000), n.p.

9 Katy June-Friesen, "Arresting Faces: A new book argues the case for the mugshot as art," *Smithsonian,* January 2007.

10 His method was popularized at the turn of the twentieth century through the World's Columbian Exposition in Chicago, where his methods were on display in 1893, and then again at the St. Louis Exposition in 1904. Kio Stark, "The Accidental Beauty of the System," in *Least Wanted: A Century of American Mugshots* (New York and Göttingen, Germany: Steven Kasher Gallery and Steidl Pub., 2006), 68.

11 Francis Galton, "Composite Portraits," *Journal of the Anthropological Institute of Great Britain and Ireland,* vol. 8 (1879): 135.

12 Michel de Certeau, *Heterologies: Discourse on the Other* (Minneapolis: University of Minnesota Press, 1986).

13 Here I am persuaded by Patricia Hills' reading of the tension between illusion and tactile objects as she describes in her essay, "Notes on Whitfield Lovell Tableaux."

14 Hills, "Notes on Whitfield Lovell's Tableaux."

15 Lucy Lippard, "Unforgettable: Whitfield Lovell as Historian of Memory," *The Art of Whitfield Lovell: Whispers from the Walls,* 11.

16 My thanks go to Salamishah Tillet and Dagmawi Woubshet for organizing an American Studies Association panel on this topic of King's aesthetic funerals. This panel first gave me the chance to think through some of these ideas in my paper entitled, "The Aesthetics of Riots and Rebirth: Belated Social Documentary Photography and Martin Luther King Jr." at the American Studies Association Annual Meeting, Albuquerque, New Mexico, 2008.

17 Whitfield Lovell, "The Dream Described," *New York Times,* January 18, 2010.

18 Frederick Douglass, "The Meaning of July Fourth for the Negro, 1852," in *The Life and Writings of Frederick Douglass,* Volume II, ed. Philip S. Foner (New York: International Publishers Co., Inc., 1950).

19 Three years after Douglass's speech, the panorama became a rhetorical device used to convey the sweep of history. Black daguerreotypist J. P. Ball published an abolitionist pamphlet which was accompanied by a 600-yard-long panoramic painting entitled "Mammoth Pictorial Tour of the United States Comprising Views of the African Slave Trade." The work is no longer extant, though it is widely thought that Robert Duncanson was part of its production, as the painter had worked in Ball's studio as a photographic retoucher beginning in 1854.

20 Frederick Douglass, "Pictures and Progress," in *The Frederick Douglass Papers* [hereafter FDP], ed. John W. Blassingame (New Haven: Yale University, 1985) (ser. 1, vol. 3), 461. Douglass delivered another version of this speech at Weiting Hall in Syracuse, New York, on November 15, 1861.

21 Lovell quoted in John Yau, "In Conversation, Whitfield Lovell with John Yau," *Brooklyn Rail, Critical Perspectives on Arts, Politics and Culture* (July/August 2006). http://www.brooklynrail.org/2006/07/art/whitfield-lovell

22 Ibid.

23 Deborah Willis, *Early Black Photographers, 1840–1940* (New York: The New Press, 1992), n.p.

24 Lovell quoted in Lilly Wei, "The Tableaux of Whitfield Lovell," in *Whitfield Lovell: Portrayals,* exh. cat. (Purchase: Neuberger Museum of Art, 2000), 13.

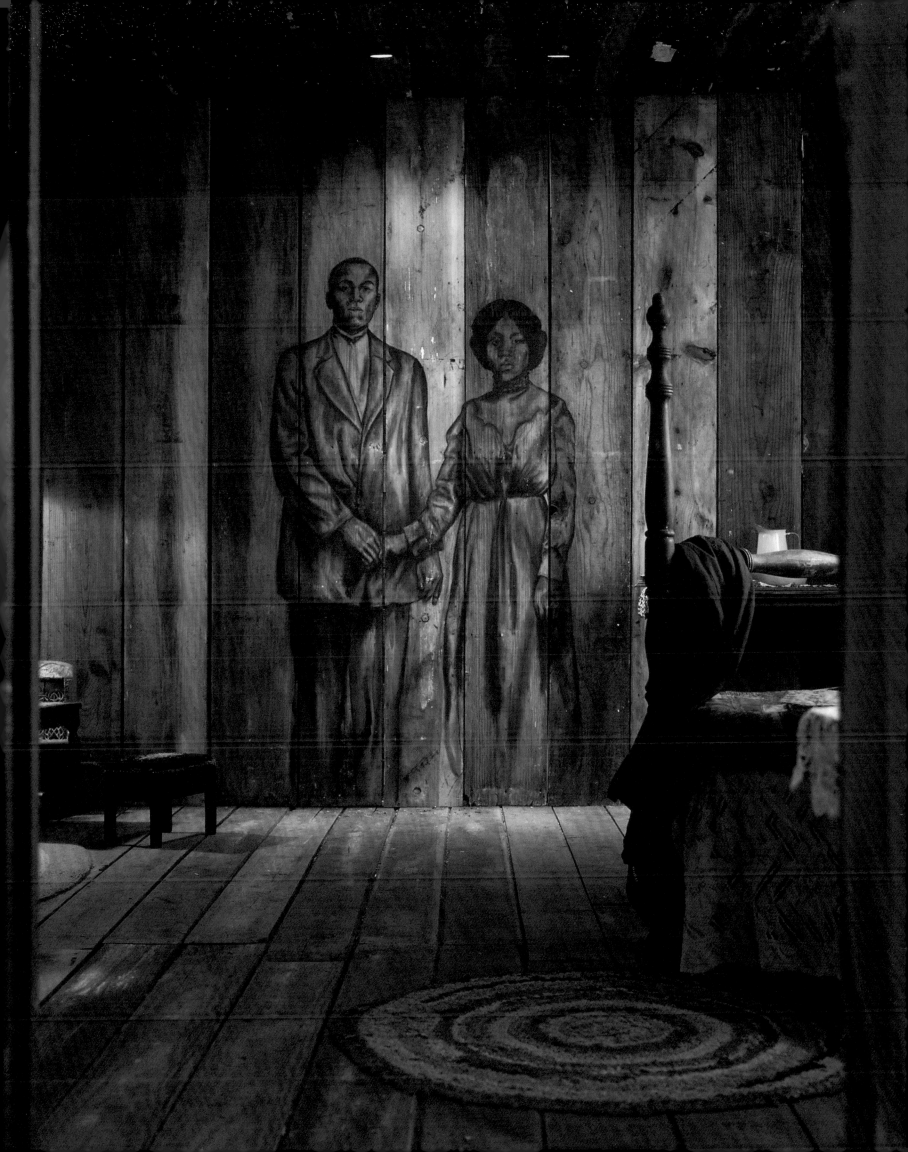

KIN
SERIES

Kin I (Our Folks), 2008. Conté on paper, found paper flags, string; 30 x 22 $^1/_2$ inches. Collection of Reginald & Aliya Browne

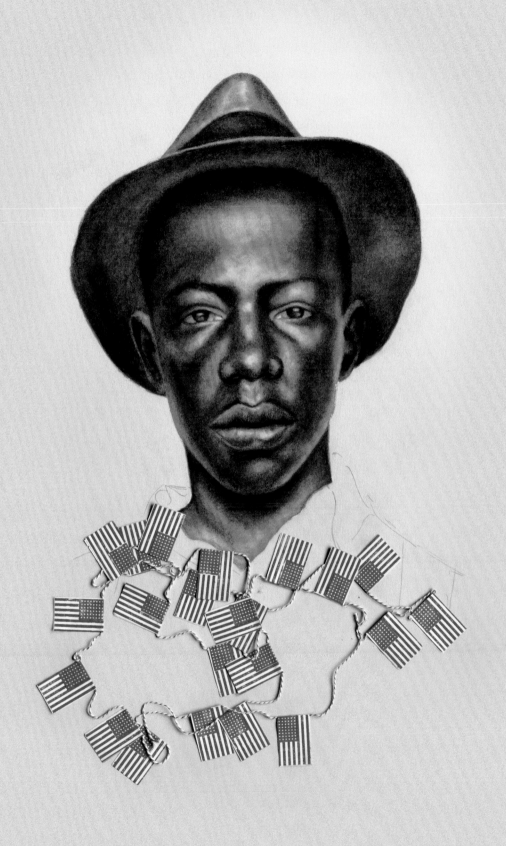

Kin II (Oh Damballa), 2008. Conté on paper, found paper flags, string; 30 x 22 1/2 inches. Mott-Warsh Collection, Flint, MI

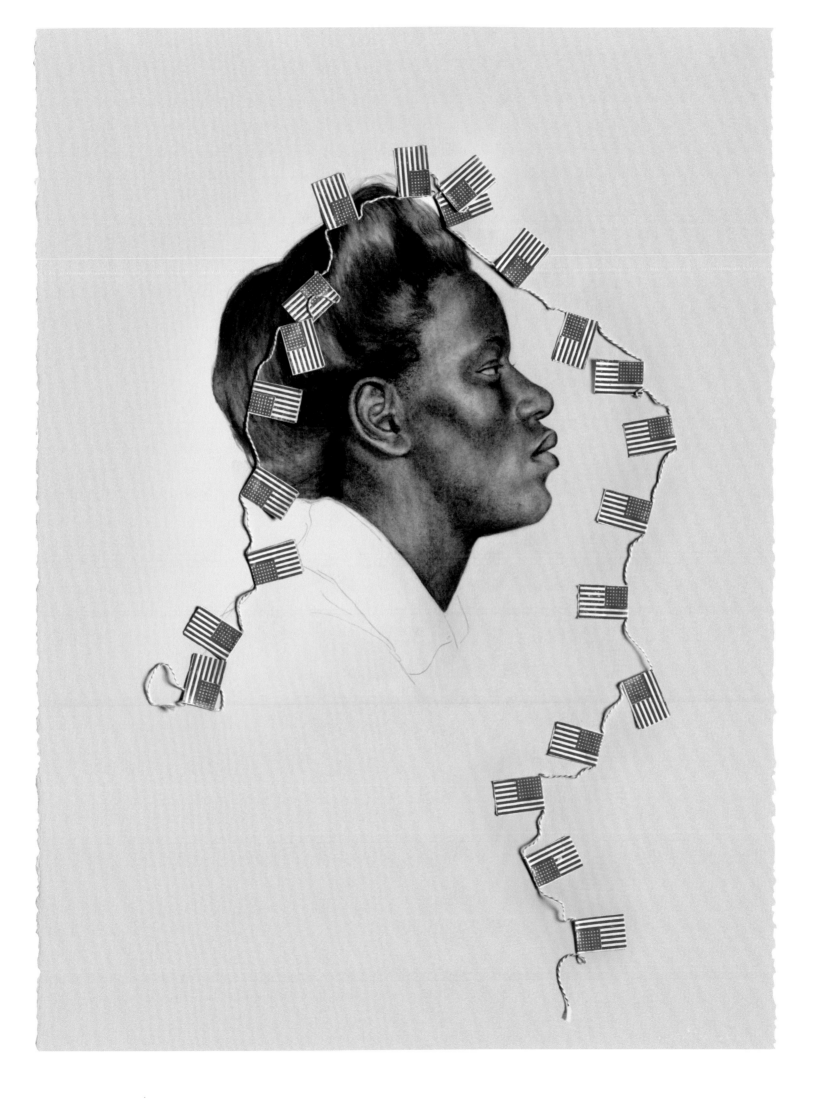

Kin III (Canto), 2008. Conté on paper, found paper flags, string; 30 x 22 $^1/_2$ x 1 inches. Springfield Art Museum, MO

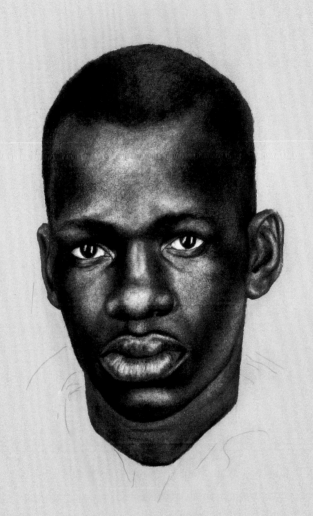
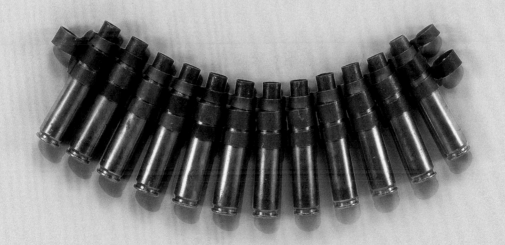

Kin IV (One Last Thrill), 2008. Conté on paper, wooden target; 30 x 22 $^1/_2$ x 2 inches. Private collection

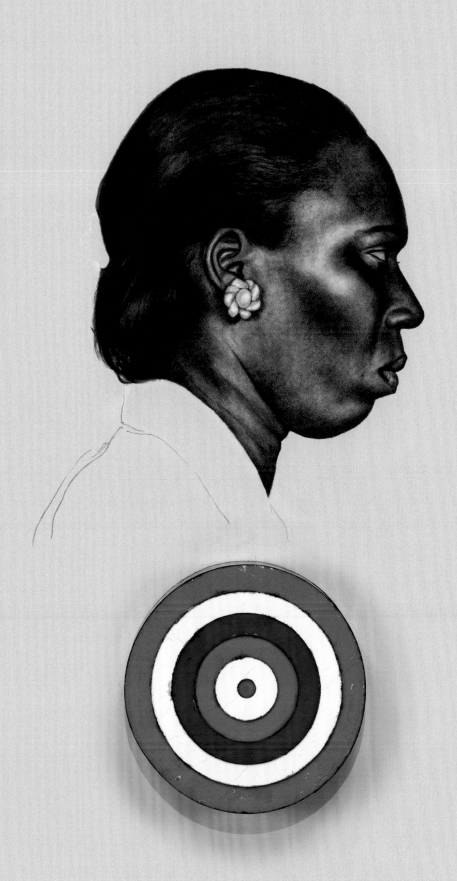

Kin V (Thou Dark One), 2008. Conté on paper, rhinestone brooch; 30 x 22 $\frac{1}{2}$ x $\frac{7}{8}$ inches.

34 Columbus Museum of Art, Ohio: Museum purchase with funds provided by Loann Crane in honor of Ray Hanley and his passion for the arts in Columbus

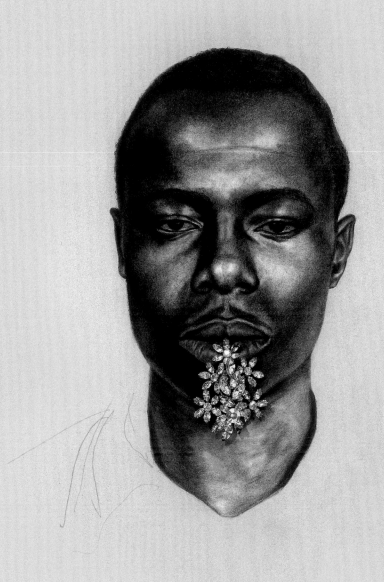

Kin VI (Nobody), 2008. Conté on paper, wooden chain; 30 x 22 $\frac{1}{2}$ x $\frac{7}{8}$ inches. Collection of Julia J. Norrell, Victoria, VA

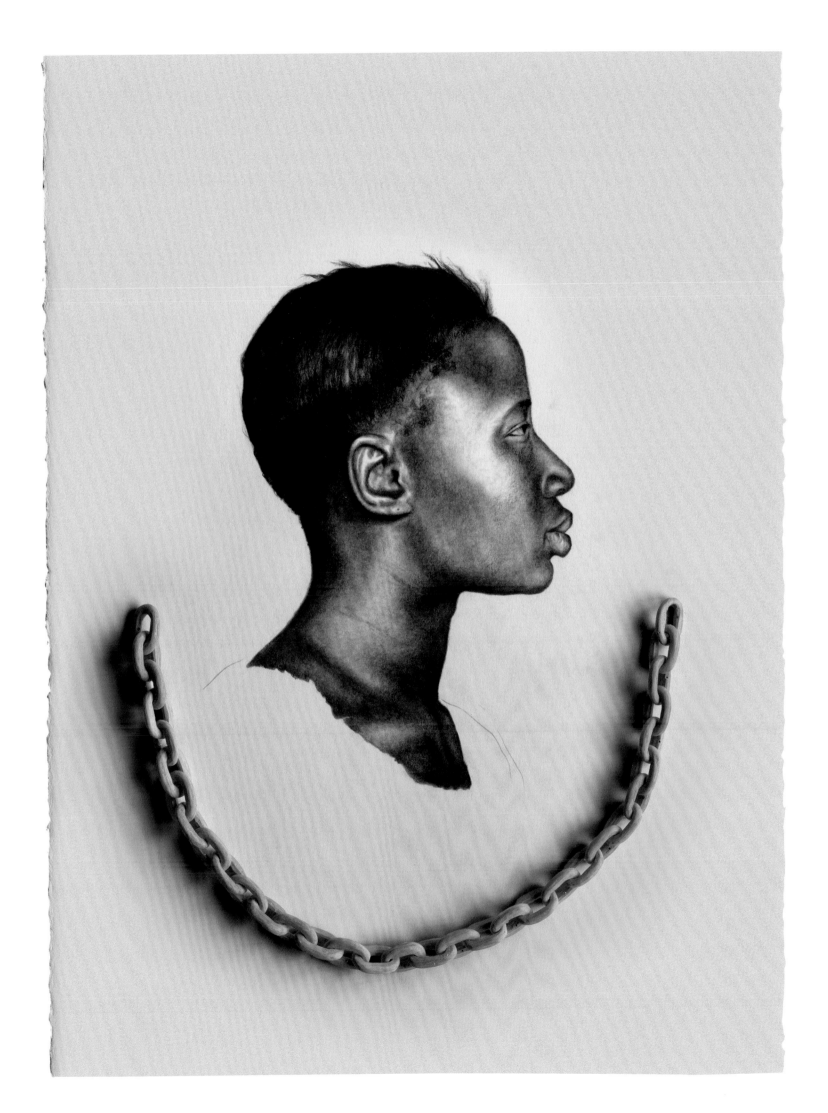

Kin VII (Scent of Magnolia), 2008. Conté on paper, silk flower wreath; 30 x 22 $^1/_2$ x 3 inches. Collection of Julia J. Norrell, Victoria, VA

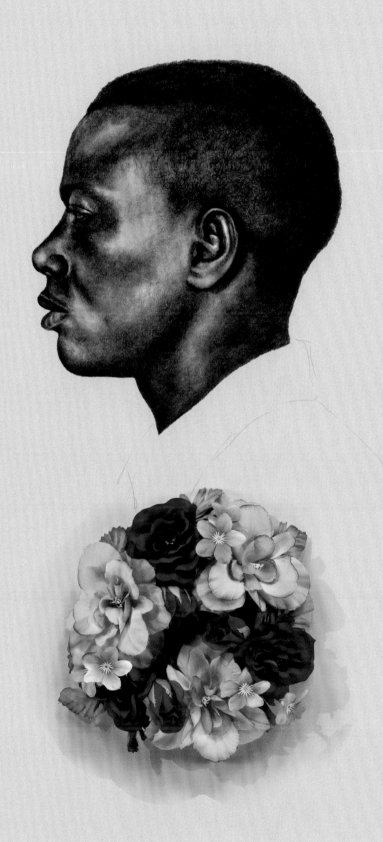

Kin VIII (1619), 2008. Conté on paper, flags; 30 x 22 $^1/_2$ x $^7/_8$ inches

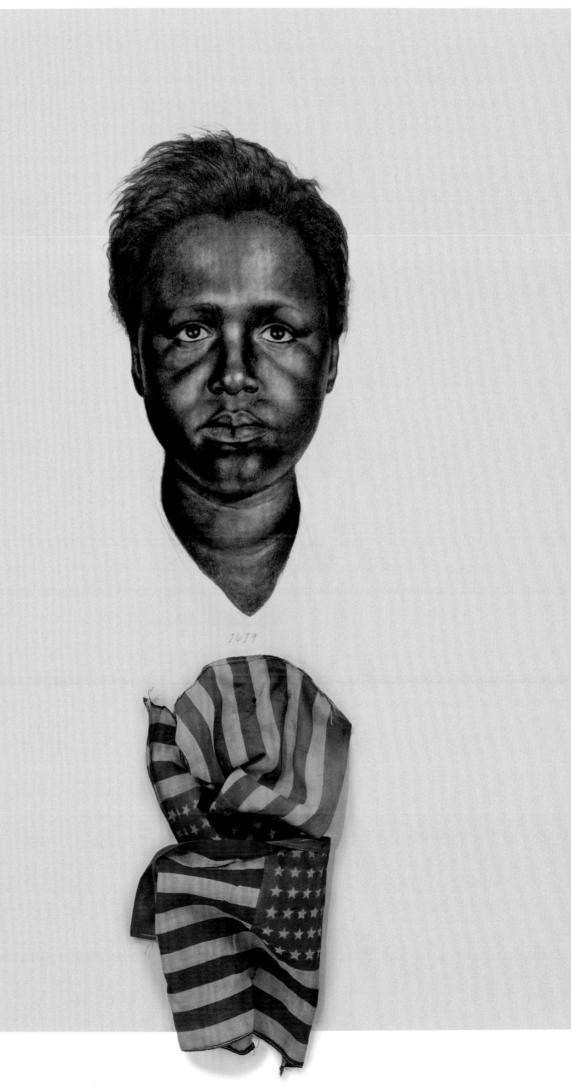

Kin IX (To Make Your False Heart True), 2008. Conté on paper, sterling silver canteen; 30 x 22 $^1/_2$ x 1 $^3/_4$ inches. Collection of Dale Mott & Ken Hyle, Washington, DC

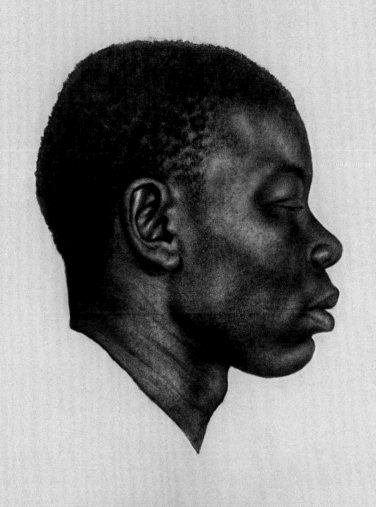

Kin X (My Pretty), 2008. Conté on paper, enamel brooches; 30 x 22 $\frac{1}{2}$ x $\frac{3}{4}$ inches. Bank of America Collection

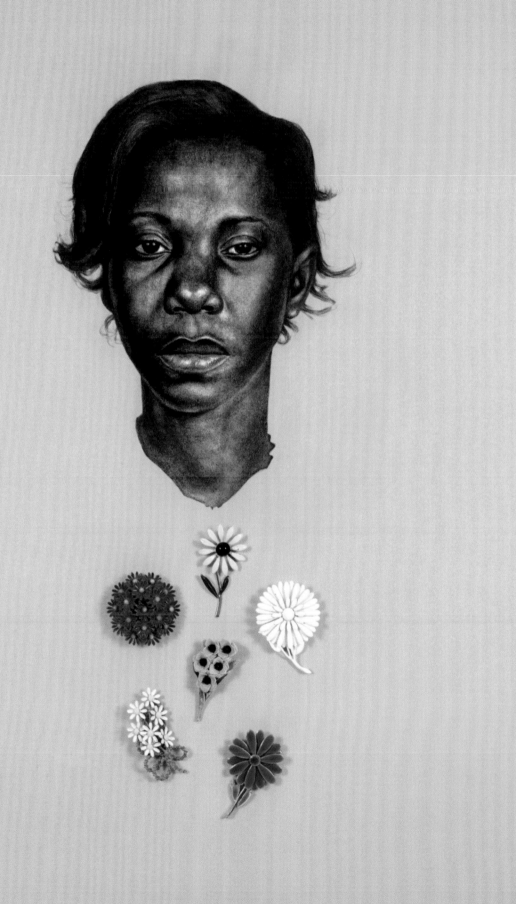

Kin XI (Play It a Long Time), 2008. Conté on paper, lead military figures; 30 x 22 $^1/_2$ x 2 $^1/_2$ inches

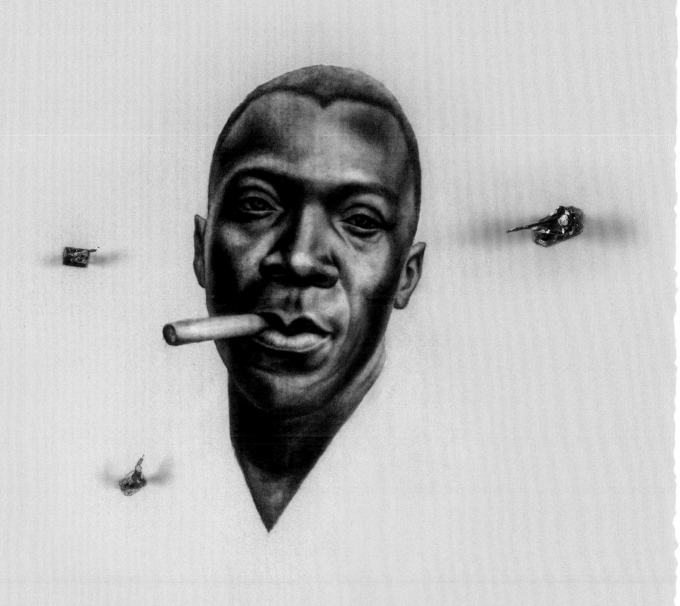

Kin XII (Fakarouni), 2008. Conté on paper, linen bouquet, glitter; 30 x 22 $^1/_2$ x 4 $^1/_2$ inches. Rodney M. Miller Collection

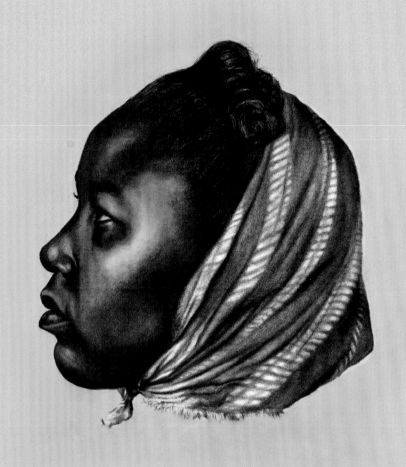
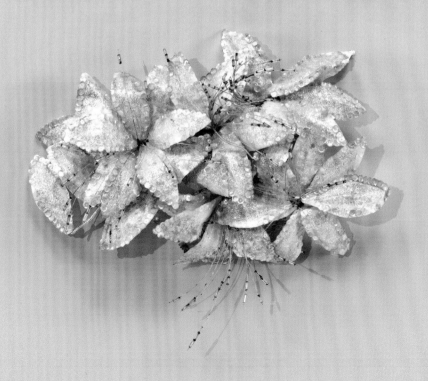

Kin XIII (Fine Kind of Freedom), 2009. Conté on paper, globe bank; 30 x 22 $^1/_4$ x 5 inches. Private collection

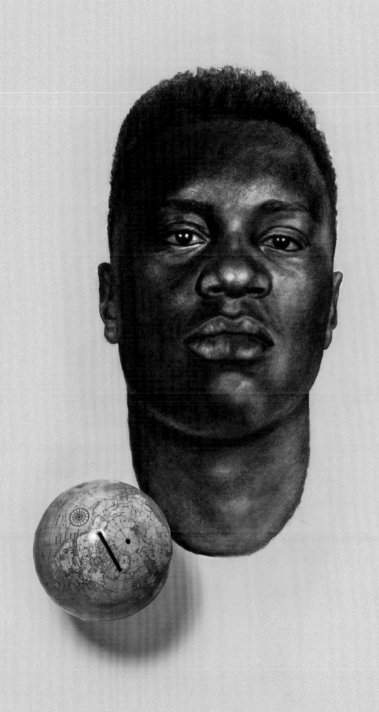

Kin XIV (No One Knows Where We Go When We're Dead or When We're Dreaming), 2009. Conté on paper, wooden clock; 30 x 22 ¹/₄ x 2 ³/₄ inches

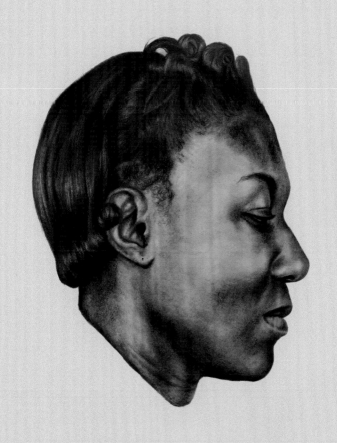

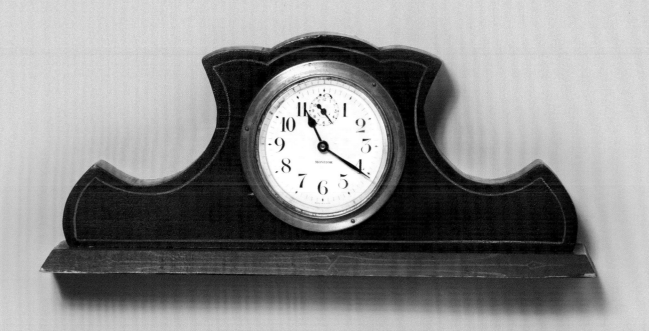

Kin XV (Seven Breezes), 2008. Conté on paper; 30 x 22 $^1/_2$ inches

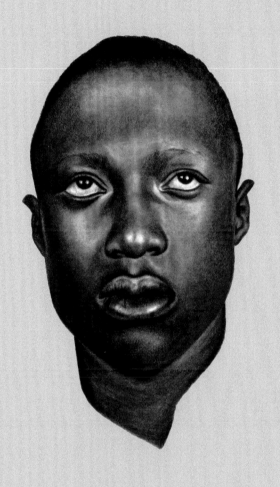

56 **Kin XVI (Love Song),** 2010. Conté on paper, recessed pistol, book; 30 x 22 $^1/_2$ inches. Collection of Laurie Garrett, New York

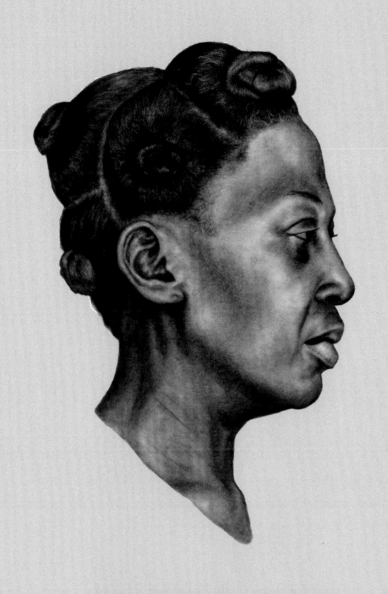

Kin XVII (Water), 2008. Conté on paper, figurine; 30 x 22 $^1/_2$ x 3 $^5/_8$ inches

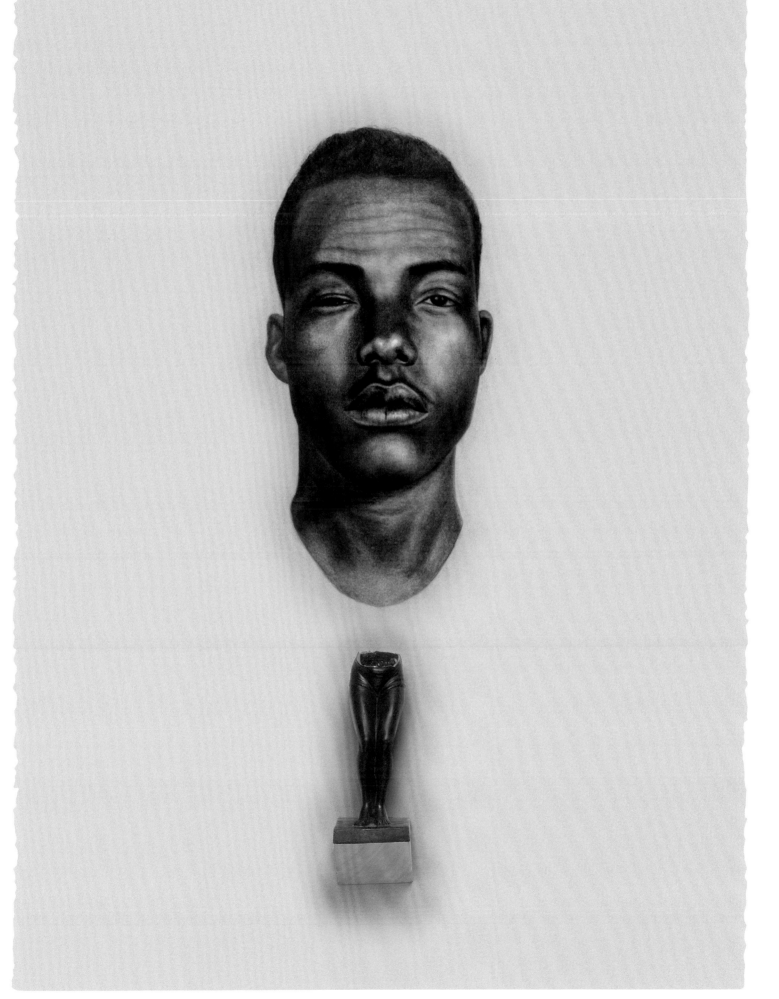

Kin XVIII (Hope Springs Eternal), 2008. Conté on paper, bottle, shelf; 30 x 22 $^1/_2$ x 3 $^3/_4$ inches.

Art Collection of the United States Embassy in Lusaka, Zambia, courtesy of Art in Embassies

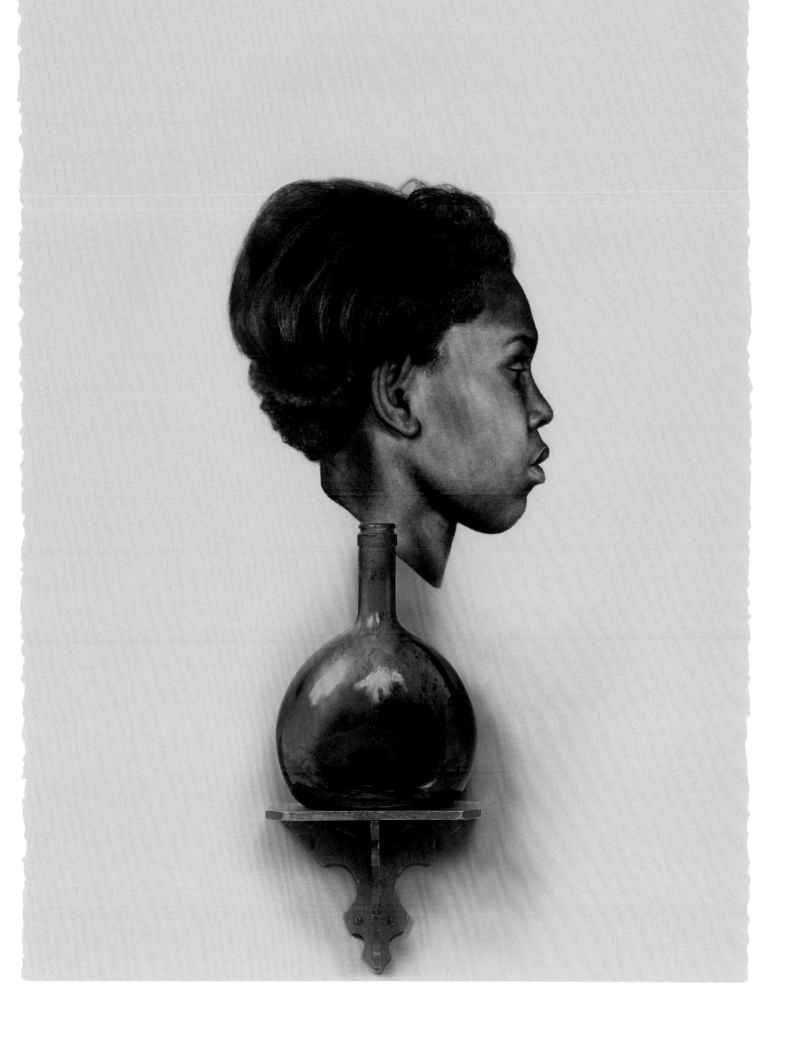

Kin XIX (You're Such an Easy Evil), 2008. Conté on paper, playing cards; 30 x 22 $^1/_2$ x $^1/_2$ inches. Private collection

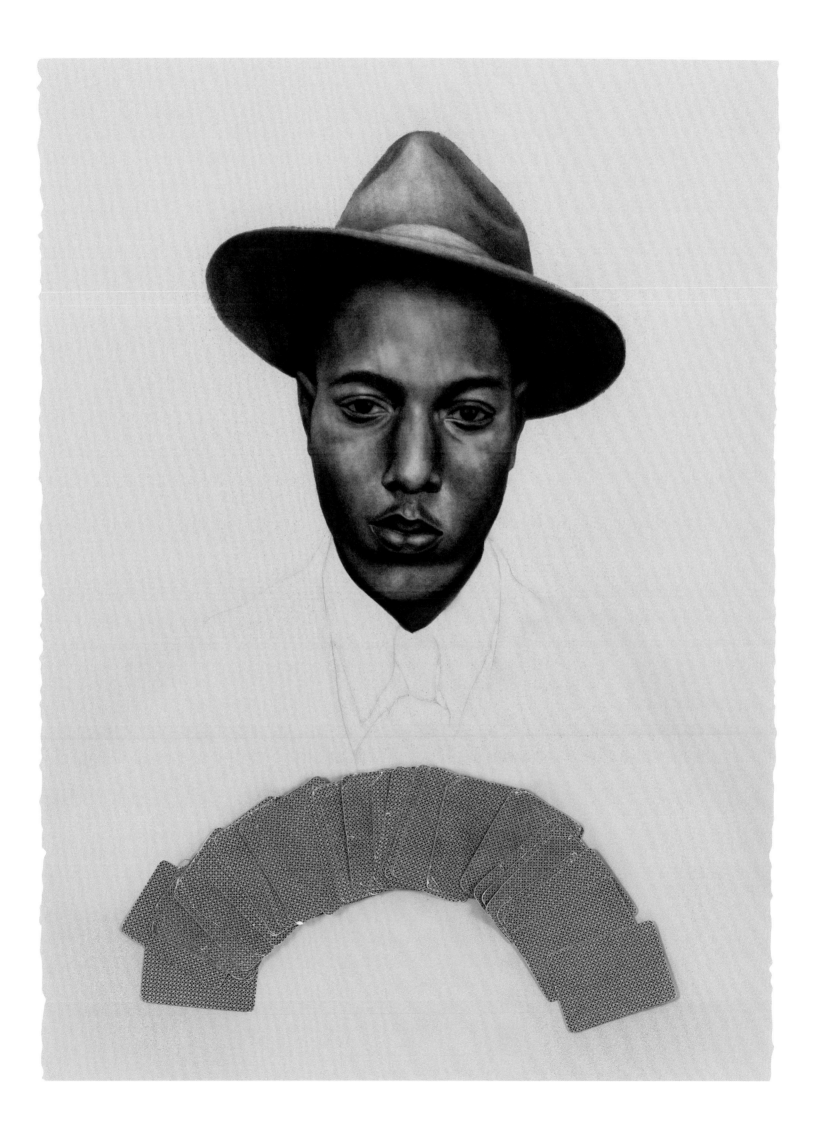

Kin XX (Be My Knife), 2010. Conté on paper, knife, museum board; 30 x 22 1/2 inches. Collection of Alan and Sally Mills, Indianapolis

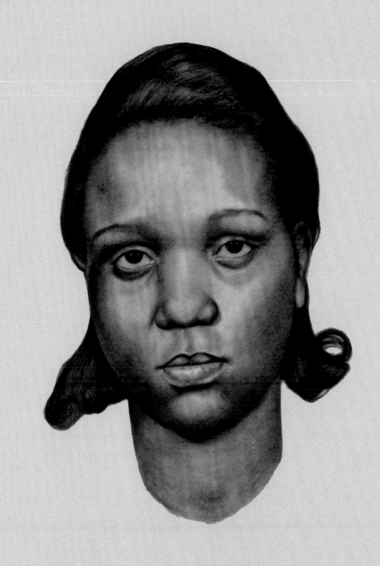

Kin XXI (De-Dah), 2008. Conté on paper, ruler; 30 x 22 $\frac{1}{2}$ x $\frac{1}{8}$ inches. Bank of America Collection

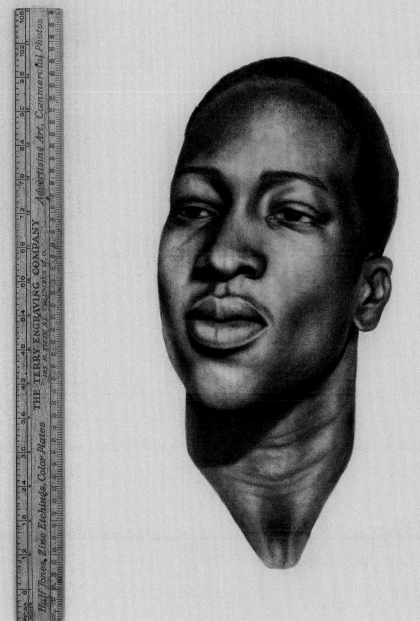

Kin XXII (Chove Chuva), 2008. Conté on paper, nails; 30 x 22 1/$_2$ x 2 inches.

68 Whitney Museum of American Art, New York; Purchase, with funds from the Drawing Committee

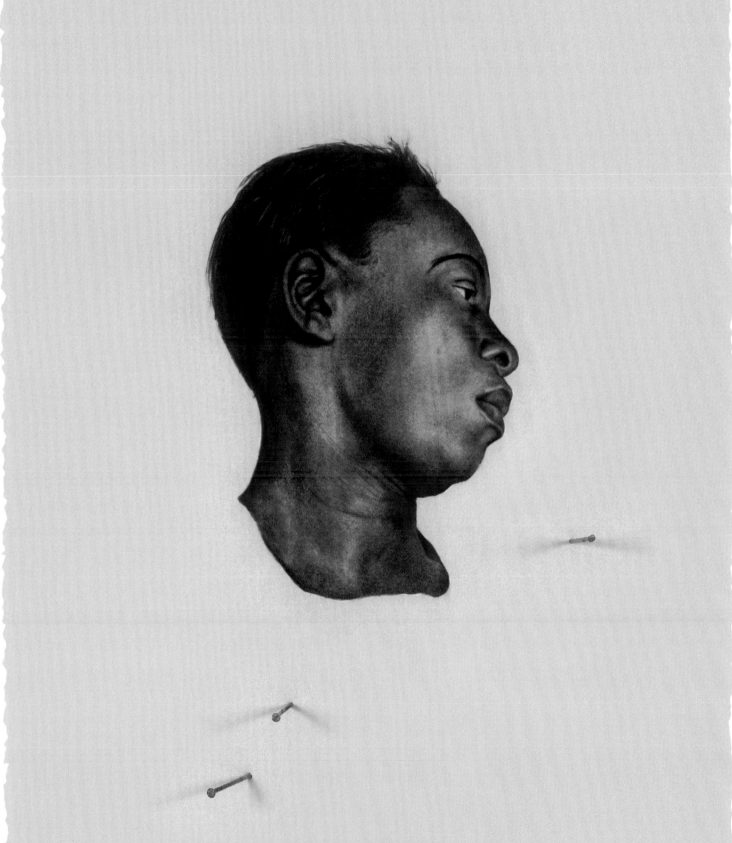

Kin XXIII (Dance or Die), 2008. Conté on paper, plaster and plastic wedding figurines; 30 x 22 $^1/_2$ x 1 $^1/_2$ inches

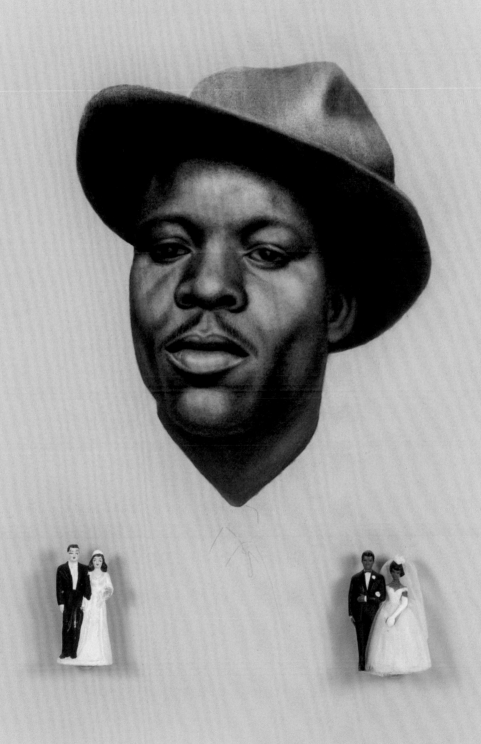

Kin XXIV (Cross the River, Round the Bend), 2008. Conté on paper, rope; 30 x 22 $^1/_2$ x 1 $^1/_2$ inches. Private collection

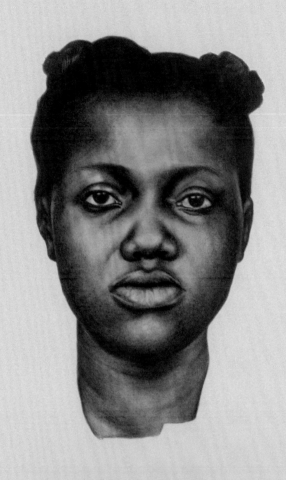

Kin XXV (River Run), 2008. Conté on paper, plaster figurine; 30 x 22 $\frac{1}{2}$ x 1 $\frac{1}{4}$ inches

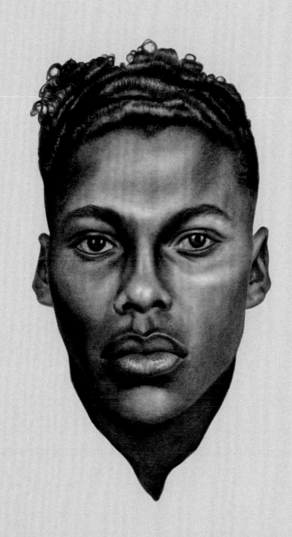

Kin XXVI (Adorada), 2008. Conté on paper, silver-plated tray, coins; 30 x 22 ¹/₂ x ³/₄ inches.

Collection of the United States Embassy in Lusaka, Zambia, courtesy of Art in Embassies

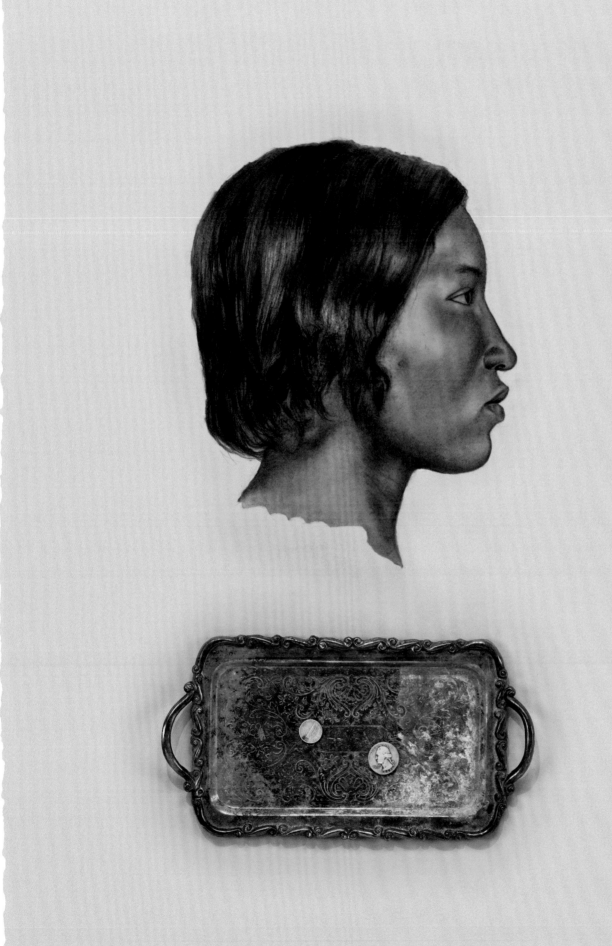

Kin XXVII (White Like Me), 2008. Conté on paper, paper rifle target; 30 x 22 $\frac{1}{2}$ inches. Collection of Kenneth Spitzbard, CT

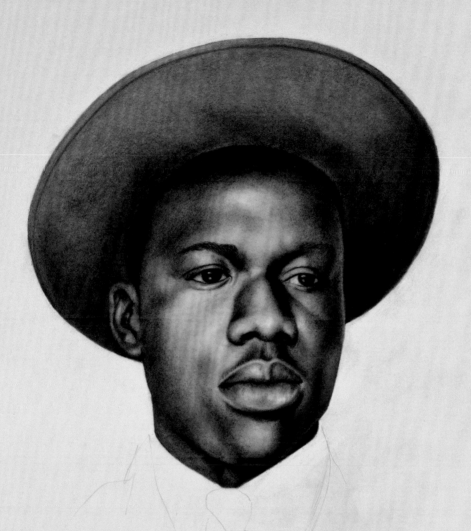

Kin XXVIII (Encanta), 2008. Conté on paper, painted silk flower; 30 x 22 $^1/_2$ x 2 $^1/_2$ inches

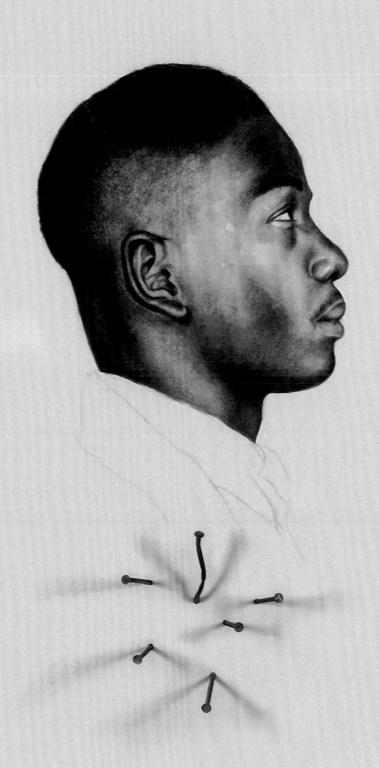

Kin XXX (Milk and Honey), 2008. Conté on paper, iron shooting gallery target; 30 x 22 $^1/_2$ x 1 $^1/_2$ inches. Private collection, New York

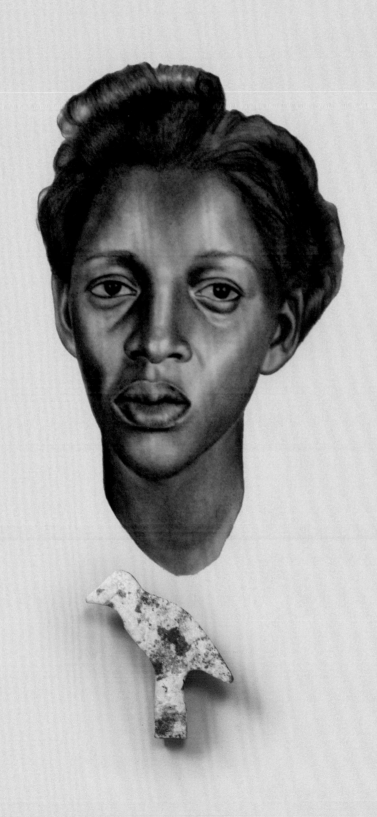

Kin XXXI (Island of My Skin), 2008. Conté on paper, wrought-iron sconce; 30 x 22 $^1/_2$ x 2 $^1/_8$ inches. Collection of Lisa and Larry Frankel

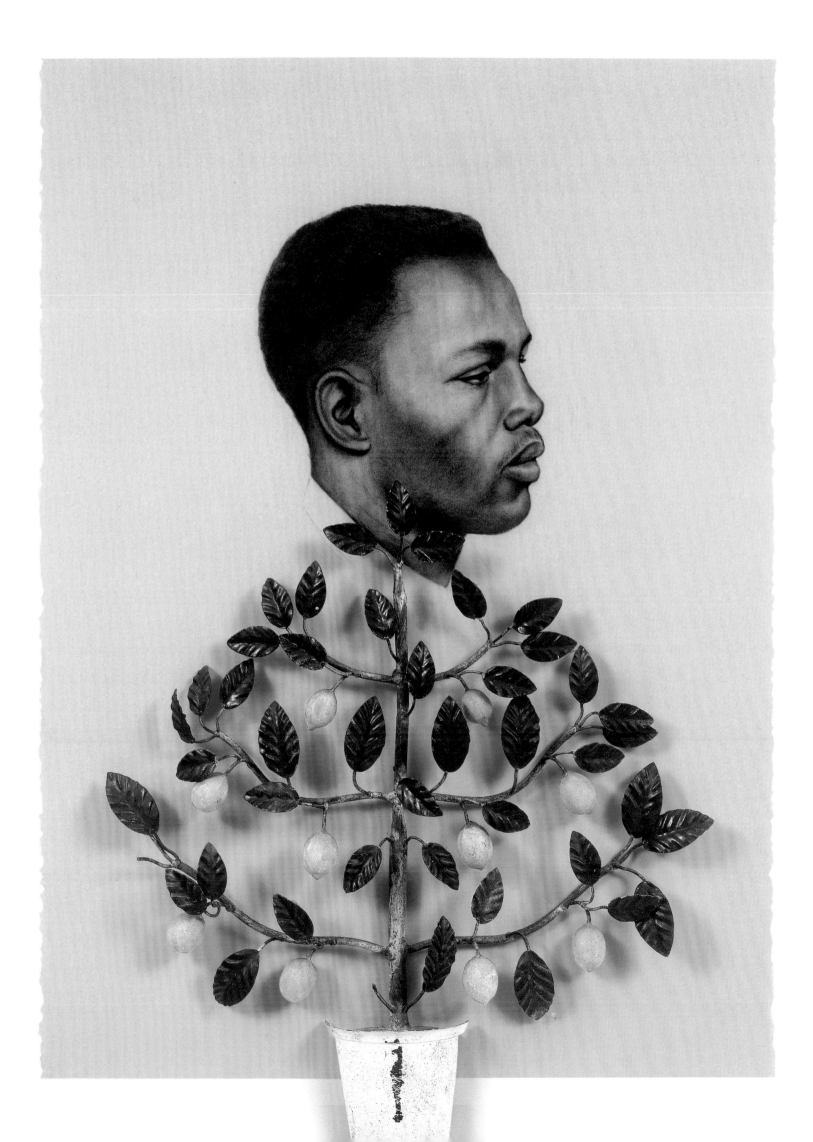

Kin XXXII (Run Like the Wind), 2008. Conté on paper, barbed wire; 30 x 22 1/2 x 3 3/4 inches.

88 Smith College Museum of Art, Northampton, MA. Purchased with the Dorothy C. Miller, class of 1925, Fund

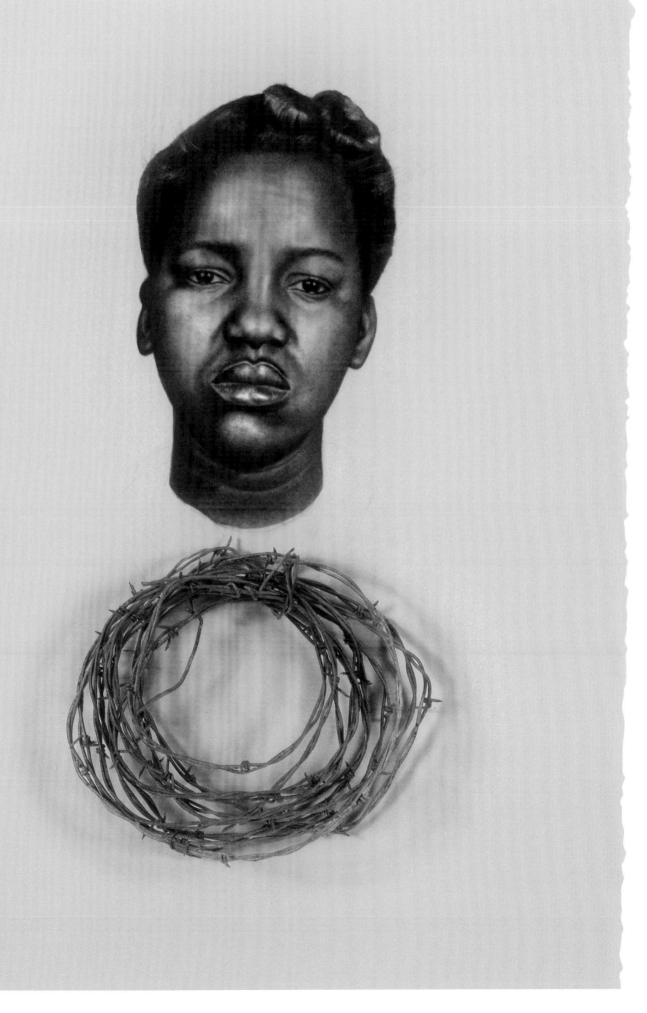

Kin XXXIII (May I Assume Whatever Form I Want, In Whatever Place My Spirit Wishes To Be In?), 2011.

Conté on paper, vintage white cloth shoe; 30 x 22 ¹/₂ x 2 ³/₄ inches. Private collection

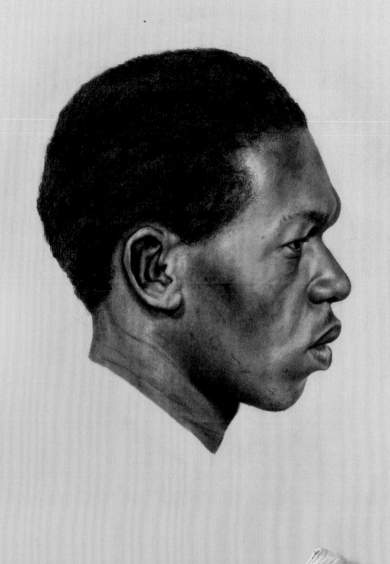

Kin XXXIV (Deep Blue Sea), 2008. Conté on paper, fabric; 30 x 22 $^1/_2$ x 2 inches

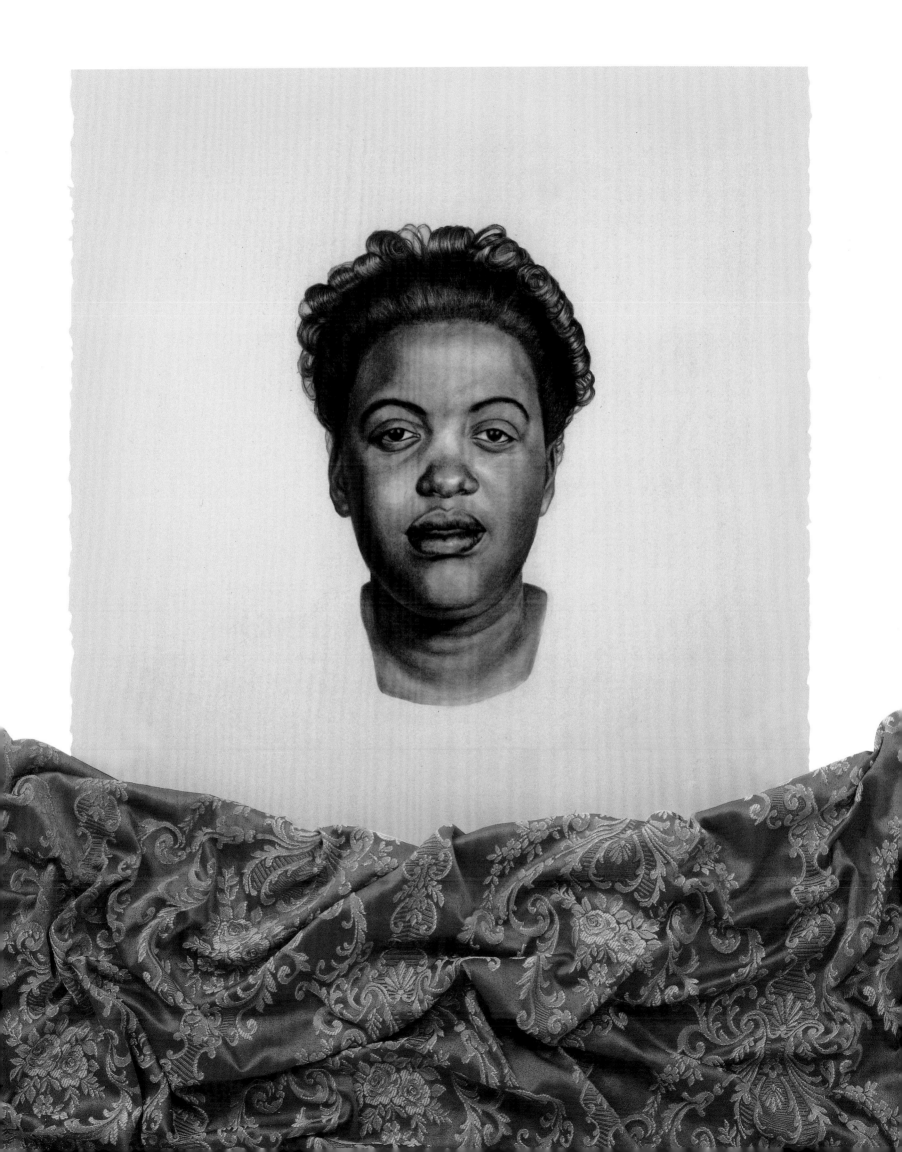

Kin XXXV (Glory in the Flower), 2011. Conté on paper, vintage clock radio; 30 x 22 $^3/_4$ x 5 $^3/_4$ inches. The Phillips Collection; The Dreier Fund for Acquisitions, 2013

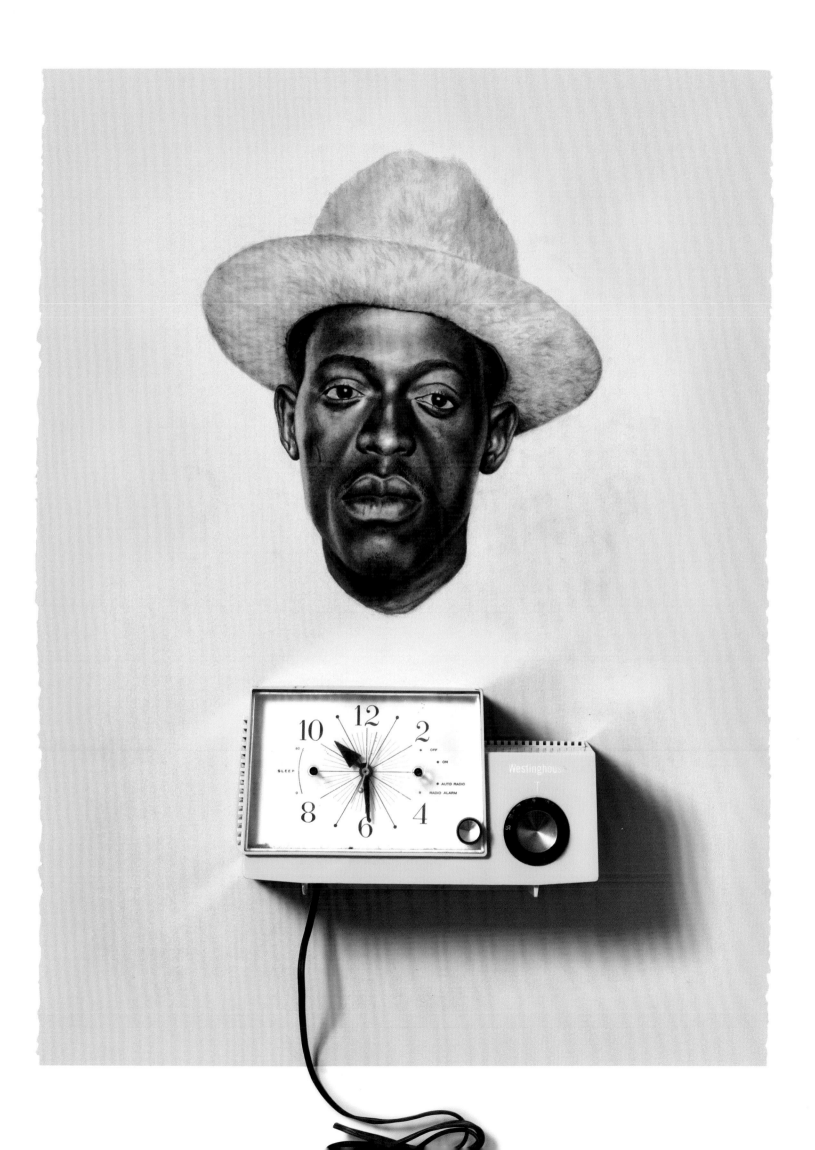

Kin XXXVI (Night Covers Us), 2010. Conté on paper, cardboard fan/mask with wooden handle; 30 x 22 $^1/_2$ x 1 inches. Collection of Matrice Ellis-Kirk and Ronald Kirk

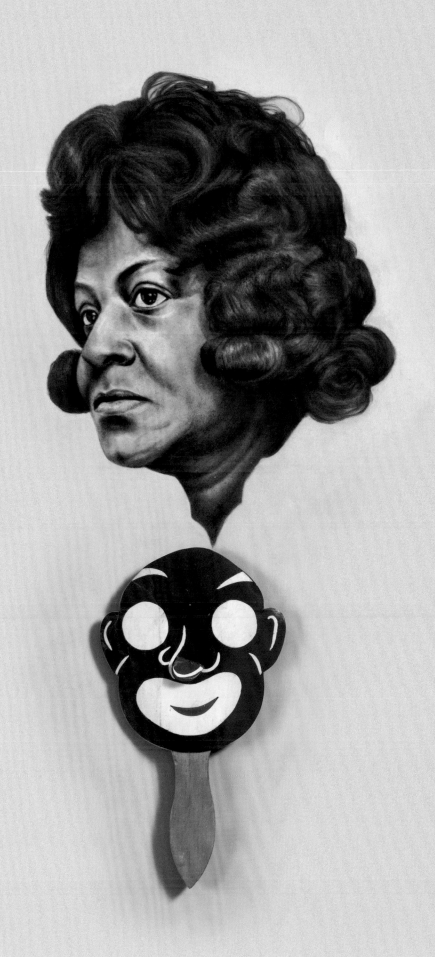

Kin XXXVII (Cancion de Cuna), 2011. Conté on paper, fire alarm bell; 30 x 22 $^3/_4$ x 3 $^3/_4$ inches

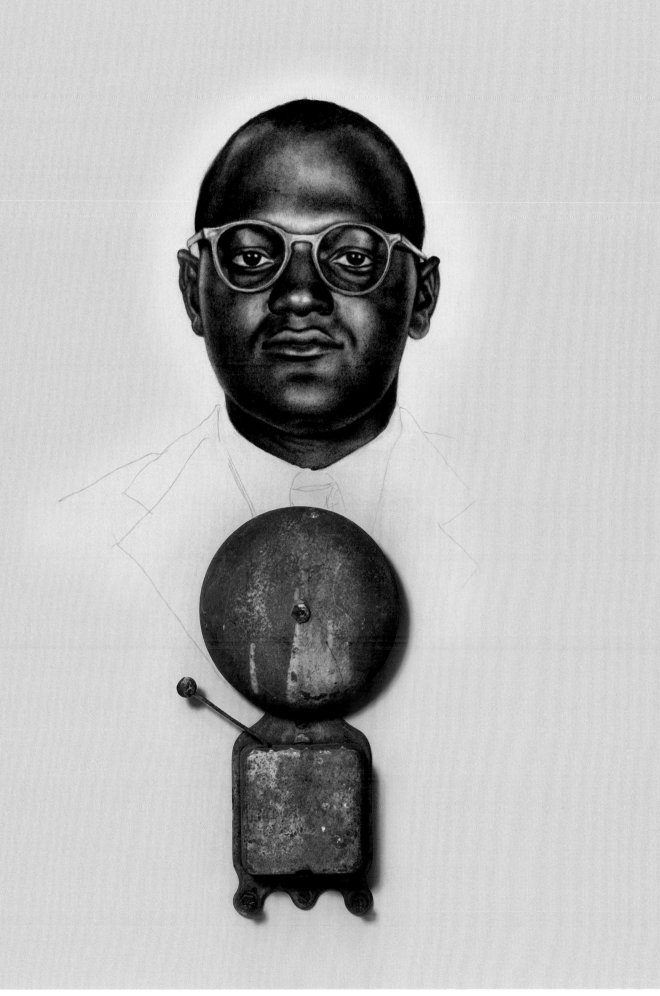

Kin XXXVIII (A Sprig of Rue), 2011. Conté on paper, enamel paint; 30 x 23 inches

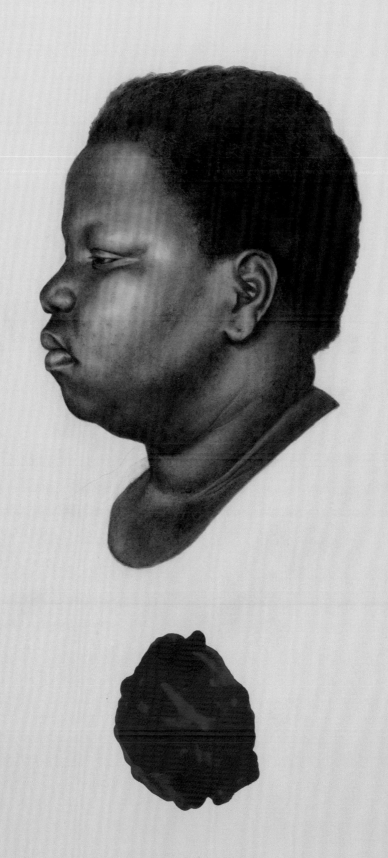

Kin XXXIX (Summer), 2011. Conté on paper, water faucet; 30 x 22 ³/₄ x 4 ³/₄ inches

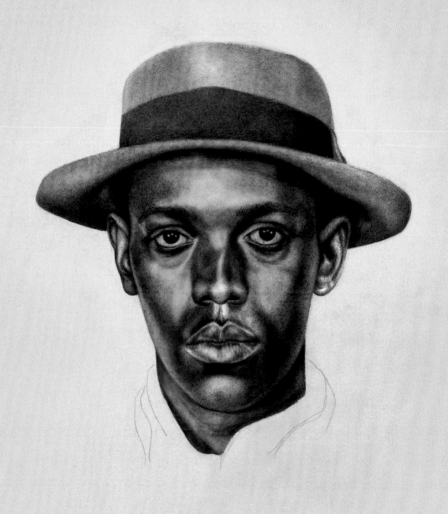

Kin XL (Breath), 2010. Conté on paper, wooden ship model; 30 x 22 $\frac{1}{2}$ x 2 inches

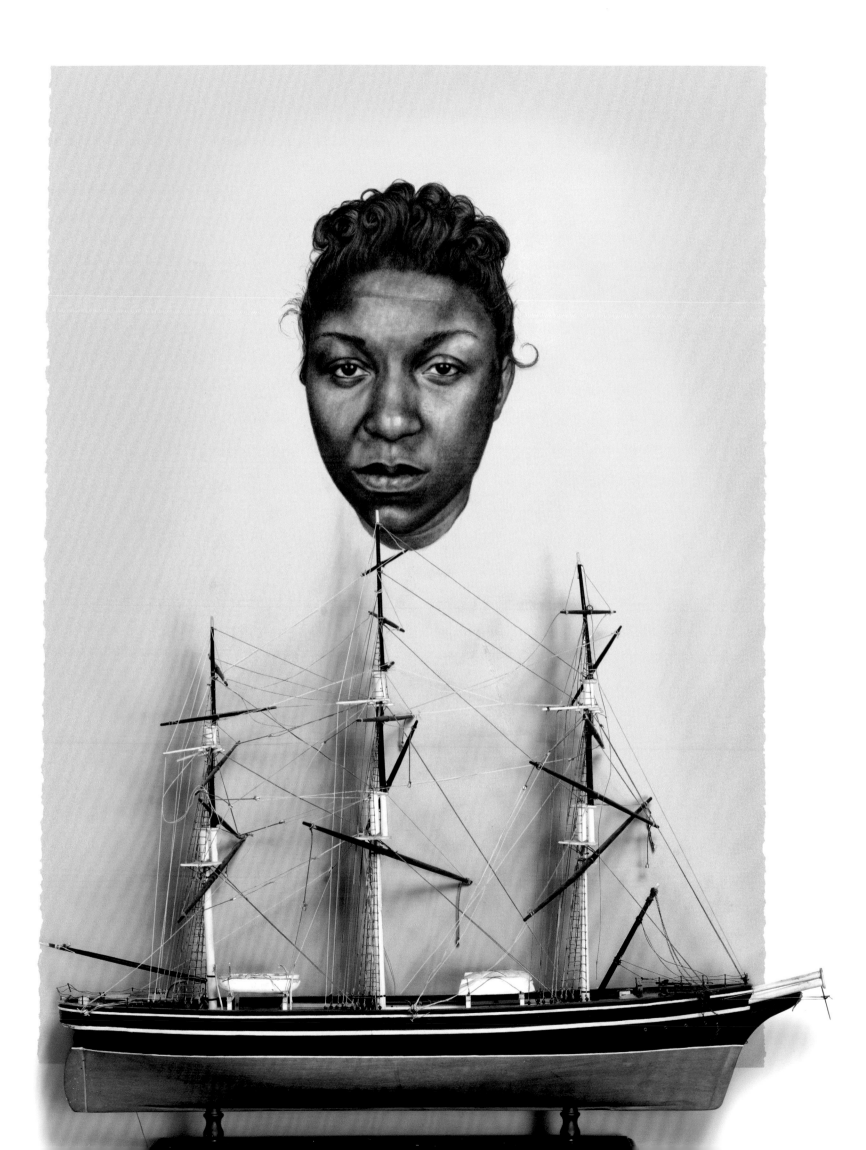

Kin XLI (Fauna), 2011. Conte on paper, stuffed bird; 30 x 22 1/2 x 3 1/2 inches.

The Phillips Collection; Gift of Mr. and Mrs. C. Richard Belger, Linda Lichtenberg Kaplan, and Carolyn C. Alper, 2013

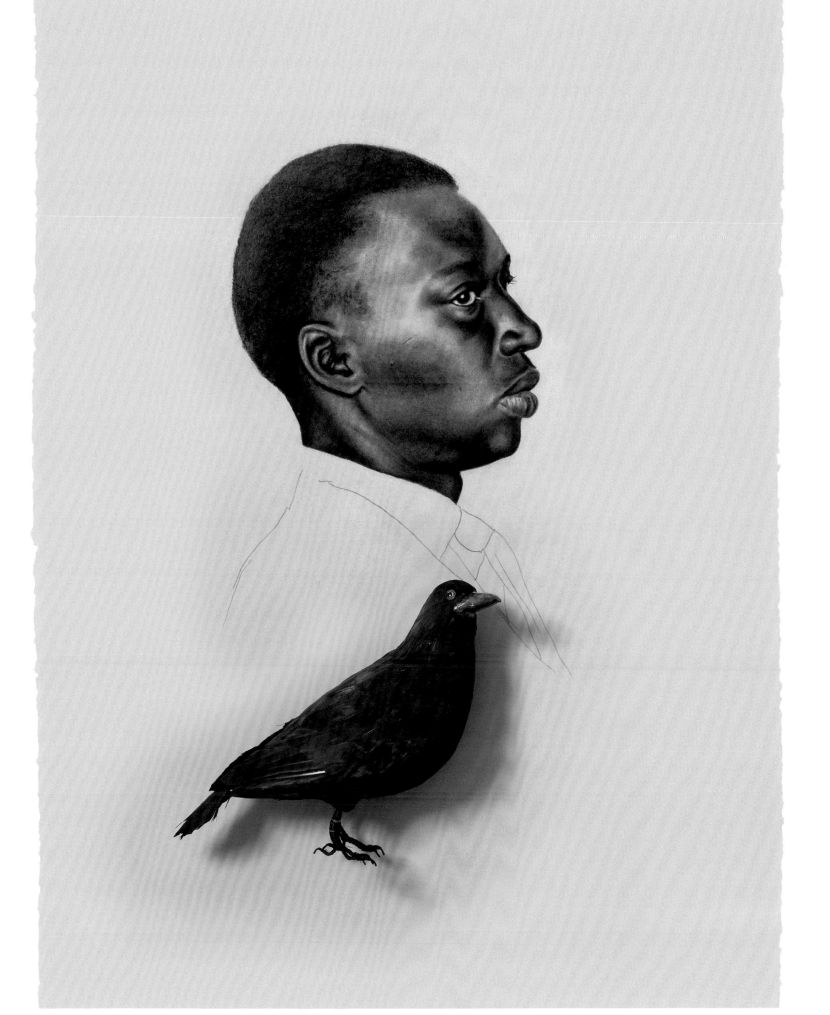

Kin XLII (Cri du Coeur), 2010. Conté on paper, shoe sole; 30 x 22 $^1/_2$ x 1 $^1/_2$ inches

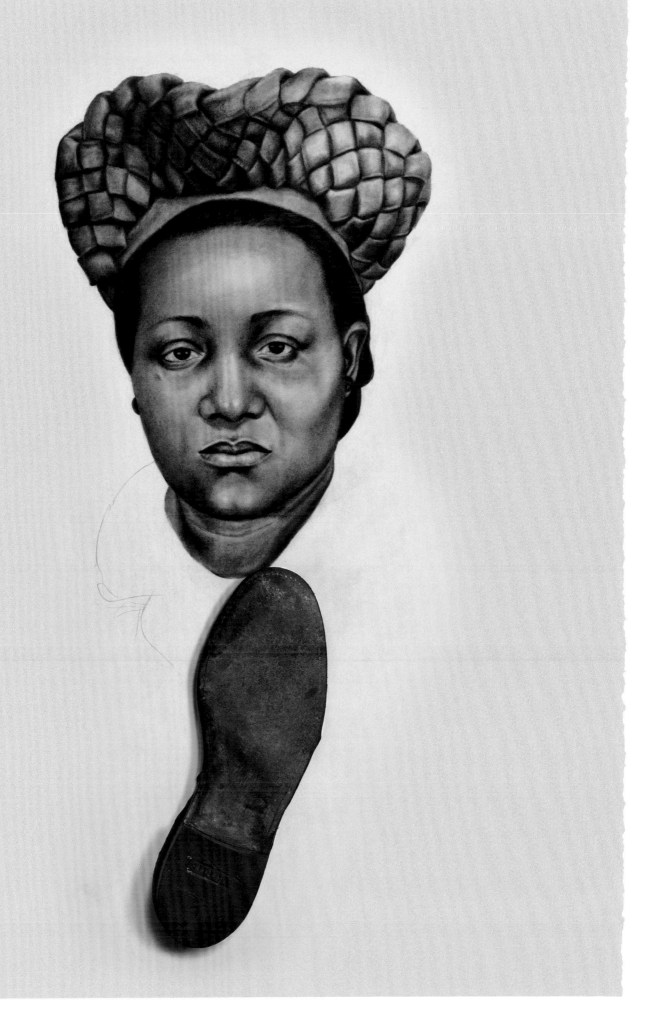

Kin XLIII (C.P.T.), 2010. Conté on paper, bound book; 30 x 22 $^1/_2$ x 1 $^1/_2$ inches

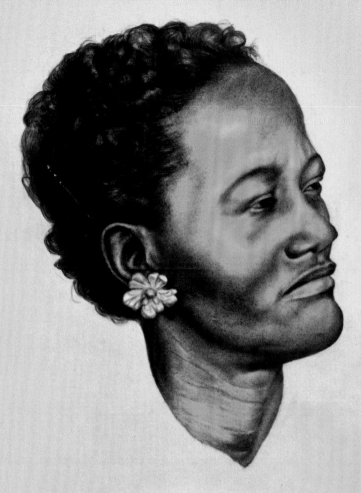

Kin XLIV (Magic), 2011. Conté on paper, copper pennies; 30 x 22 $^3/_4$ x $^3/_4$ inches. Courtesy Rodney M. Miller Collection

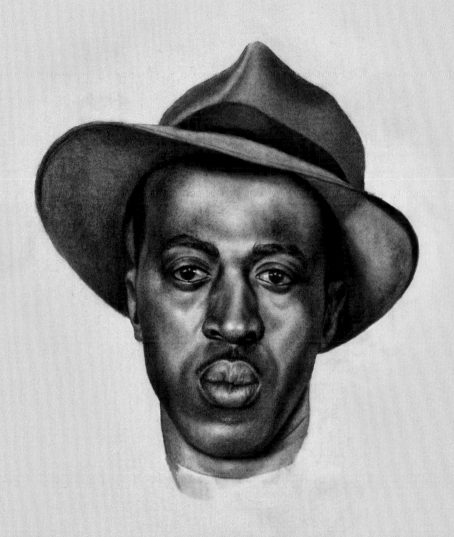

Kin XLV (Das Lied Von Der Erde), 2011. Conte on paper, string of pearls; 30 x 23 x ¹/₈ inches. The Phillips Collection; The Dreier Fund for Acquisitions, 2013

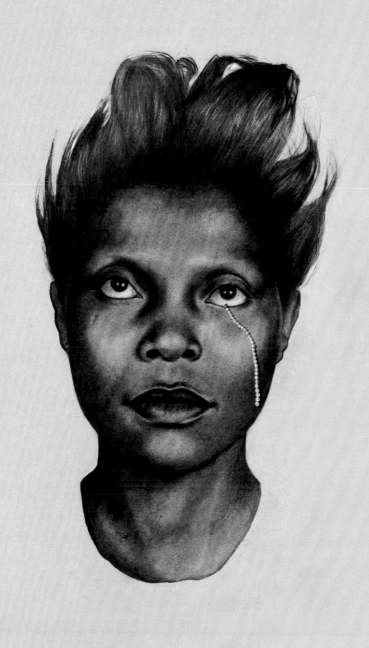

Kin XLVI (Follie), 2011. Conté on paper, shooting gallery target; 30 x 22 ¼ x 2 inches

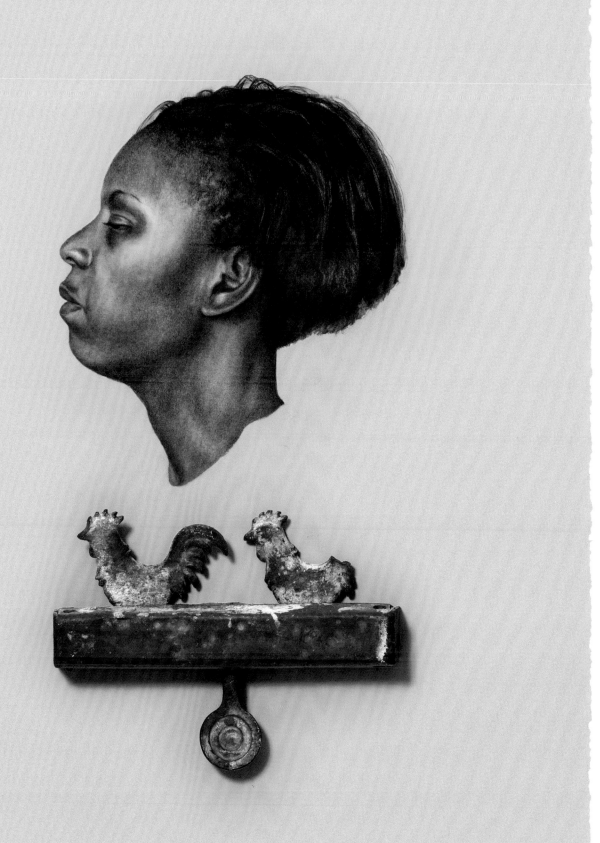

Kin XLVII (Rimshot), 2011. Conté on paper, cardboard display advertisement; 30 x 22 $\frac{1}{2}$ x $\frac{1}{4}$ inches

Kin XLVIII (Life Is But a Dream), 2011. Conté on paper, metal hand mirror; 30 x 22 $\frac{1}{2}$ x $\frac{3}{4}$ inches. Private collection, New York

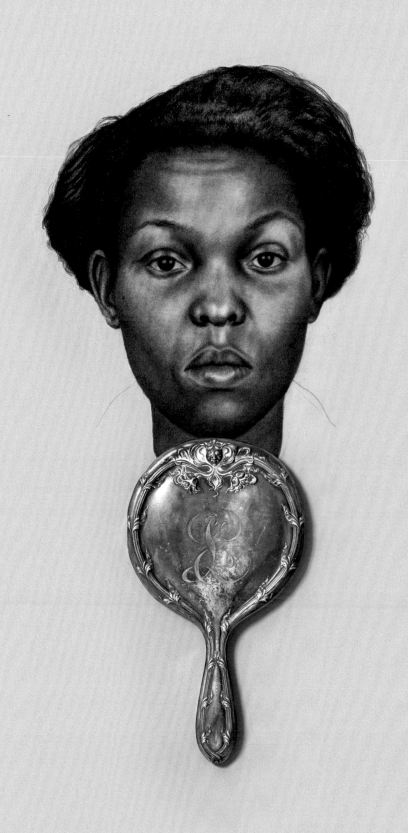

Kin XLIX (The Well), 2011. Conté on paper, enamel pot; 30 x 22 $^1/_4$ x 4 inches

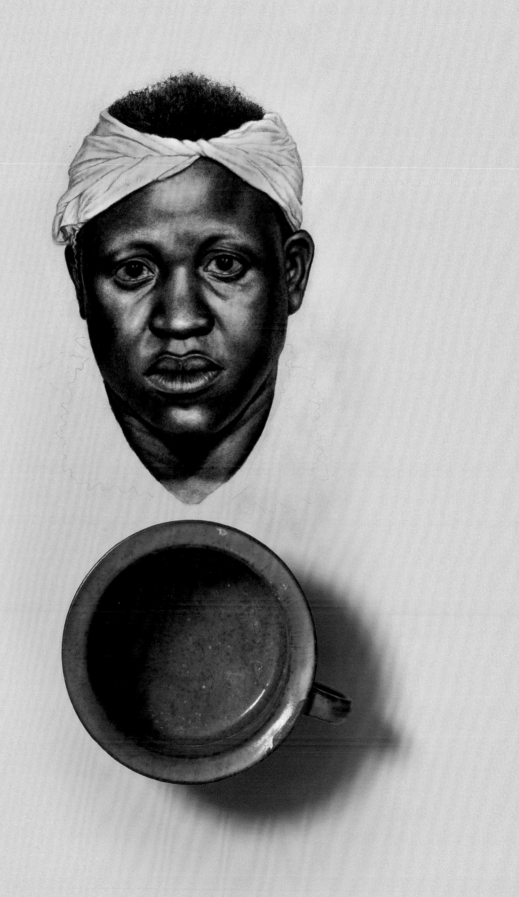

Kin L (Ego), 2011. Conté on paper, vintage leather bag; 30 x 23 x 6 inches

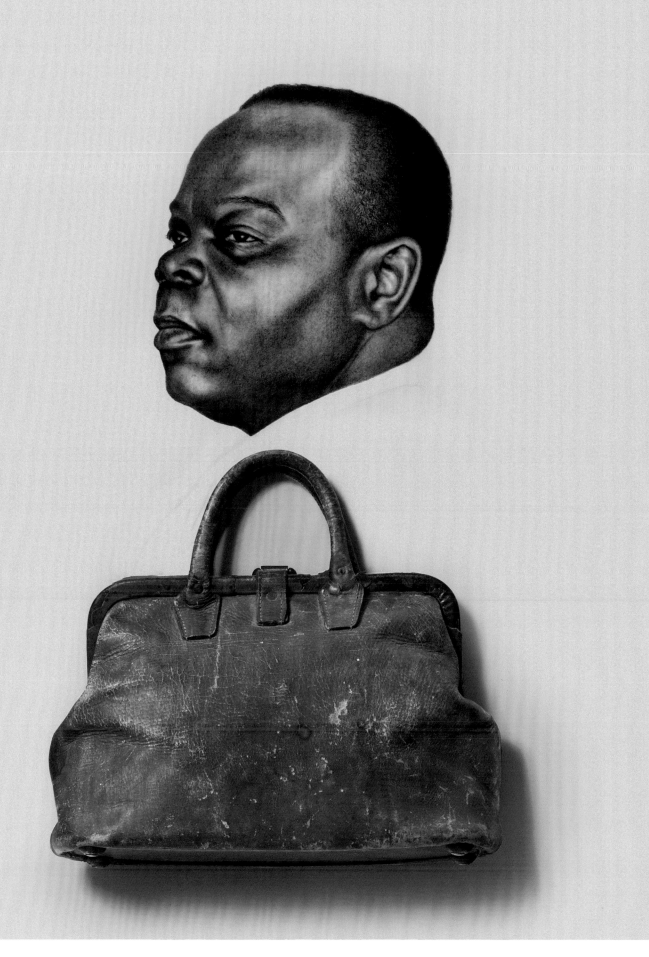

Kin LI (Nocturne), 2011. Conté on paper, metal coins; 30 x 22 ³/₄ x ³/₄ inches. The Studio Museum in Harlem; Museum purchase made possible by a gift from Rodney Miller

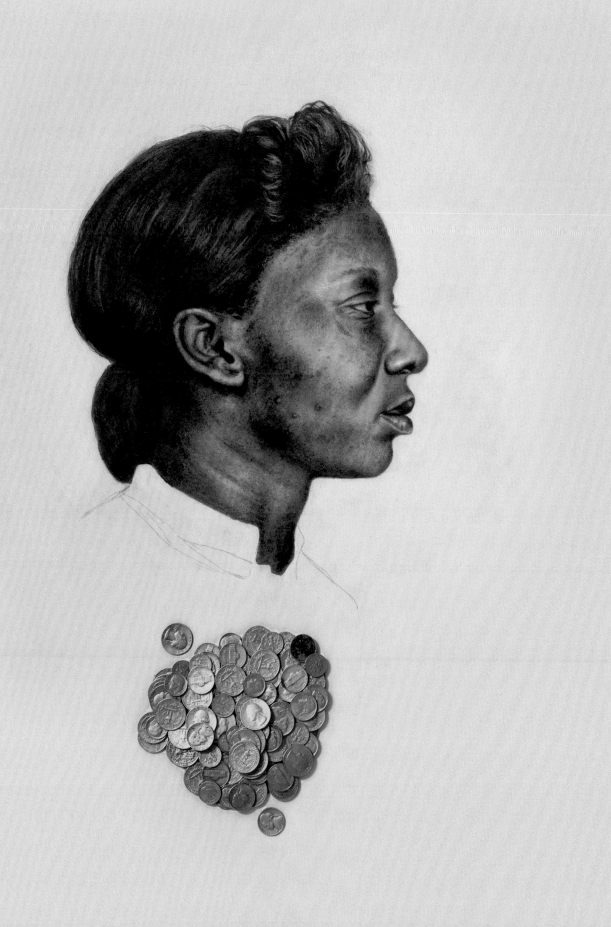

Kin LII (Pie in the Sky), 2011. Conté on paper, plaster sculpture with base; 30 x 22 $^{1}/_{2}$ x 4 inches

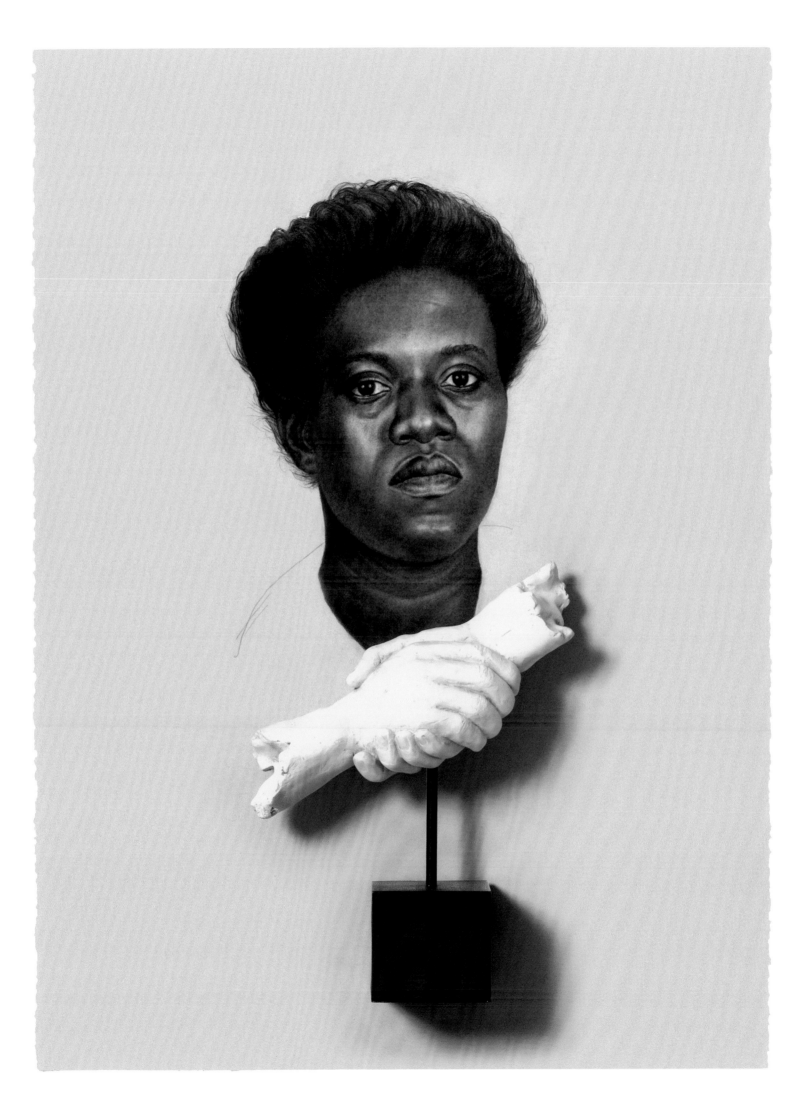

Kin LIII (The Way I Love You), 2011. Conté on paper, four bullets; 30 x 22 $\frac{1}{2}$ x 3 $\frac{3}{8}$ inches

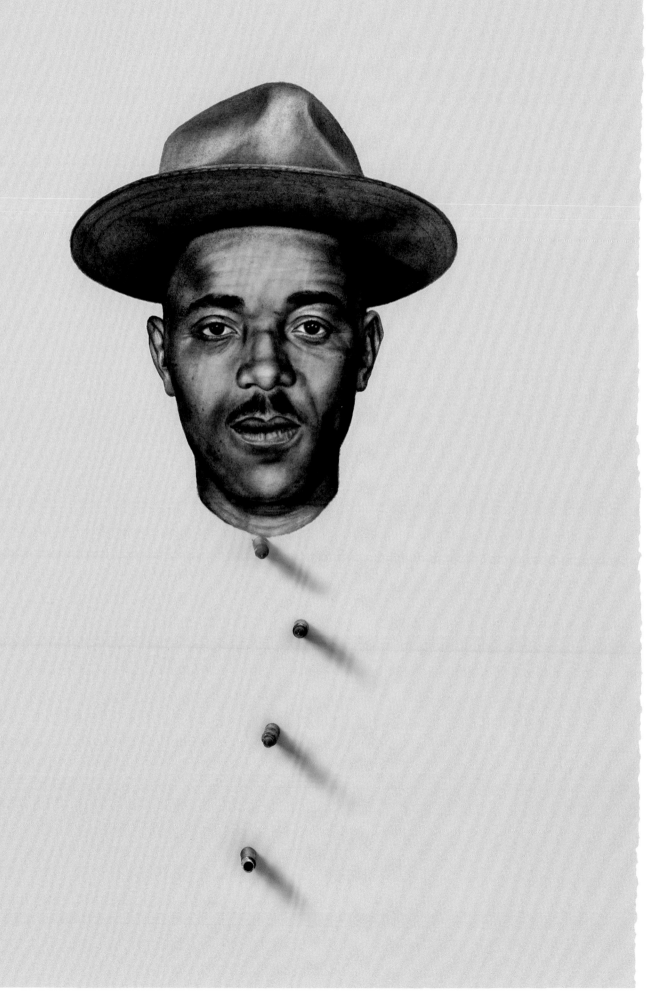

Kin LIV (Frankincense and Myrrh, These Are the Gifts We Bring), 2011. Conté on paper, paper, hypodermic needle; 30 x 23 x 1 inches

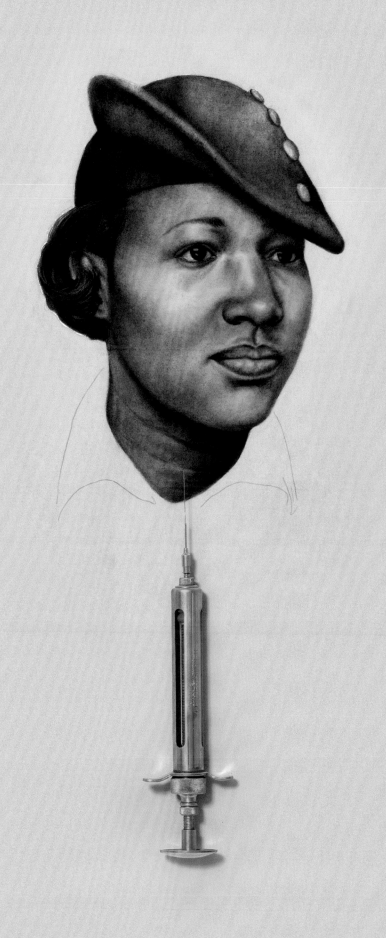

Kin LV (The Moral Compass), 2011. Conté on paper, wooden roulette wheel; 30 x 22 $^1/_2$ x 2 $^1/_2$ inches.

134 The Kalamazoo Institute of Arts, MI; Elisabeth Claire Lahti Fund Purchase, 2011

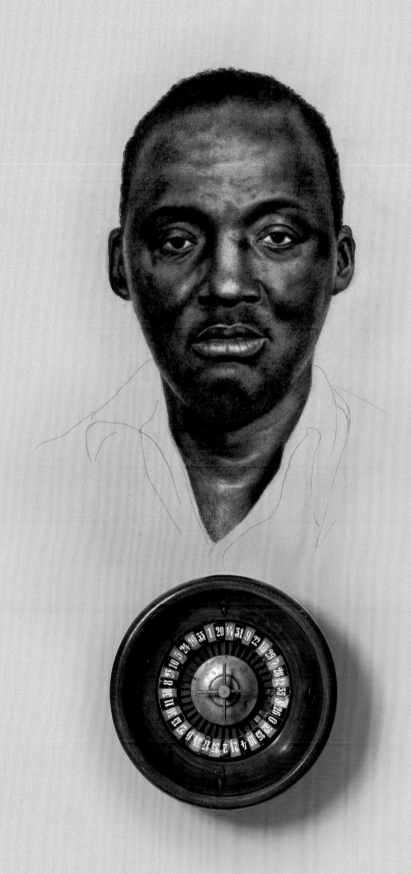

Kin LVI (Revolution), 2011. Conté on paper, three model train cars, tracks; 30 x 22 $^1/_4$ x 3 inches. Collection of Susan and David Goode

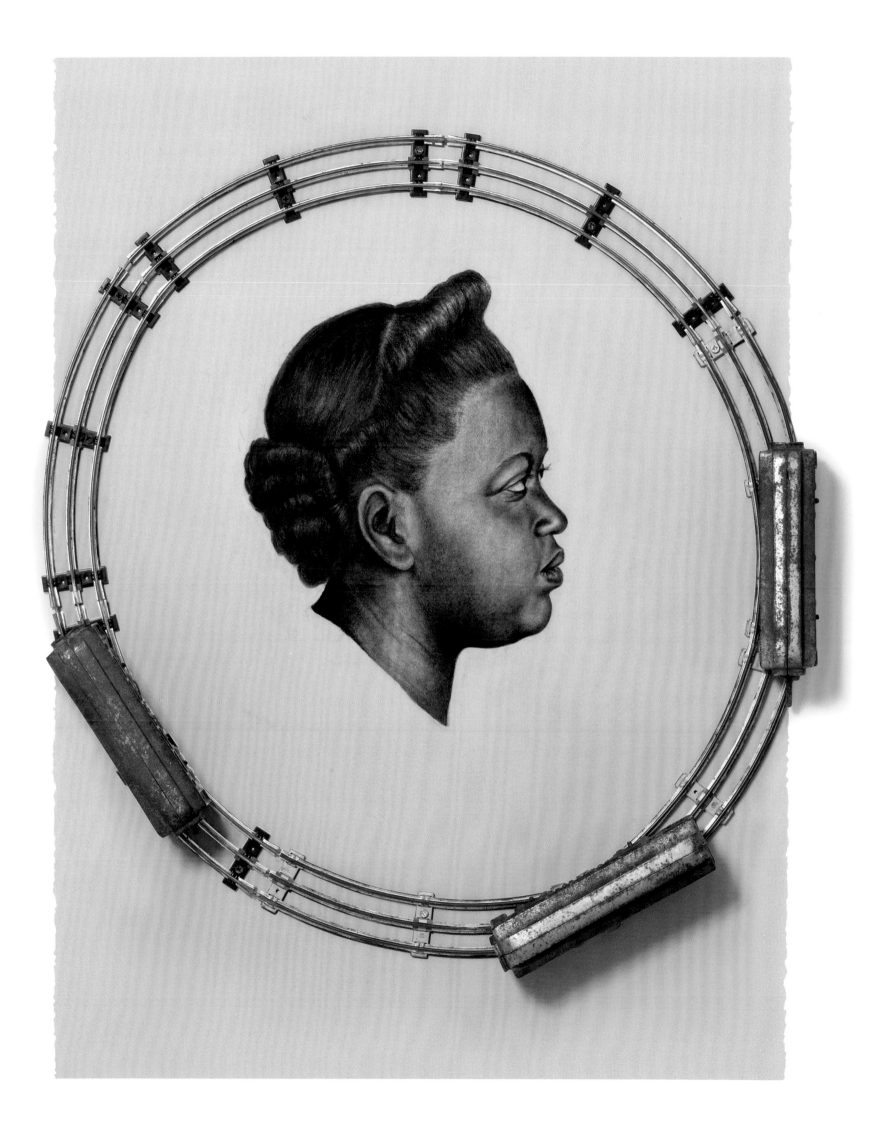

Kin LVII (Howl), 2011. Conté on paper, twigs, twine; 30 x 22 $\frac{3}{4}$ x 5 $\frac{1}{8}$ inches. Private collection

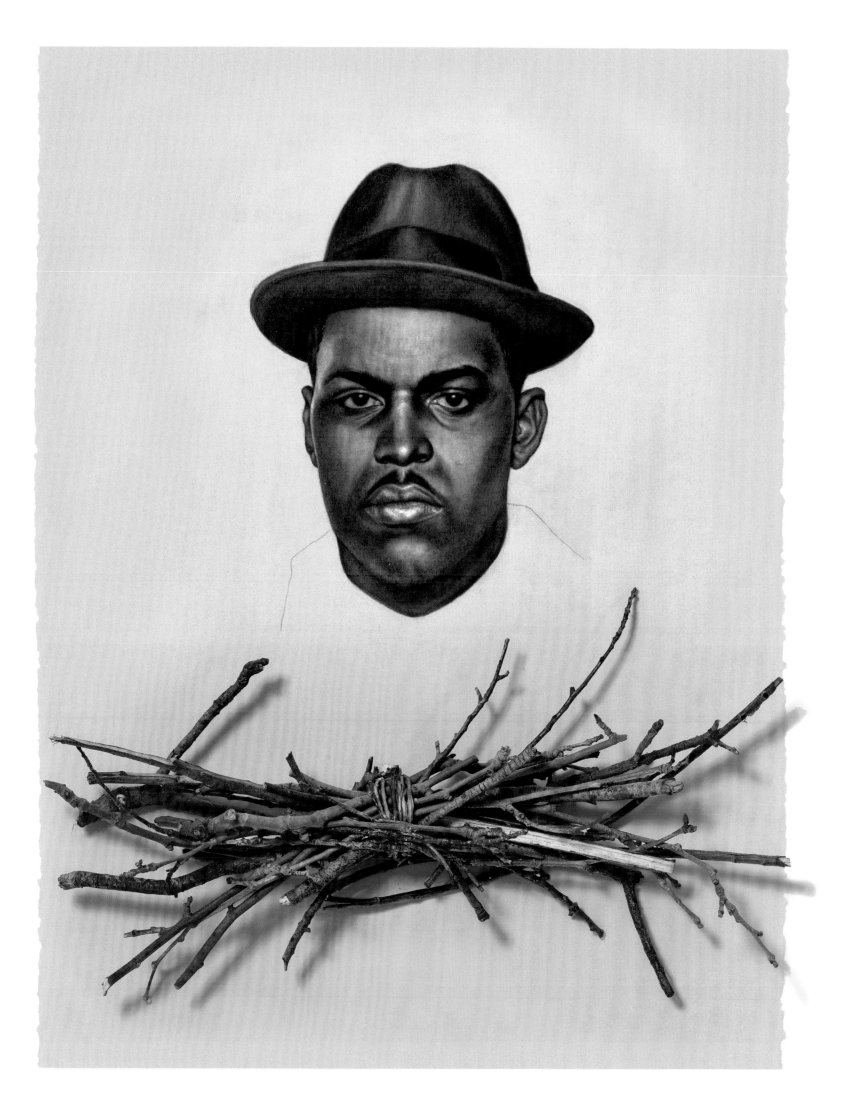

Kin LVIII (Heaven), 2011. Conté on paper, string of pearls; 30 x 22 $\frac{1}{4}$ x 2 $\frac{1}{2}$ inches. Private collection

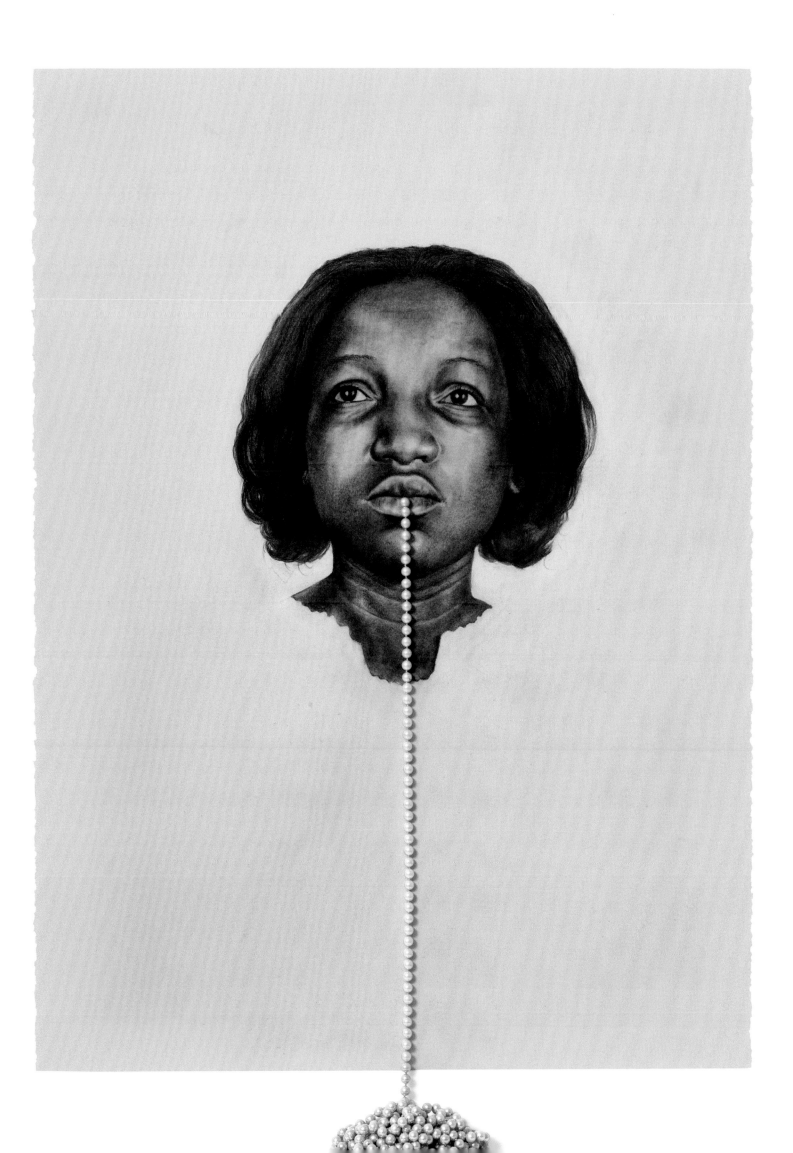

142 **Kin LIX (The Power of Myth),** 2011. Conté on paper, dagger; 30 x 23 x 1 inches. Private collection, New York

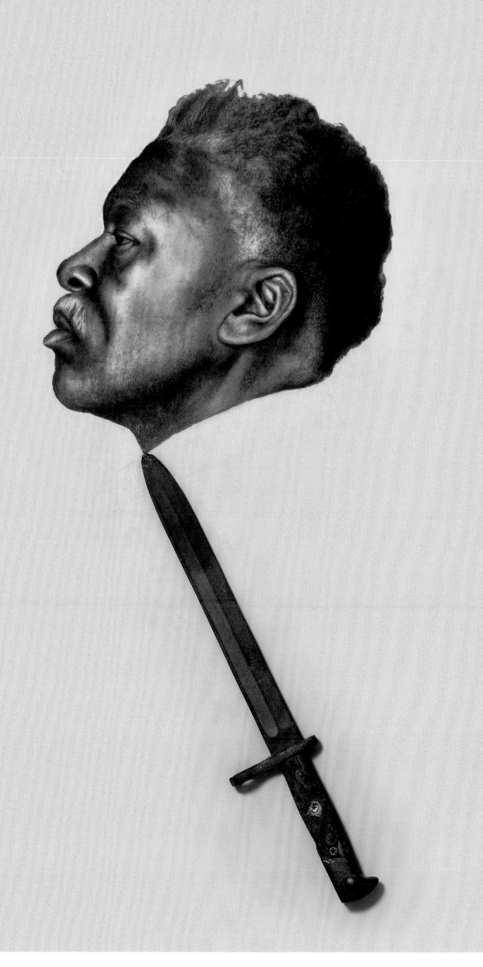

Kin LX (Le Rouge et Le Noir), 2011. Conté on paper, twigs; 30 x 22 $^{3}/_{8}$ x 6 $^{1}/_{2}$ inches. Collection of Hans Dorsinville

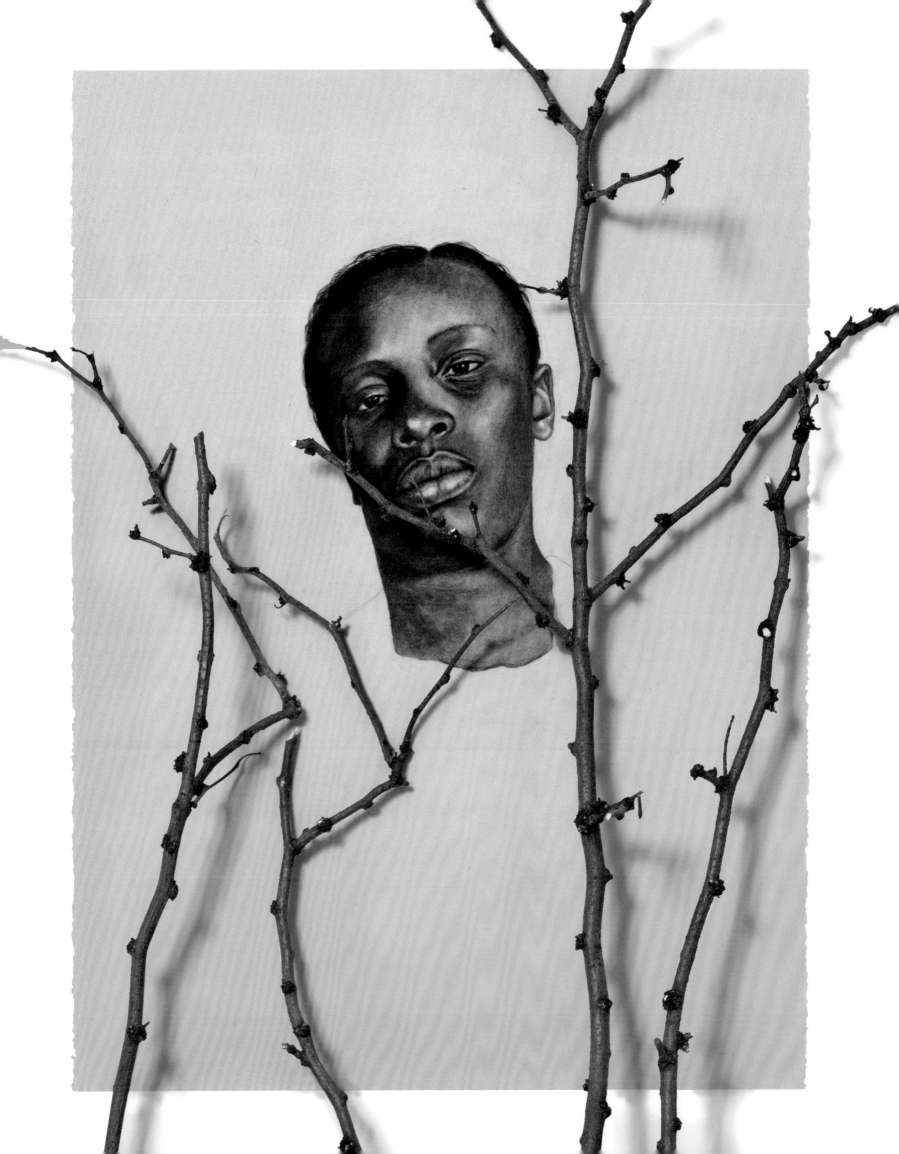

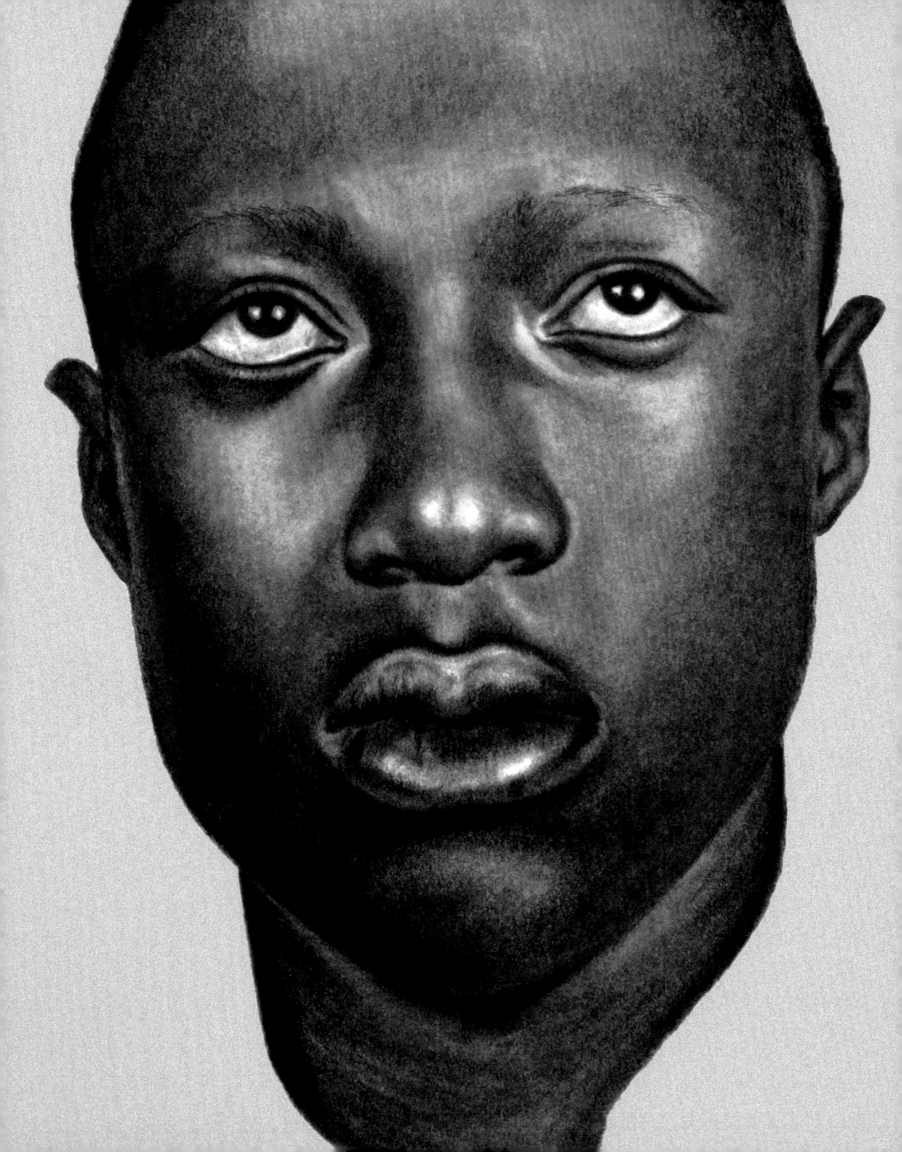

Whitfield Lovell's Kin:
A Double-Voiced Discourse

Klaus Ottmann

Each of us, helplessly and forever, contains the other – male in female, female in male, white in black, black in white.

—James Baldwin[1]

Neutral spatters and stains (it is a type of gray-black);… Neutral is a color like the others.

—Roland Barthes[2]

Whitfield Lovell's Kin series consists of sixty close-up depictions of black men and women in profile or full face, exquisitely drawn with Conté crayon on tan paper, all but one paired with found objects attached to the paper. While the imagery used in the Kin series is derived from vintage ID photos or police mug shots, Lovell insists that these works not be considered portraits. The pairing of drawing with objects creates, as the artist says in his conversation with Julie L. McGee, "both disruption—a break in potential for a literal narrative reading of the work—and solidity."[3]

It is impossible, however, not to read these drawings as deeply rooted in the experience of being an African American man or woman in the first half of the twentieth century, in that "strange meaning of being black," as W. E. B. Du Bois famously described it,[4] just as the attached objects often seem to resonate strongly with Lovell's own life (as an African American growing up in the Bronx in the 1960s and 1970s), as the artist himself has mentioned.

To me, Lovell's Kin series recalls most markedly the hundreds of portraits of African Americans, each shown in a pairing of full and profile views, that were among the 363 photographs assembled by Du Bois for the American Negro exhibit at the Paris Exposition of 1900.[5] Du Bois displayed the portraits as pairs of full and profile views, mimicking the common two-part side-view and front-view police mug shot, standardized by French police officer Alphonse Bertillon in the late 1880s and popularized by the so-called rogues' gallery that began in New York in the late nineteenth century.

Lovell does not share with Du Bois the aim of fostering a different view of African Americans. But like Du Bois's portraits, the works in the Kin series, which pairs found objects with portrayals of anonymous African Americans, subvert what Du Bois called "the white supremacist gaze," which is still today operational in the form of racial profiling.

Lovell's pairings of drawings with objects in his Kin series constitute a "double-voiced" discourse in the sense of the Russian formalist Mikhail Bakhtin. In an essay on Ishmael Reed's 1972 novel Mumbo Jumbo, Henry Louis Gates Jr. links Bakhtin's concept to the Afro-American narrative tradition of double-speech, often referred to as "signifyin(g) monkey":

> This "inner dialogization" can have curious implications, the most interesting, perhaps, being what Bakhtin describes as "the splitting of double-voiced discourse into two speech acts, into two entirely separate and autonomous voices."[6]

As Gates commented more recently, "thinking about the black concept of Signifyin(g) is a bit like stumbling unaware into a hall of mirrors: the sign itself appears to be doubled, at the very least, and (re)doubled upon ever closer examination."[7]

Lovell decided to add no object to one drawing in the series, Kin XV (Seven Breezes), 2008 (opposite and p. 55). While it thus seems less removed from its photographic source, the drawing's detailed treatment by Lovell's signature process of repeatedly drawing and erasing, adding and subtracting, makes it clear that the gap between the denotative and the figurative, the imaginative and the real in his works, is not created merely by juxtaposing objects with the drawings, but is inherent in his technique. Lovell has repeatedly said that his drawings are of imagined persons.

In recent years, the radical French philosopher François Laruelle has been developing a rigorous *zero-degree* philosophy, which he calls "non-philosophy," by reintroducing science into philosophy in order to lead philosophy away from dogmatic knowledge. His efforts, which he has expanded into the area of aesthetics, and more specifically, that of photography, may at times appear alarmingly antimodern; yet they question century-old mindsets in order to arrive at a practice of radical autonomy.

His non-philosophy, which he declares to be "antihumanist" (I would call it "transhumanist"), makes a surprising link between humanism and racism:

> If, within non-standard thought, the knowledge of human nature (to put it in traditional terms) remains entirely problematic, not at all the object of some dogmatic knowledge, this only goes to show that there is no absolutely determined knowledge of the human, of man; and in particular it aids the struggle against every dogmatic definition of human nature—against racism, for example: if one has no absolutely certain knowledge of human nature, it becomes far more difficult to develop a racist thought.[8]

Laruelle's concept of a non-philosophical aesthetics "aligns [humans] with generic humanity rather than a narcissistic delirium of the modern individual."[9] Laruelle's non-philosophical approach challenges us to look at things by shedding any particular philosophical doctrine or scientific theory and instead "grasp them on the basis of their immediate claims."[10] It abandons the notion of relatedness for what he calls a "vision-in-One."[11] This non-relational vision-in-One is defined by a new type of experience, which Laruelle, borrowing a term from mathematics, calls *idempotence,*[12] "an algebraic lived experience." (It seems not unlike Frank Stella's famous minimalist statement: "My painting is based on the fact that only what can be seen there is there. . . . What you see is what you see."[13])

Applying Laruelle's concept of a transhumanist non-philosophy to the artistic genre of portraiture, "non-portraiture" would not be a negation of portraiture but rather a conversation on the essence of portraiture, especially as it relates to its inherent *double-consciousness,* "the sense of always looking at one's self through the eyes of others."[14]

In his study on "non-photography," Laruelle argues that "in its essence, all photography is 'photo-ID,' identity-photography—but only in the last instance; this is why photography is a fiction that does not so much add to the World as substitute itself for the World."[15] He proposes a practice that is "neither a mode of philosophical reflection . . . nor a mode of unconscious representation or a return of the repressed. Neither Being nor Other; neither Consciousness nor the Unconscious; neither the present nor the repressed." Instead, he introduces a third option, which he calls "The One or Identity 'in-the-last-instance.'"[16] This third option "allows us to give the most universal and the most positive description" of a work of art "without being constrained to reduce it to its conditions of existence, whether perceptual, optical, semiotic, technological, unconscious, aesthetic, political."[17]

Laruelle's anti- or transhumanism resembles the "planetary humanism" advocated by the African American scholar Paul Gilroy—a humanism that turns away from African archaism, racial hierarchy, and colonial myths toward a future that reconnects to "democratic and cosmopolitan traditions that have been expunged from today's black political imaginary."[18]

In his 1930 novel, *The Man Without Qualities,* Robert Musil writes:

> In earlier times one could be an individual with a better conscience than one can today. . . . Today, responsibility's center of gravity lies not in the individual but in the relations between things.[19]

While Laruelle's "One or Identity in-the-last-instance" prompts us to go *beyond* humanism, another radical thinker, Kwame Anthony Appiah, reminds us that while the connection to art through identity is powerful, "one connection—the one neglected in talk of cultural patrimony—is the connection not *through* identity but *despite* difference":

> We can respond to art that is not ours; indeed, we can fully respond to "our" art only if we move beyond thinking of it as ours and start to respond to it as art. But equally important is the human connection. . . . The connection through a local identity is as imaginary as the connection through humanity. . . . [B]ut to say this isn't to pronounce either of them unreal. They are among the realest connections that we have.[20]

Lovell's Kin series accomplishes pushing "the imaginary beyond imagination," beyond the imagination of black and white, past and present, toward a "fusion of idempotence and lived experience,"[21] while reminding us, at the same time, that, as Roland Barthes discovered when spilling one of his Sennelier ink bottles, neutral is a color, and it will splatter and stain.

Lovell's Kin, at once imaginary strangers and kith, point to a shared nature that, as Appiah writes, "allows us to make sense of one another":

> [W]hen the stranger is no longer imaginary, but real and present, sharing a human social life, you may like or dislike him, you may agree or disagree; but, if it is what you both want, you can make sense of each other in the end.[22]

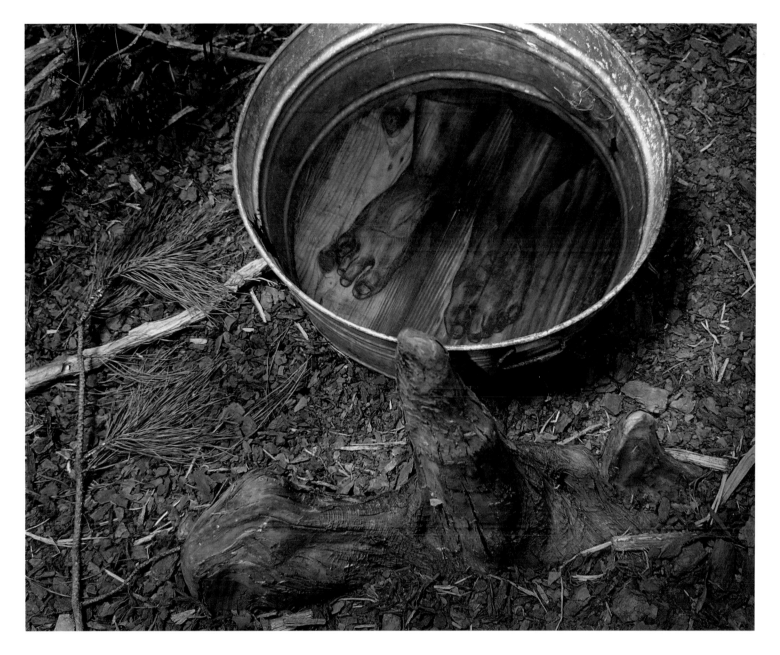

1 James Baldwin, "Here Be Dragons," in *The Price of the Ticket: Collected Nonfiction, 1948–1985* (New York: St. Martin's Press, 1985), 690.

2 Roland Barthes, *The Neutral*, trans. Rosalind E. Krauss and Denis Hollier (New York: Columbia University Press, 2005), 49.

3 See "After an Afternoon: Whitfield Lovell in Conversation with Julie L. McGee," in this volume.

4 W. E. B. Du Bois, *The Souls of Black Folk* (Oxford: Oxford University Press, 2007), 3.

5 See Shawn Michelle Smith, "W. E. B. Du Bois's Photographs for the 1900 Paris Exposition," *African American Review* 34, no. 4 (2000):, 581–99. Reprinted in *The Souls of Black Folk: One Hundred Years Later*, ed. Dolan Hubbard (Columbia, MO: University of Missouri Press, 2003). Smith identified at least one African American photographer, Thomas Askew of Atlanta, as having created photographs for Du Bois's collection.

6 Henry Louis Gates Jr., "The 'Blackness of Blackness': A Critique of the Sign and the Signifying Monkey," *Critical Inquiry* 9, no. 4 (June 1983): 700.

7 Henry Louis Gates Jr., *The Signifying Monkey: A Theory of African American Literary Criticism* (Oxford: Oxford University Press, 2014), 49.

8 François Laruelle, *From Decision to Heresy: Experiments in Non-Standard Thought*, ed. Robin Mackay (Falmouth/New York: Urbanomic/Sequence Press, 2012), 11–12.

9 François Laruelle, *Photo-Fiction: A Non-Standard Aesthetics*, trans. D. S. Burk (Minneapolis: Univocal, 2012), 18.

10 Laruelle, *From Decision to Heresy*, 200.

11 François Laruelle, *The Concept of Non-Photography*, trans. Robin Mackay (Falmouth/New York: Urbanomic/Sequence Press, 2011), 143.

12 A term first introduced by the nineteenth-century American mathematician Benjamin Peirce: "When, raised to a square or higher power, [an expression] gives itself as the result, it maybe called idempotent." (*Linear Associative Algebra* [New York: D. Van Nostrand, 1882], 8) Idempotency is expressed mathematically as $An = A$.

13 Bruce Glaser, "Questions to Stella and Judd," in *Minimal Art: A Critical Anthology*, ed. Gregory Battcock (Berkeley: University of California Press, 1995), 158.

14 Du Bois, *The Souls of Black Folk*, 8.

15 Laruelle, *The Concept of Non-Photography*, 27.

16 Ibid., 34.

17 Ibid.

18 Paul Gilroy, *Against Race: Imagining Political Culture Beyond the Color Line* (Cambridge, MA: Harvard University Press, 2001), 356.

19 Robert Musil, *The Man Without Qualities*, trans. E. Wilkins and E. Kaiser (New York: Pedigree, 1953), 174–75.

20 Kwame Anthony Appiah, *Cosmopolitanism: Ethics in a World of Strangers* (New York: W.W. Norton & Company, 2006), 135.

21 Laruelle, *From Decision to Heresy*, 25.

22 Appiah, *Cosmopolitanism*, 99.

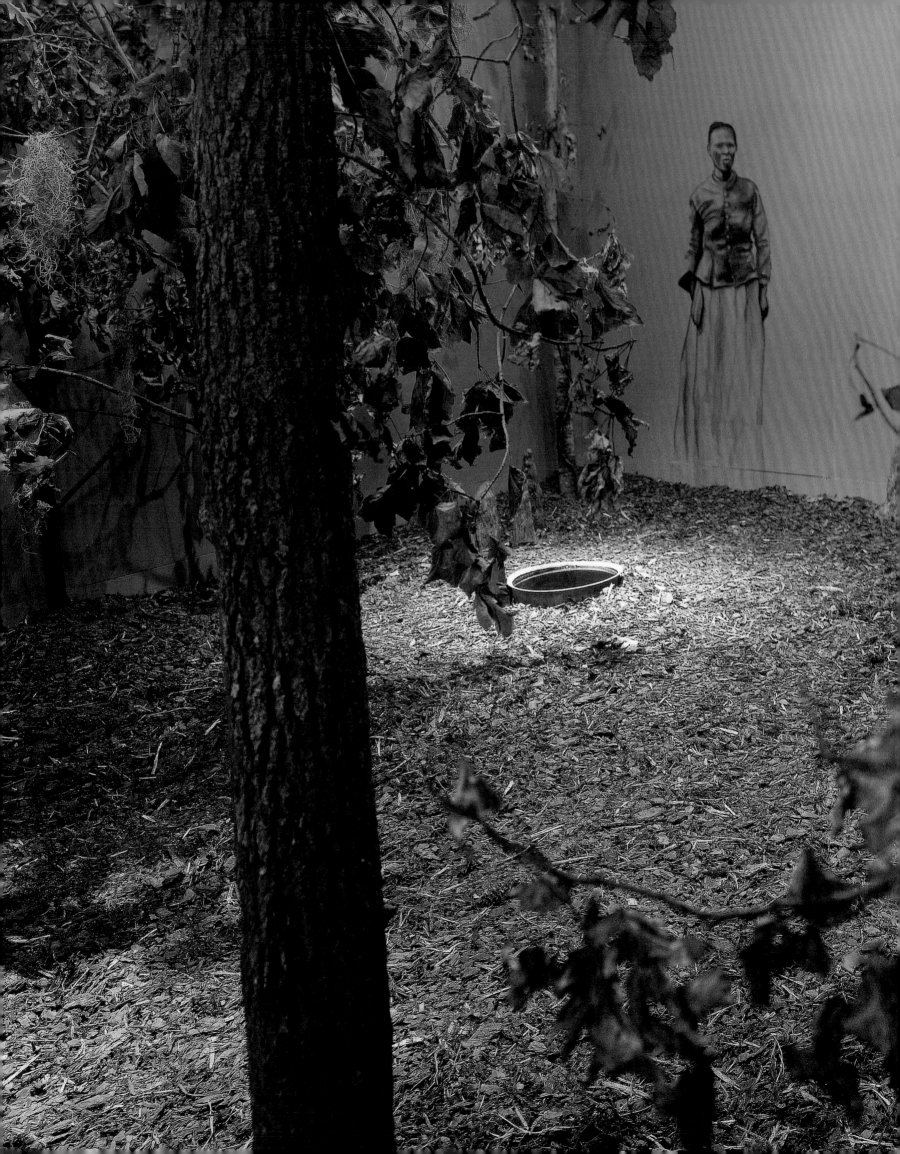

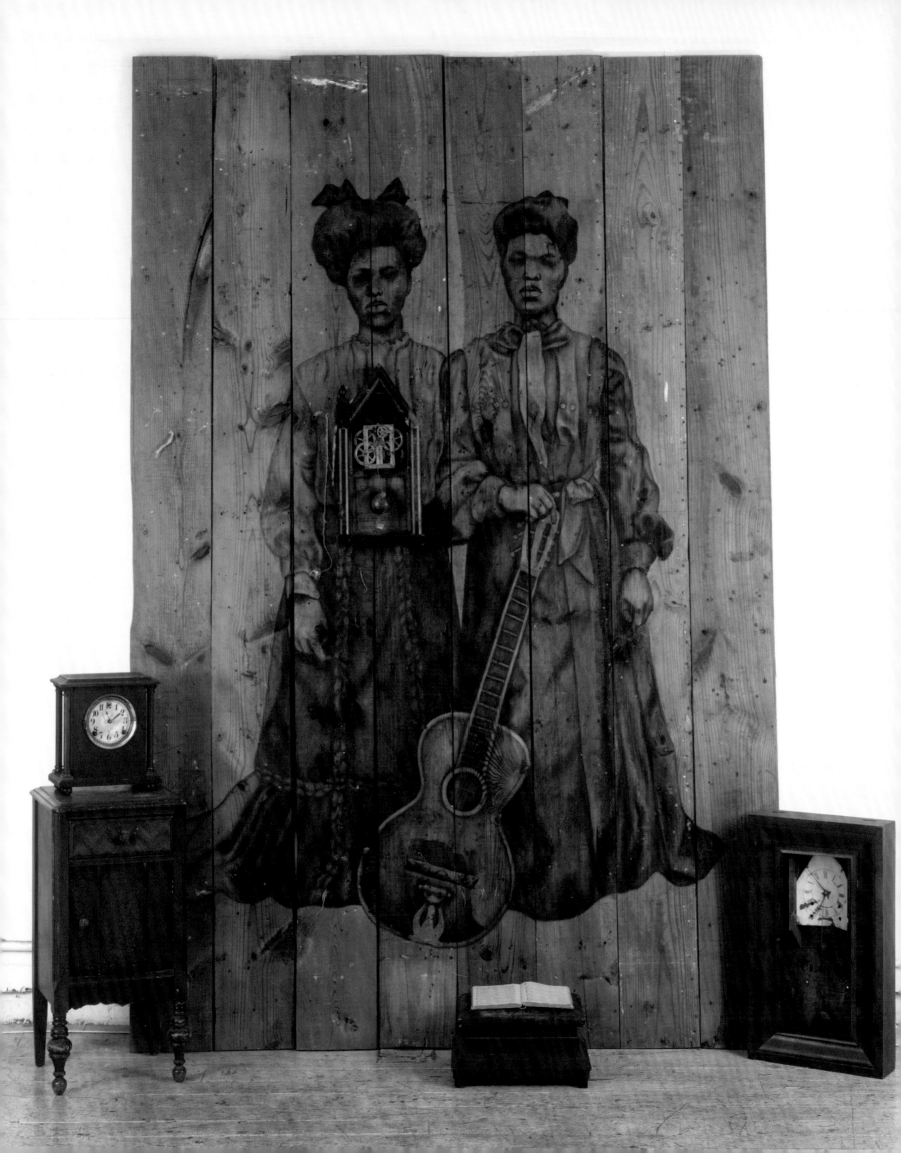

Loaded Objects:
The Soulful Reverie of Whitfield Lovell

Elsa Smithgall

> The contemplation of objects, the image that rises out of the reverie that objects provoke—those are the song. … To name an object is to destroy three-quarters of our pleasure in a poem—the joy of guessing step by step.
>
> —Stéphane Mallarmé[1]

Artists have long been drawn to objects of material culture as powerful conveyors of emotional expression. Since the 1990s, Whitfield Lovell has reinvigorated this tradition with carefully crafted juxtapositions of found objects and drawn figures—embodied presences that transport the viewer from past to present, from the material to the spiritual worlds.

The unexpected accident of seeing humble objects from his everyday surroundings in proximity to his art awakened Lovell to the transformation that can happen when an object interacts with an image. He recalls, "I did a piece called *Scream* [1984]. It was a very colorful image of a screaming woman who had just learned that someone in her family was murdered. At that time I was working from newspaper photographs …, I had this rather large drawing hanging on the wall in my apartment. I had a party, and the morning after the party, there were all these balloons on the floor below the drawing. With all of the bright yellows and oranges and reds [in the drawing] and the brightly colored balloons all over the floor, I just couldn't help but see a connection. The balloons brought the image into the room and created a whole other dimension."[2] Seeing this interplay of object and image inspired Lovell, who soon found himself holding objects beside drawings to see "how the objects affected, changed, enhanced, resonated with the images."[3]

Though he was clearly moved by these experiences, Lovell resisted bringing objects into his work. "For practical reasons, I did not explore the possibilities of incorporating objects into my work at that time," he says.[4] To do so would have demanded larger working and storage spaces. About a decade later, Lovell created his first mural-size wall drawings in an artist's retreat in Capriata d'Orba, Italy, the Villa Val Lemme, a mansion that had been built by a slave trader (overleaf and p. 17). Lovell's drawings directly on the walls summoned spirits, "giving a voice," as Lovell said, "to those African slaves."[5]

Two years later, while an artist-in-residence at Rice University, Lovell at last acted upon his impulse to incorporate objects into his work. For his installation *Echo* at Project Row Houses (p. 20), Houston, he drew on the walls of an abandoned shotgun house, juxtaposing many found objects with the wall tableaux. Lovell enjoyed scouring the streets, seeking items in antiques stores and flea markets. Soon after, when a collector wished to acquire one of the walls from the installation, Lovell had a carpenter remove the planks with drawings on them from the room and reassemble them as freestanding tableaux.

Whereas in *Echo* the objects were placed on the floor, separate from the wall drawings, a few years later Lovell began to make tableaux with objects attached directly to the wood panels. Lovell explains what inspired the first of these, *Vanity*, 1998 (p. 157): "Some flea market items such as vessels and jars were sitting on the sink. I rested an artwork on the sink and saw how those vessels brought the drawing to life. I gave in to the urge to use the objects in that piece. From then on, I became more and more excited about playing objects off drawings."[6] In *Vanity*, glass bottles are placed alongside the lower portion of a drawn female figure. The result is a beautifully composed tableau that leads directly to Lovell's evocative pairings of drawn faces with timeworn objects. Rather than fall into the trap of reading this or any other work by Lovell literally as a likeness or portrait, the viewer is challenged to go deeper, to find a multiplicity of associative or symbolic meanings beneath its surface. The intensity of the figure's expression in *Vanity* is softened by the elegant arrangement of bottles of various sizes and shapes below her, ranging from plain vessels to elaborate cut crystal. The work's title conjures many associations. Do the spent bottles connote the sense of vanity as being devoid of worth? Or does the work raise questions about vanity as a conceit that masks one's true character? Might the physical piece of furniture at which the drawn portrayal

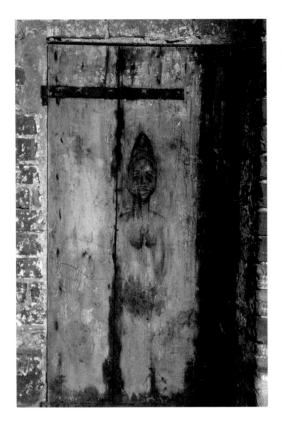
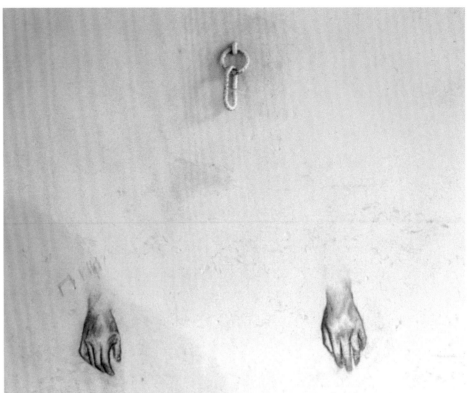

notionally sits be termed a vanity? Lovell's work is memorable precisely because it provokes such open-ended questions and challenges the viewer to see beyond obvious meanings.

Lovell's urge to employ found objects has continued unabated while taking various new turns across several mediums and at various scales. All the while, he has continued to invest his art with a subtle complexity and emotional charge. Whether in an intimately composed work on paper from the *Kin* series or a monumental wood tableau such as *So Soon*, 2001 (p. 154), Lovell continually mines the past to reveal truths about the human condition. The role of objects in his creative practice draws upon the rich history of modernist assemblage, in particular works by several of its leading practitioners, from Marcel Duchamp, André Masson, and André Breton to Joseph Cornell, Robert Rauschenberg, Jasper Johns, and Edward Kienholz. Building on this great legacy, Lovell has forged a highly personal style that is activated by his deep spiritual bond with anonymous African Americans seen in old photographs.

The history of assemblage owes a great debt to French artist Marcel Duchamp for introducing in the 1910s a radical new category of art dubbed the ready-made, designating as artworks manufactured objects. Reacting against the then-prevailing view that art is designed to appeal to the eye, Duchamp insisted that an ordinary and seemingly unattractive object, such as a bottle rack, urinal, coatrack, snow shovel, or comb, held artistic value not based on its visual qualities but on its potential to stimulate the mind. Although the ready-made stirred outrage and disbelief on the part of the public and critics, it soon became a major catalyst for the widespread acceptance of manufactured objects into the realm of modern art, including the creative practice of assemblage.

Several of Duchamp's compatriots, including Man Ray, Max Ernst, and André Masson had the occasion to further explore the possibilities of the "assisted" (altered) ready-made when they were each given a life-size female mannequin to transform into a work of art for a corridor leading into the 1938 International Surrealist Exhibition at the Galerie Beaux-Arts, Paris. The one created by Masson is the most frequently reproduced of the sixteen mannequins (p. 159). On the head of his realistic female mannequin Masson placed a wicker birdcage. He gagged her mouth with a strip of green velvet, accented by a purple pansy, inserted tiny stuffed birds under her armpits, covered her private parts with an oval mirror on a cloth surrounded by glass tiger eyes and feathers, and placed little traps containing phallic pimentos at her feet. Masson's sexually charged formal alterations of the female body are clearly couched with overtones characteristic of the Freudian underpinnings of Surrealist art. The erotic connotations aside, Masson's choice and symbolic use of the cage in concert with a female figure reverberates decades later in Lovell's tableau *Cage*, 2001 (p. 158).

A round wire cage does not cover the head of the woman drawn in *Cage* but instead her lower body, from her waist down. The cage, which protrudes nearly two feet from the drawing, is evocative of a womb, suggestive of pregnancy. It is harmoniously married to her frame and it simultaneously traps her. The contradiction speaks to the uneven treatment women historically have received, being at once matriarchs in the domestic sphere and victims of subjugation and inequality in the public one. Imprisoning his mannequin within a cage and silencing her, Masson participates in that discourse, though he does so in an especially sensational manner.

The unsettling and at times paradoxical relationship Lovell elicits by his use of titles, *Cage* being an example, is paralleled by

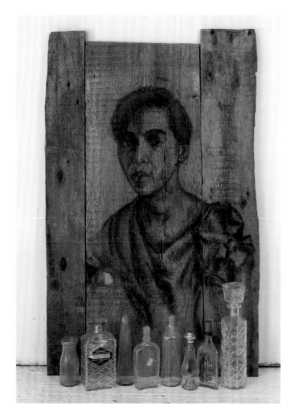

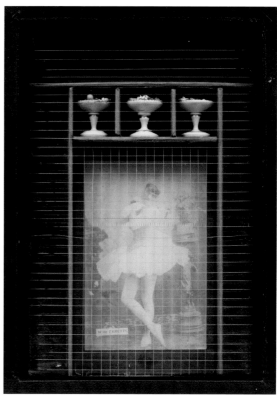

the role of text in the work of French Surrealist André Breton. In the 1930s and early 1940s, Breton explored the poetic possibilities of mixing words and objects in a series of works he called *Objet-Poèmes*. In them, Breton hoped to create a "novel sensation" that was at once "disturbing and complex."[7] By activating relationships between the poetic and the plastic arts, Breton further sought to reveal "their power to excite one other."[8] In a poem-object of 1941, Breton interspersed objects—a carved wooden male bust, a framed photograph, an oil lantern, and toy boxing gloves—with phrases that connote a discontinuous journey between earth (*ces terrains* / the land) and the heavens (*la lune* / the moon). In which direction are we meant to connect the words and the images or objects? Breton has successfully created an ambiguous flow that is charged with an emotional, dizzying energy. The words *vaincu par l'ombre* (defeated by the shadow) call out from the tethered gloves. By bringing the linguistic and visual fragments together, Breton achieved an abstract synthesis that realized his ambition for the work to be at once "disturbing and complex."

Lovell's approach sometimes draws on a similarly disorienting poetic sensibility. His allusive titles are not meant to be explicit or narrow, but instead seek to open up to the viewer any number of shades of meaning. Tableaux such as *Bleck*, 2008 (p. 8), and *Strive*, 2000, both showing boxing gloves dangling from a female figure, are examples of Lovell testing assumptions and pressing us to "think a little deeper."[9] Why do we see a woman and not a man with these boxing gloves? Lovell has altered our usual frame of reference. When we view the gloves less literally, the combining of gloves and the image of a woman may suggest her perseverance, strength, and struggle. Lovell relishes the kind of jolt that can occur when unexpected pairings force the viewer to overcome stereotypes and think outside the box.

Lovell's work also bears striking analogies with the art of Joseph Cornell, who had been tantalized by the Surrealists' use of found objects. Not long after Cornell's debut in a 1932 exhibition at Julian Levy's New York gallery, he began to craft theatrical shadow-box constructions in which he presented found objects, frequently in combination with images from his wide-ranging collection of nineteenth- and twentieth-century photographs and printed images. In early examples of the boxes, Cornell experimented with constructions that were focused on a single figure, for example, one taken from his collection of cabinet cards. In *Untitled (Mlle. Faretti)*, 1933 (above), Cornell activates the space around the photograph of the ballerina with two mirrored panels on either side. Faretti commands center stage in her floating tutu, head tilted to her left as she gazes coyly at the viewer. She appears behind an open mesh of brightly colored strings, a grid-like "curtain" threaded in pink and white and crowned by three gold-trimmed miniature compote dishes brimming with delicacies. Cornell's carefully choreographed moment combines a photograph with found objects to evoke the dynamism of the dancer through both formal and symbolic means. He invites the viewer to participate in the scene, to engage with object and image on his or her own terms.

In many ways, Cornell's shadow boxes are an interesting counterpart to the framed assemblages of Lovell's *Kin* series. In all but one of the *Kin* images, Lovell positions a drawing of a head with one or several carefully chosen objects.[10] Like Cornell, Lovell has gathered rich collections of historical photographs as source material for his work. Yet while Cornell incorporated actual photographs in his work, Lovell expressly does not. For him photographs function as an emotional touchstone for the content of his work. In freely drawn Conté-crayon compositions combined with

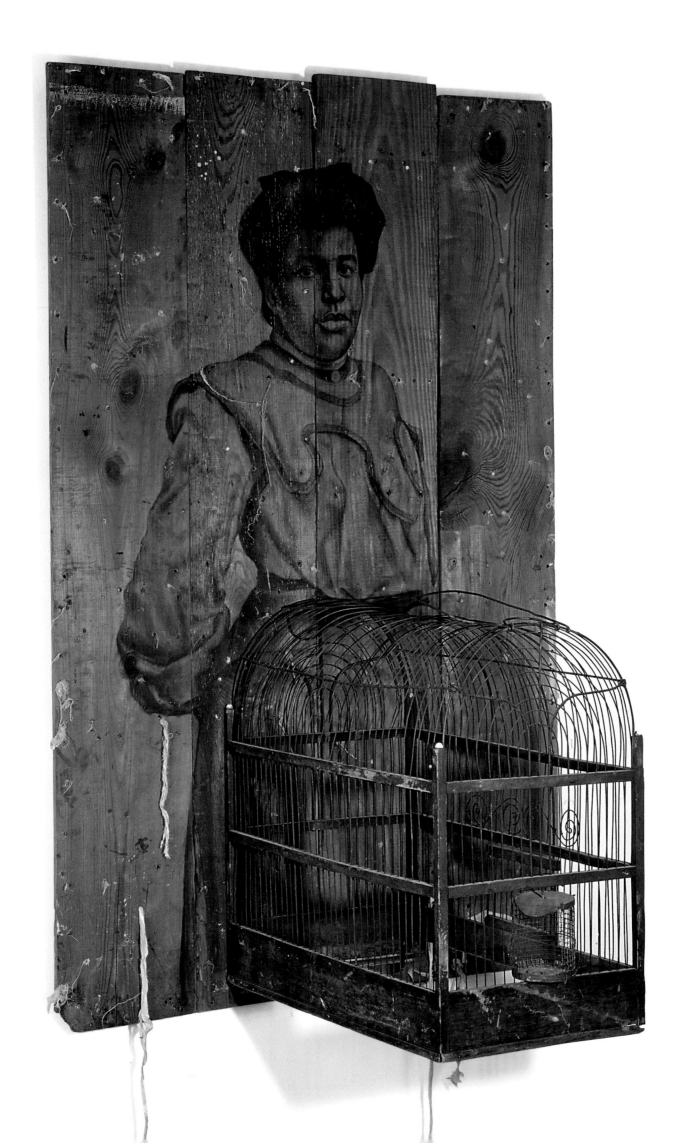

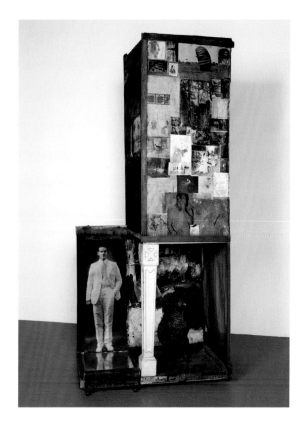

objects, Lovell channels his own feelings into each *Kin* piece. "They are artworks; I don't think of them as portraits in terms of traditional portraiture," Lovell has said, adding, "I bring some of myself to how I'm interpreting this person's image, as well as whatever I'm saying with the objects. . . . I deal with a lot of my own emotions and ideas through these artworks, and so the images of these people sort of help me to express them."[11] Cornell similarly subscribed to the view that his art existed on an abstract level as "image making akin to poetry."[12] While the incorporation of drawn elements plays a major role in Lovell's work, in contrast to that of Cornell, the two artists share a subtle, sophisticated approach o their carefully chosen juxtapositions of objects and images.

The artistic inventions of Rauschenberg and Johns expanded the conceptual and formal approaches to assemblage in the mid-twentieth century in ways that have had lasting reverberations in contemporary practice. Rauschenberg and Johns saw beyond artificial distinctions between representation and abstraction and challenged prevailing notions about the depersonalized nature of mass-produced objects. Considering them to be neither painting nor sculpture, Rauschenberg called his novel experiments Combines. They embodied his belief that "all material has its own history built into it. . . . An artist manufactures his material out of his own existence—his own ignorance, familiarity or confidence."[13] Inspired both by Duchamp and the unorthodox mix of "trash" in the *Merz* collages of Kurt Schwitters, Rauschenberg built up his own richly sensorial art form out of photographic reproductions, printed matter, and ordinary objects, sometimes heavily encrusted with paint. The extraordinarily dense, nonlinear, free-flowing Combines unravel elements of time, history, and memory through a fluid network of associative meanings, which they set into motion.

"The iconography of the Rauschenberg pictures," William Rubin has observed, "seems to reach back through time and consciousness, memory by memory . . . they never relinquish their autobiographical intimacy."[14] This personal association is noticeably apparent in Rauschenberg's *Freestanding Combine*, 1954 (above), which he sometimes called *Plymouth Rock* for the stuffed chicken that occupies its partially enclosed lower portion. Objects incorporated in the work take the viewer on a journey through moments in the artist's life, from a photograph and a letter from his son Christopher, to a photograph of his ex-wife Susan Weil, newspaper clippings about his parents and sister, and photographs of his friend Jasper Johns. At the same time, Rauschenberg includes anonymous figures in photographs, including the large standing male dressed in white and a mother kissing her daughter. That these anonymous figures are equally valued in the artist's nonhierarchical view is no accident. "I recognize the individuality of all objects," Rauschenberg has insisted; "each object has distinction. It has uniqueness. Anything that has uniqueness deserves respect."[15] Lovell would later echo this comment, remarking that he is "always conscious of these people, . . . honoring the dignity" of those he brings into his work.[16]

In choosing as subjects the flag and the target, Jasper Johns introduced two potent symbols into the realm of art and inflected them with new meaning. Unlike the latest abstract expressionist tendencies, Johns's flag and target paintings were seen in their time as purely objective expressions, devoid of personal signification. But as the artist later confessed, the works were in fact channeling deeply personal feelings.[17] Johns acknowledged that the idea to paint an American flag came to him in a dream. He further identified with this motif because he and his father had been named after a Revolutionary War hero, Jasper Sergeant,

ces terrains vagues
et la lune
accrochée
à la
maison
de
mon cœur
vaincu
par l'ombre
où j'erre

Left: André Breton, **Poem-Object,** December 1941. Assemblage mounted on drawing board: carved wood bust of man, oil lantern, framed photograph, toy boxing gloves, and paper; 18 x 21 x 4³/₈ inches. Collection of The Museum of Modern Art, New York. Kay Sage Tanguy Bequest

Right: **You're My Thrill,** 2004. Charcoal on wood, bombshell casings; 54 x 36¹/₂ x 14 inches

who had "lost his life raising the American flag over a fort."[18] This contributed to the artist's preoccupation with the motif over endless variations in color, scale, medium, and form. The fact that each one has a distinctiveness affirmed the artist's belief that with each "slight reemphasis of elements, one finds that one can behave differently toward [an image], see it in a different way."[19] Mixed into the thickly layered surfaces of Johns's encaustic paintings are cryptic fragments from newspapers, most of which are not legible. Through these veiled references buried in the works, Johns heightened the enigmatic reading of the motifs. In *Target with Four Faces*, 1955, he similarly probed ideas about the hidden and the exposed. Unlike the fixed, open chambers of Cornell's shadow boxes, Johns created a hidden space above the target in which objects are either present or hidden, depending on whether the door has been lifted. In this context, the large dominant element of the target looms large beneath the four tinted plaster faces above. That the figures have been "defaced," with eyes masked and intentionally cut off from our view, provokes fascinating questions about the symbolism of the target motif as a potent dehumanizing weapon leveled at humankind. Johns infuses a deliberate tension into the work with these masked faces, alternately concealed or revealed in the chambers above the target, and they must have held personal meaning for the artist. Johns understood what it meant to be the victim of discrimination as a closeted gay man living in the repressive, homophobic McCarthy era.[20]

With the target and the flag motifs, Johns firmly laid the groundwork for the assimilation of these familiar emblems into the language of art. Both motifs are notably present in a number of Lovell's works. They are seen in pairings of the flag or target with a single figure, in several *Kin* series works, and in pairings

with one or more figures in the larger tableaux. In *Kin IV (One Last Thrill)*, 2008 (p. 33), and *At Home and Abroad*, 2008 (p. 165), for example, Lovell includes a small red, white, and blue target, allowing them to be read in two different contexts, one that considers women as the subjected targets of discrimination and the other African American soldiers.

The target's colorful circular form creates a formally elegant counterpoint to the round profile of the woman's face in *Kin IV* and reinforces the circular rhythm of the three figures in *At Home and Abroad*. However, the deceptively simple form of the target in both works portends a harsher reality, one which Lovell has personally experienced (Lovell suffered the loss of his grandfather Eugene Glover, who was killed in a mugging in 1984): "Every target, every bull's-eye…holds a personal resonance for me…I am rarely thinking of, or reliving those losses…but rather using these as symbols for the losses of everyone, the violence we perpetrate upon our fellow human beings, be it physical or verbal, political or psychological. We are always, as a society, throwing darts, aiming bombs and missiles at one another and using people as target practice."[21] In *At Home and Abroad*, about African Americans serving in World War I, the target is freighted with racial implications. African Americans found themselves on both the receiving and giving ends of violence, whether as patriots defending the cause of freedom abroad or as second-class citizens in a segregated society at home. In a similar vein, in *Kin I (Our Folks)* (p. 27), *Kin II (Oh Damballa)* (p. 29), *Kin VIII (1619)* (p. 41), all from 2008, and *America*, 2000 (p. 21), Lovell reaches beyond the American flag's patriotic associations to raise complex questions about what it means to belong to a nation (questions that resonate strongly with today's controversy surrounding immigration). In the process, as with Johns's flags and targets, Lovell's

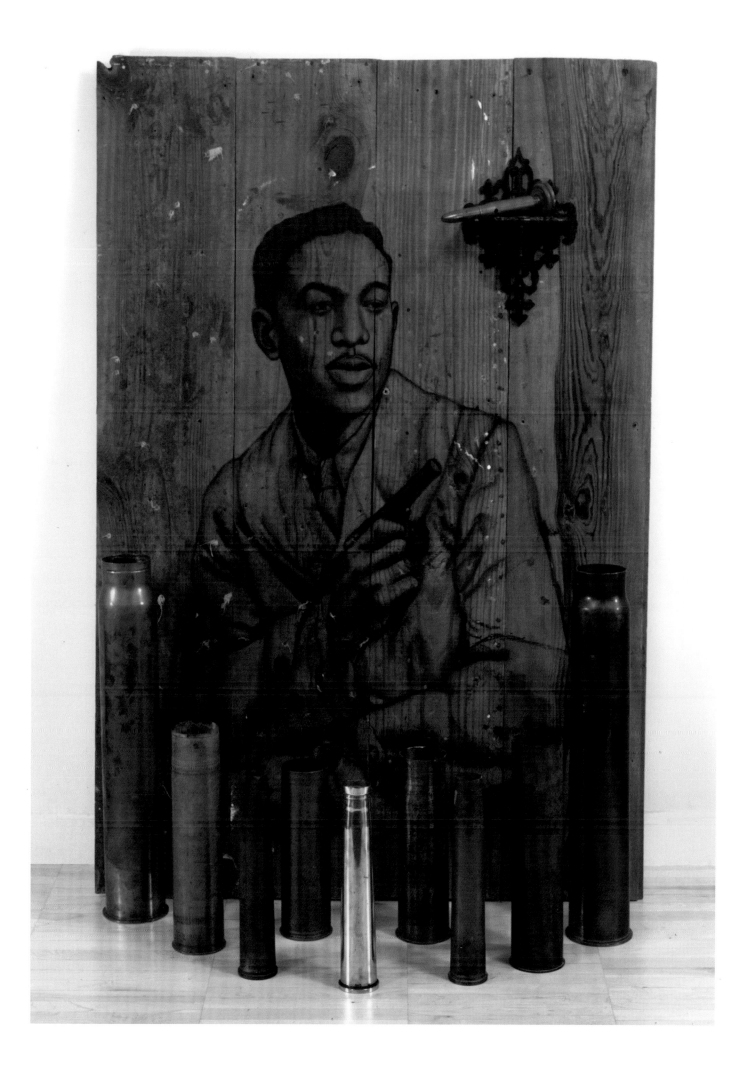

Left: Edward Kienholz and
Nancy Reddin Kienholz,
**Portrait of a Mother
with Past Affixed Also,**
1980–81. Mixed media;
99 ⁷/₈ x 94 ⁷/₈ x 81 inches
overall. Collection of Walker
Art Center, Minneapolis.
Walker Special Purchase
Fund, 1985

Right: **Guide My Heart,**
2006. Conté on wood,
two-man crosscut logging
saws; 77 x 52 ¹/₂ inches.
Collection of Diane I.
and Quintin E. Primo III

placement of symbols in new contexts disrupts our culturally conditioned readings of signs present all around us.

In the post–World War II era, a new generation of American artists continued to push the boundaries of assemblage, creating tableaux and installation pieces that brought their works into the physical space of the viewer. Los Angeles–based artist Edward Kienholz was among those introducing vital new approaches. From his earliest experiments in 1960 with the installation *Roxys*, recreating the interior of a brothel, Kienholz established his skill in social satire and in telling stories of the marginalized and powerless through a mixture of found objects. Many of the objects included in it, such as the room's furnishings, a 1943 calendar, and a framed picture of General Douglas MacArthur, conjured memories of his youth. Kienholz continued to mine the junk we all throw away, seeing it as a "form of education and historical orientation for me. I can see the results of ideas in what is thrown away by a culture."[22]

This proved to be the case for Kienholz during a stay in Berlin in the 1970s, when he discovered in flea markets many old Bakelite radios of the 1930s and 1940s and subsequently learned how they functioned in disseminating Nazi propaganda. This type of radio, known as a *Volksempfänger* or "people's receiver" (in a manner analogous to the Volkswagen or "people's car"), inspired a major series of the same name by Kienholz. *The Cage*, 1975, is one from the series in which Kienholz placed ten of these radios in an illuminated cabinet wrapped in barbed wire and surrounded by metal barriers. He then added a contraption on the floor that the viewer can walk on, activating sounds of Mahler's music.

The lack of freedom symbolized by the old German radios, whose daytime reception was generally limited to official government stations, provides an interesting counterpoint to Lovell's *After an Afternoon*, 2008 (p. 182). Five stacks high, this assemblage of thirty-seven antique radios is accompanied by three alternating sound tracks featuring archival broadcasts from the mid-twentieth century, from Billie Holiday's "Yesterdays" and "Strange Fruit," to commentator Walter Winchell's World War II newscasts and *The Beulah Show*, a radio turned television sitcom known for its mockery of blacks.[23] Through the soothing timbre of Holiday's voice and the lighthearted antics of *The Beulah Show*, these broadcasts offered audiences an antidote to the harsh realities of life in a racially contentious pre–civil rights era.

Just as Lovell was coming of age, Kienholz was mining the deep, emotional content of his family's past in *Portrait of a Mother with Past Affixed Also*, 1980–81 (above). The scene unfolds within a replica of his mother's actual house in Hope, Idaho, furnished with some of its original contents. Just inside the door is a mannequin dressed as the mother bearing the head of her gilded framed portrait. She peers into a framed photograph of her younger self from which extend two plastic outstretched baby hands. Through the doorway, we glimpse a table set with fine china and crystal in a room surrounded by photographs of her late husband and other mementos.[24] Symbolically gesturing for us to come in through the wide-open door, Kienholz brings the spectator into an intimate domestic home to visually partake in the warmth of a family meal and the spiritual aura of times past. The setting is reminiscent of the immersive, domestic interiors that Lovell would later create in his large-scale installations *Whispers from the Walls*, 1999 (pp. 22–23) and *Visitation: The Richmond Project*, 2001 (p. 13). Lovell's installations share with Kienholz a desire to invite the viewer into a revered space for contemplation of memory, heritage, and time's transitory passage.[25] Yet, unlike such Kienholz installations as *Portrait of a Mother*, Lovell's installations allow the viewer to fully engage three-dimensionally by physically becoming a part of the artwork itself. In *Visitation*, the visitor enters a room where "a young man is standing near a desk with many letters, a pipe, and a can of tobacco. The[re] [are] aromas of the tobacco and the whiskey on a nearby table, combined with the scent of the vintage wood...There is an organ...A gospel tune emanates from an old radio with the words, 'I'm waiting, though my faith's not so

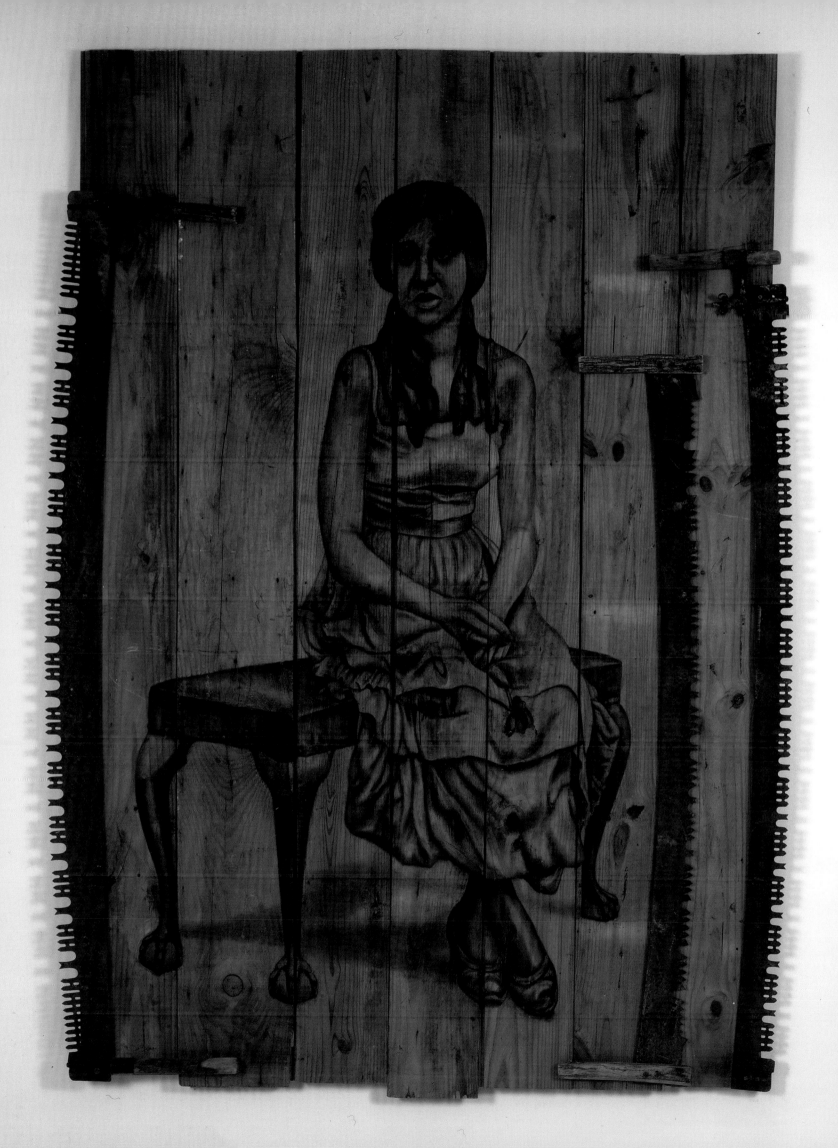

Right: **At Home and Abroad,** 2008. Conté on wood with target, nails, and fabric; 65 x 45 x 3 ¹/₂ inches. Muskegon Museum of Art, MI: Purchased in honor of the 100th Anniversary of the Muskegon Museum of Art through the Art Acquisition Fund, the 100th Anniversary Art Acquisition Fund, the support of the Alcoa Foundation, and the gift of Dr. Anita Herald

Overleaf: **Dawn to Dawn,** 2006. Conté on wooden door and industrial spool disk, earth, found objects; 97 x 219 ¹/₂ x 40 inches

strong.'"[26] Being immersed in the room's sights, sounds, and aromas, the visitor is transported to a place that hovers between the real and the imagined, a place in which one can "feel the spirit of the past for the moment."[27]

Along with many artists of the twentieth century, Lovell expresses a profound desire to find meaning in the magic created by the combination of objects and images. While building on this modern tradition, Lovell has extended its power and scope into the twenty-first century. Memories, family, friends, and intangible thoughts and feelings converge in his art. In the subtlety of his poetic combinations and the restraint of his formal means, Lovell honors the individuals who came before us. He renders in painstaking detail each of their expressions and attributes, marking their unique existence with his masterful hand. "This is my movie," Lovell tells us, "Each of these pieces are pieces of me."[27] On some level, this could be said of any form of creative expression; however, the deep reservoir out of which flows the beauty and poignancy of Lovell's art is destined to carry us into the twenty-second century and beyond.

I would like to thank Evelyn Braithwaite for her thoughtful reading of this manuscript and her invaluable research assistance.

1 Stéphane Mallarmé, in Francis Steegmuller, *Apollinaire: Poet Among the Painters* (New York: Penguin, 1986), 36.

2 Interview with the artist, November 3, 2015.

3 Ibid.

4 Ibid.

5 "Chronology," with notes by Whitfield Lovell, in *The Art of Whitfield Lovell: Whispers from the Walls* (San Francisco: Pomegranate: 2003), 118.

6 Interview with the artist, November 3, 2015.

7 André Breton, "Surrealist Situation of the Object," lecture delivered in Prague, March 29, 1935, in *André Breton: Manifestoes of Surrealism,* trans. by Richard Seaver and Helen R. Lane (Ann Arbor: The University of Michigan Press, 1969), 263.

8 Breton defined his *poème-objet* as "une composition qui tend à combiner les ressources de la poésie et de la plastique et à spéculer sur leur pouvoir d'exaltation réciproque." ("A composition that tends to combine the resources of poetry and sculpture and to reflect upon their power of mutual exaltation.") See André Breton, 'Du poème-objet,' *Le Surréalisme et la peinture* (Paris: Gallimard, 1965), 284, cited in Peter Lang, "Surrealism," in *Surrealism: Crossings/Frontiers,* ed. Eliza Adamowicz (Bern: International Academic Publishers, 2006), 113–14.

9 "In Conversation: Whitfield Lovell with John Yau," *Brooklyn Rail,* July 10, 2006: 8.

10 The one *Kin* that does not include objects is *Kin XV (Seven Breezes),* 2008 (p. 55).

11 Interview with the artist, November 3, 2015.

12 Joseph Cornell Papers, Archives of American Art, Washington, DC, April 15, 1946, cited in Hartigan, *Joseph Cornell: Navigating the Imagination* (New Haven, CT: Yale University Press, 2007), 269, n. 3.

13 Robert Rauschenberg and Barbara Rose, *Rauschenberg: An Interview with Robert Rauschenberg* (New York: Vintage Books, 1987), 58.

14 William Rubin, "Younger American Painters," *Art International* 4, no. 1 (January 1960): 26, cited in Paul Schimmel, "Autobiography and Self-Portraiture in Rauschenberg's Combines," in Paul Schimmel et al., *Robert Rauschenberg: Combines* (Los Angeles: The Museum of Contemporary Art, 2005), 211, n. 2.

15 *Rauschenberg,* 121.

16 Interview with the artist, November 3, 2015.

17 "In my early work I tried to hide my personality, my psychological state, my emotions…eventually it seemed like a losing battle." Jasper Johns interview, *Vanity Fair,* 1984; reprinted in *Jasper Johns: 35 Years,* ed. Susan Brundage (Leo Castelli, New York, 1993), n.p., cited in Leo Steinberg, *Encounters with Rauschenberg* (Chicago: The University of Chicago Press, 2000), 15, n. 7.

18 Jasper Johns, interview, 1990, cited in Isabelle Loring Wallace, *Jasper Johns* (New York: Phaidon Press Limited, 2014), 15.

19 "Interview with Jasper Johns," by Christian Geelhaar, in *Jasper Johns: Working Proofs* (Basel: Kunstmuseum Basel, 1979), 67, cited in Nan Rosenthal, "Flag," in *Jasper Johns: Seeing with the Mind's Eye,* ed. Gary Garrels (New Haven, CT: Yale University Press; San Francisco Museum of Modern Art, 2012), 24.

20 Some scholars have suggested Johns may have felt victimized as a closet homosexual. See Kenneth E. Silver, "Modes of Disclosure: The Construction of Gay Identity and the Rise of Pope Art," in *Hand-Painted Pop: American Art in Transition, 1955–62,* ed. Russell Ferguson (Los Angeles: The Museum of Contemporary Art, 1992), 183.

21 See "After an Afternoon: Whitfield Lovell in conversation with Julie L. McGee," in this volume.

22 Edward Kienholz in *Kienholz: A Retrospective: Edward and Nancy Reddin Kienholz* (New York: Whitney Museum of American Art, 1996), 160.

23 For more on *After an Afternoon,* see Julie L. McGee, "Whitfield Lovell: Autour du Monde," *Nka Journal of Contemporary Art,* 26 (Spring 2010): 52–53.

24 Rosetta Brooks further suggests that Kienholz's rendering of his mother bears association with an Annunciate Virgin, thereby evoking a moment of "miraculous revelation." See Rosetta Brooks in *Kienholz: A Retrospective,* 187.

25 Lovell sees his installations "as being artworks that you step into." Interview with the artist, November 3, 2015.

26 Whitfield Lovell, interview by Leslie King Hammond, *The Art of Whitfield Lovell: Whispers from the Walls,* 65.

27 Whitfield Lovell, cited in Melissa Messina, "A Reverence for Ordinary People," in *Mercy, Patience and Destiny: The Women of Whitfield Lovell's Tableaux* (Atlanta: The ACA Gallery of Savannah College of Art and Design, 2009).

28 Interview with the artist, November 3, 2015.

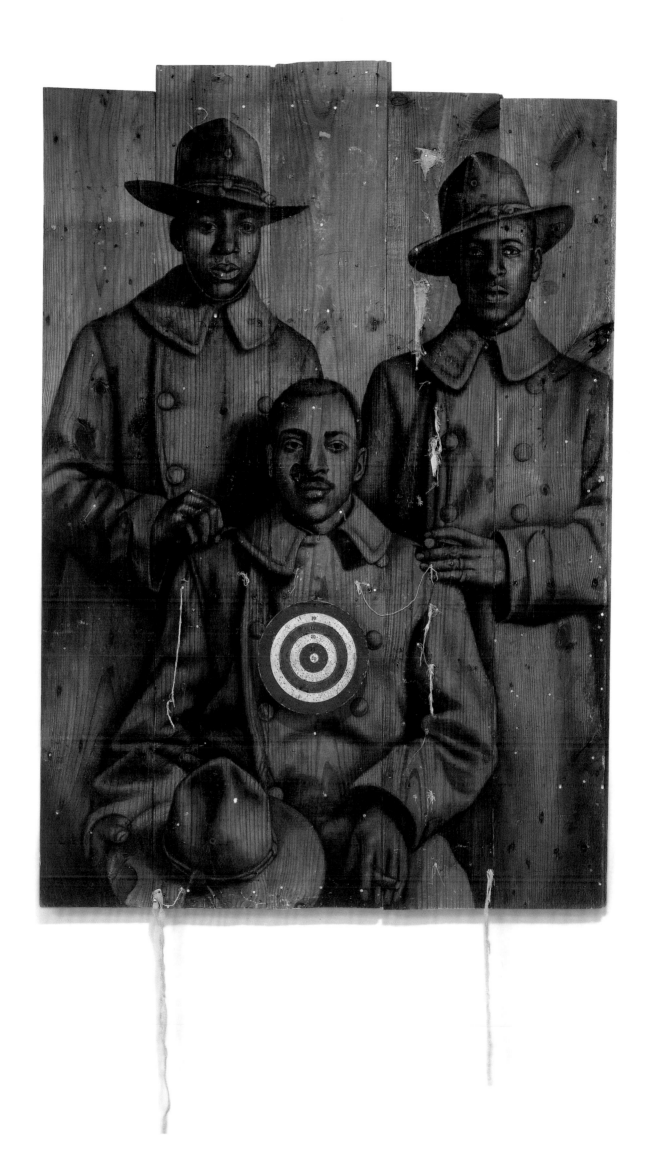

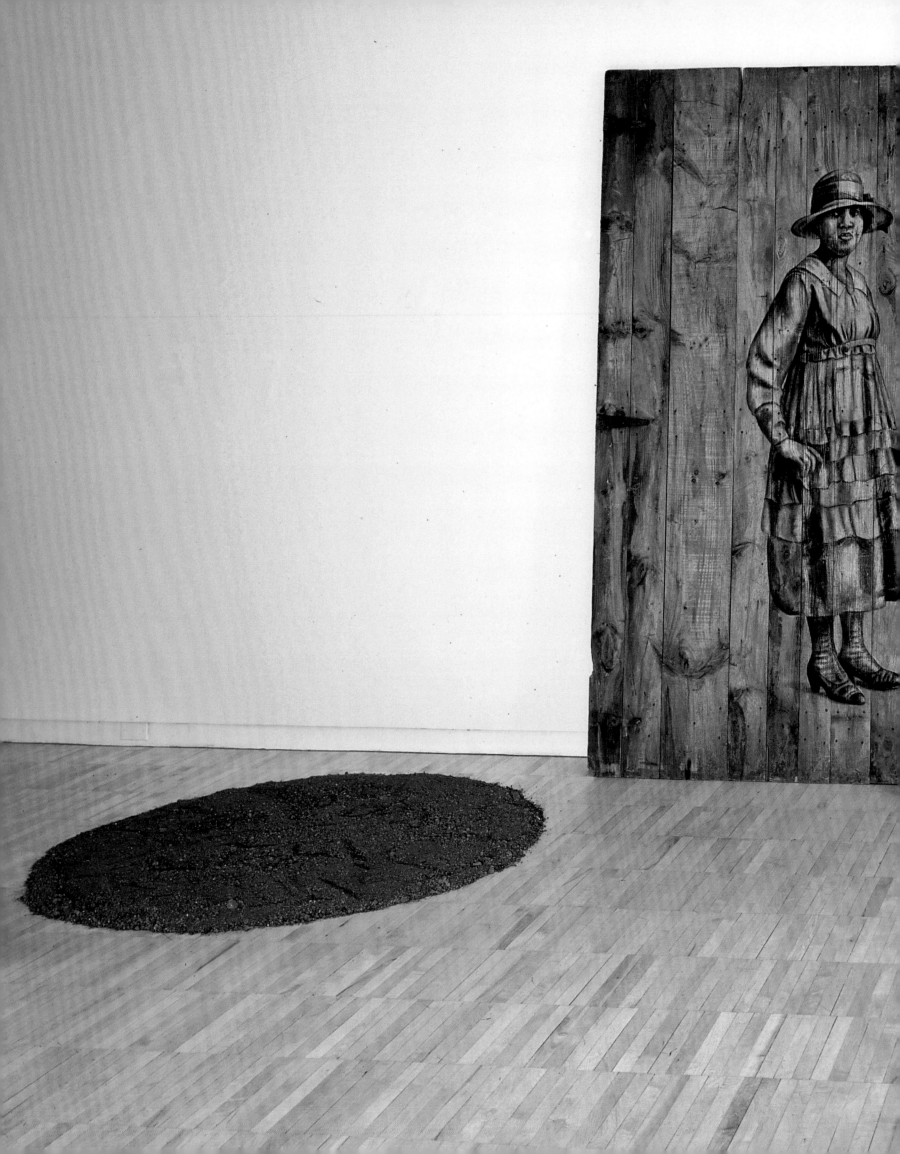

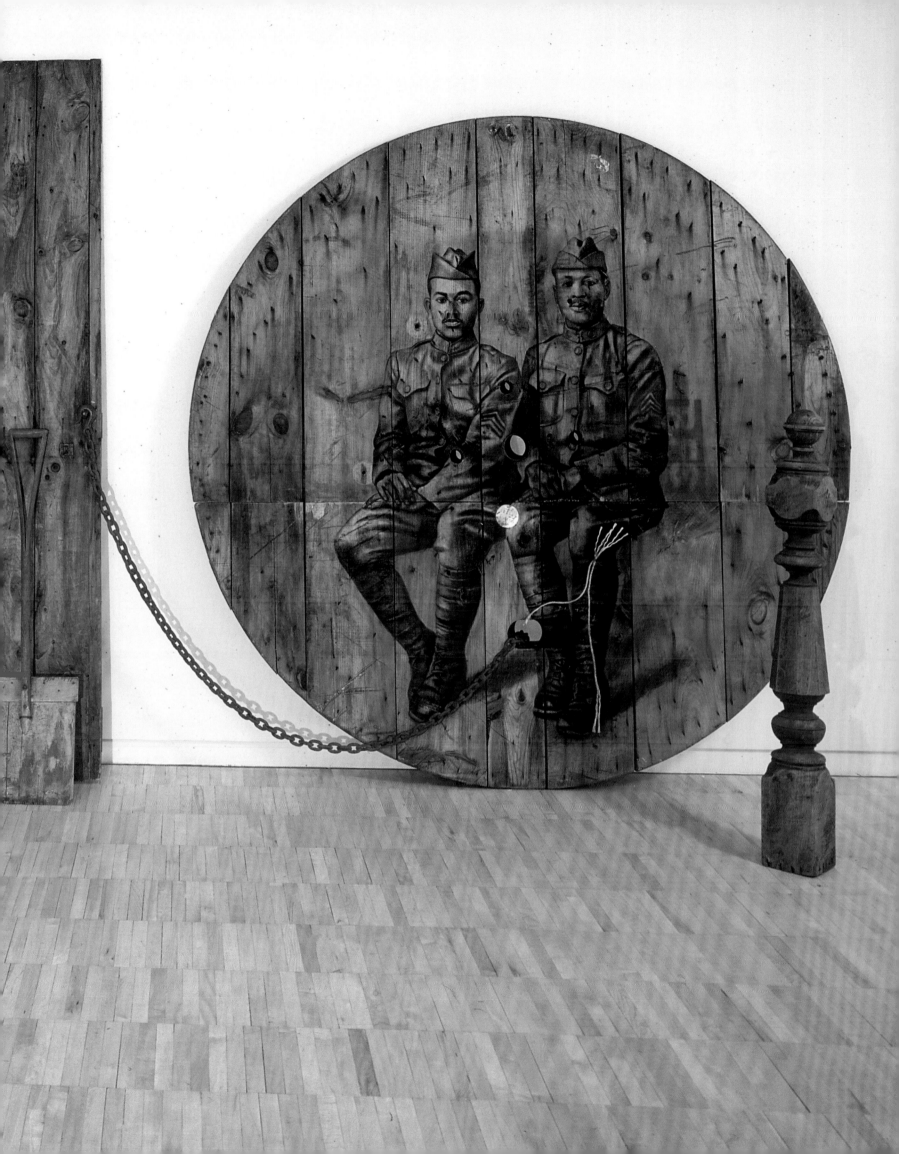

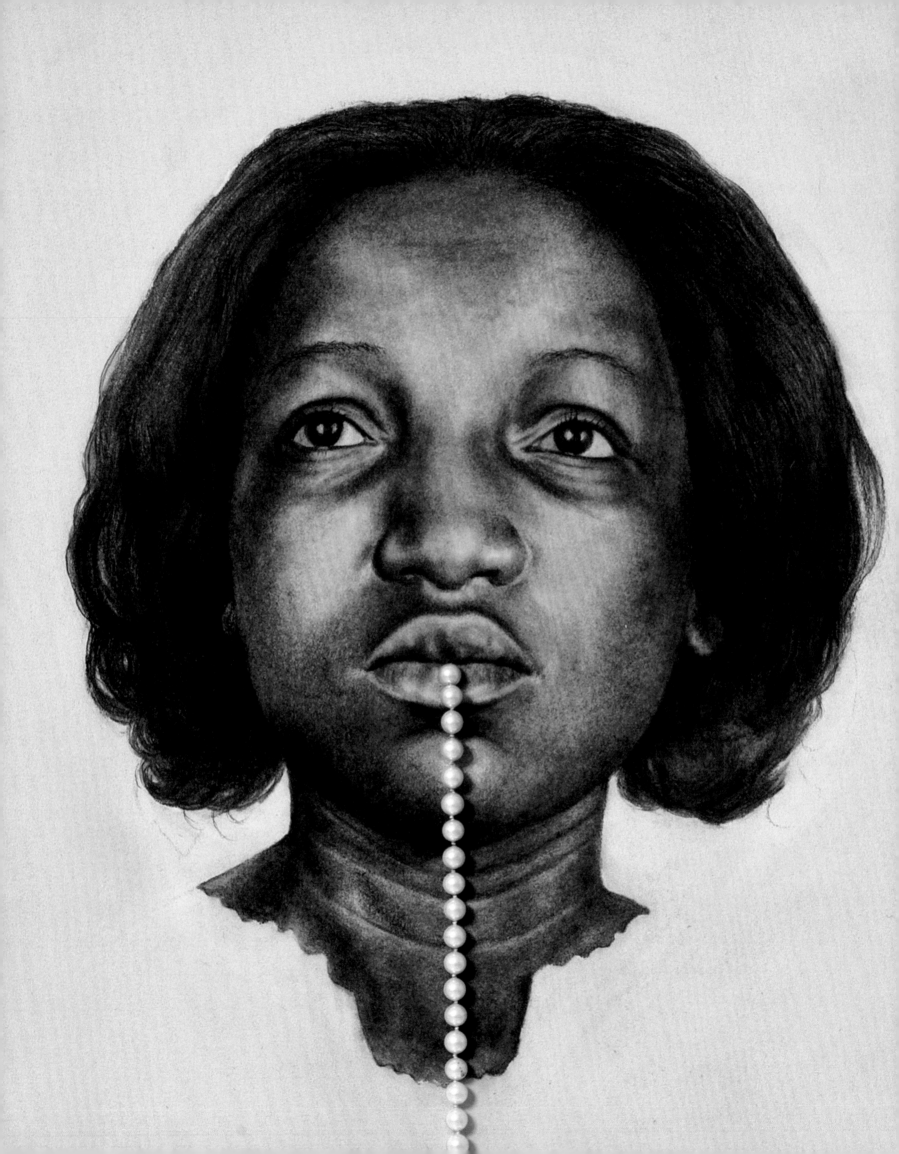

Sophisticated Geometries

Julie L. McGee

The envelope bearing the letter emitted a musty rose smell and the paper of the stationery had faded to powder blue. But the words, in Geneva's elegant cursive handwriting, remained legible.

Dear Gladys,

I've been thinking about prayer lately . . . the only ones that ever make sense to me are those intended to reach loved ones, the ancestors. Not prayers of the Rosary—like the Our Father, Hail Mary, or Glory Be—but prayers to kith and kin. I've been thinking too about the look and feel of old hymnals and prayer books, the kind with supple covers that sit just right in your hands and stay open to the pages you need; the paper-thin, almost transparent paper would lay open easily, a slight rise near the center spine and relaxed slope toward your hands. The text, often columnar and justified, seemed the antithesis of the tenderness of the book—all the same I never questioned the observable asymmetry. Pearls and faces have observable asymmetry that we rarely question and often stop seeing. I found Gigi's pearl necklace last week; it had fallen behind the bottom drawer of the armoire and must have been there for years. She used to say it was her pathway to heaven, her Holy Rosary.

Affectionately, Sis

This letter, an elegy for *Kin LVIII (Heaven)*, 2011 (opposite and p. 141), by Whitfield Lovell, which I invented, is inspired by the elements provided by the artist and the associations they engender: a string of pearls, a snapshot of a woman with relaxed hairstyle and a broad, graceful brow, veritably re-embodied in Lovell's Conté crayon drawing, and a word: *Heaven*.

Lovell has been collecting and using vintage photographs and accoutrements—the material culture of late nineteenth- and early twentieth-century American life—for many years. Comprising sixty works, the *Kin* series is a family album of sorts, virtuosic Conté drawings of individual male and female subjects on toned Stonehenge paper.[1] As with his installations and tableaux, which combine superb charcoal and Conté drawings on weathered wood with antique objects, the *Kin* series drawings are judi-

ciously wedded with objects whose narrative function is suggestive, rather than determining, and which provide formal accents in the overall work. The dimensional qualities of these actual objects call attention to the masterful illusionism of Lovell's drawings. Finding just the right object to set in relation to his drawn images—in what Lovell calls "the place where the formal and artistic elements meet"—requires both judgment and intuition, and it is a process that can, and often does, take years to be resolved. Collectively epic yet and individually familial, à la nineteenth-century family Bibles, the *Kin* series is nonetheless epistolary in nature. Imagined thusly, each *Kin* is an intimate letter.

Marked by expectation, the art of personal letter writing—committing thoughts to paper that are subsequently stamped, postmarked, and delivered—requires patience, an acceptance of certain vagaries of delivery and reception. The gap of time, space, and sentiment between the writing and the reading generates the realm of possibilities. Emotive and temporal dissonance seems certain, yet intimacy flows in the gap; expectancy is an energized field. Long ago letters read anew share temporal complexity: the past takes up residence in the present. As readers (and viewers of Lovell's work), we accept and even take pleasure in this incongruity.

In Lovell's oeuvre, images and objects perform similarly charged exchanges that complicate and enrich narrative associations. The process of composing and animating the exchange is central to Lovell's artistry. Consider Lovell's use of globes, spherical objects, in *Kin XIII (Fine Kind of Freedom)*, 2009 (p. 51), and the tableau *Autour Du Monde*, 2008 (pp. 204–5). Nineteen vintage globes are incorporated in the latter: attached to the wood panels, placed immediately before them, or set at a distance of some ten feet in front of them. The arrangement of the globes generates a number of triangular relationships that activate the space: the eye is drawn out and back and out and across, multiple times. The shadows cast by the globes—on the floor and the panels—

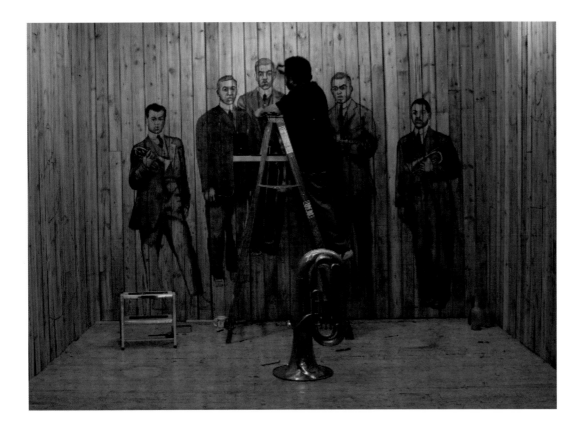

Installation view with the artist and a work in progress, January 2005

Page 168: **Kin LVIII (Heaven),** 2011 (Detail). Conté on paper, string of pearls; 30 x 22 ¼ x 2 ½ inches. Private collection

reinforce this formal rhythm and distract us from noticing that the artist has, for compositional integrity, manipulated the shadows cast by the standing soldiers. Conditioned by lighting, cast shadows provide yet another varying dimension to Lovell's work. The shadows are anticipated by the artist, and their presence reinforces the spatial and conceptual play between internal and external influences.

In Kin XIII, the globe and the shadow it casts emphasize the modulated sinuosity of the drawn image of an adult male: his globular Adam's apple, arching eyebrows, and lips. The sphere, an antique bank with a slit for coins, is echoed by the enlarged dark pupils of the figure it adjoins. Like the elegant line of a skater doing repeated figure eights, the curvilinear movement around and between image, object, and shadow is continual, punctuated by the diagonal slit in the bank, a gap between Canada and the Arctic. There's irony in the juxtaposition of the bank with the title *Fine Kind of Freedom*. Is freedom gratis, truly free and fine? Or is it costly and does it necessitate reserves?

Lovell's parenthetical titles, offerings that pose beautiful questions, further the conceptual geometry: informational cues move back and forth between image, object, and word, generating playful associations, intentional mix-ups, and profound malapropisms. In *Kin XXXII* (*Run Like the Wind*), 2008 (p. 89), a circle of barbed wire, neatly rolled and tied, seems playfully decorative. Placed below the image of a young woman, the barbs project outward and call attention to the loose strands in the woman's hairdo. Her expression suggests sorrow. Casting a network of shadows, the coiled wire recalls the safety of a bird's nest and the pain of a crown of thorns. Whether they are functioning metaphorically or metonymically, objects like these provide indeterminate cues, at once liberating but then again portentous.[2]

As cues, Lovell's titles are enticing, yet they thwart simple narrative relationships between the drawn images and accompanying objects. Titles stand outside the work and operate like an intersection between work and viewer. Many of the Kin works are linked by their titles to music, reflecting Lovell's consummate knowledge. These references locate the works in a historical period and provide shades of associative meanings—some amusing, some oblique, and many quite profound. Like the objects conjoined with the rendered images, they are quintessential Lovell gestures, destabilizing the literalism of his exquisitely rendered images and simultaneously enlarging our reading of the works. The elegance and eloquence of Austrian composer Gustav Mahler surfaces in *Kin XLV* (*Das Lied Von Der Erde*), 2011 (p. 115). Completed in 1909, *Das Lied von der Erde* ("The Song of the Earth") is a symphonic setting of six songs for two voices and orchestra. The title metaphorically grounds the woman in *Kin XLV*, whose image seems spirit-like. The verse from "Der Einsame im Herbst/ The Solitary One in Autumn," the second song of the symphonic composition, seems particularly apropos:

> I weep often in my loneliness. Autumn in my heart lingers too long. Sun of love, will you no longer shine to gently dry up my bitter tears?[3]

Caressed by delicate pearls that appear to stream gracefully down her cheek, the woman depicted in *Kin XLV* glances heavenward and weeps.

The parenthetical title for *Kin LX* (*Le Rouge et Le Noir*), 2011 (p. 145), appropriates lyrics from a popular French song by the Belgian singer-songwriter Jacques Brel: "Ne me quitte pas" ("Don't leave me"). Composed in 1959, the song has been translated and performed in several languages and adapted by many singers. "Ne me quitte pas" became a repertoire standard for

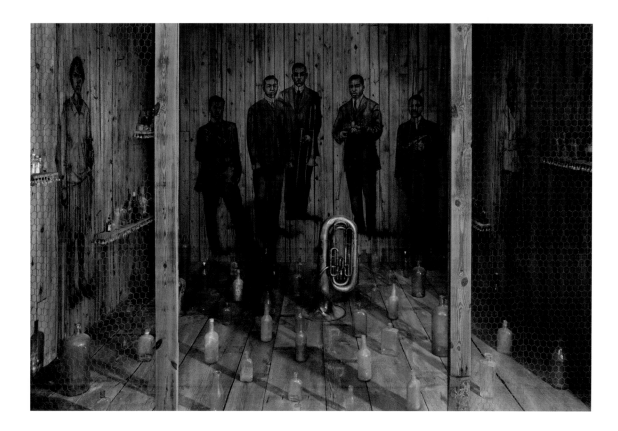

Nina Simone, a vocalist beloved by Lovell. Simone recorded it in French for her 1965 album *I Put a Spell on You*. In Brel's song, the verse describes colors of an evening sky: *le rouge et le noir* (the red and the black). Reused by Lovell in association with *Kin LX*, the five sequenced words assume new associations and disassociations: they put a spell on you.

Indeed, *Le Rouge et le Noir* is also the title of the classic novel by Stendhal published in 1830.[4] In the literary world, Stendhal's intriguing title and the epigraphs used for each chapter have long been subjects of analysis.[5] "Boredom," "Pronunciation," "Night Thoughts," "Open-Work Stockings," "The Day After," and "Last Adieux" are among the seventy-five chapter titles. The titles deployed by Lovell for the *Kin* series—epigrammatic in their own way—operate similarly: They are delightfully ambiguous and defy singular interpretation.

In *Kin LX*, Lovell foregrounds and frames the drawn image, a woman, with branches. The slight tilt of the figure's head, to the side and back, elongates the neck: it is narrow yet articulated like the branches from behind which the figure peers out. The woman is unembellished and the boughs barren; this may be their winter before new buds appear. A branch runs parallel to the diagonal axis of the figure's right cheek. Anticipating the cast shadows, subtle gestures establish the geometry of perpendicular, transverse, and vector emphases. The gaze of the figure is outward, even as the head recedes; Lovell's selection and placement of the branches with this visage secures the dynamism of the compositional matrix.

Considered in the context of his tableaux and installations, the *Kin* series advances our understanding of Lovell's studio practice. The individual figures differ from the many Lovell has executed based on vintage studio photographs, the *Kin* series images

being developed instead from identification photographs (e.g., passport photos, mug shots, and photo-booth pictures he has collected). These sources offer at once institutionalized perspectives and official documentation; for example, the photo-booth images, products of automatic kiosks with preset cameras and lighting, provide a vending-machine quality and a distinctive range of imagery, lighting, and framing that clearly distinguishes them from studio portraits. The final developed image—what we see—reveals Lovell's artistry and dexterity. A subtle but fundamental aspect of the artist's practice is his free interpretation of the photographic images: he does not disturb their authenticity unnecessarily, but he is no mechanical copyist, bound to his photographic sources.

The arc of Lovell's narrative runs hand-in-hand with the artist's aesthetic intentions, and the *Kin* works slow us down, teaching us to look beyond narrative and even to dream. While the *Kin* series provides opportunities to see Lovell's compositional motives intimately, similar aesthetic choices and sensitive maneuvers underpin his tableaux and installations. Encountering Lovell's work, we are like the figures and histories he mines for source material, in the sense that we are always simultaneously in and out of the multiple temporal and spatial realities that prevail in his work. As artist Tom Otterness mused in *Bomb* magazine:

> The interior of the "object" of the home, the objects that furnish these homes, the objects that absent people once used: chairs, beds, glasses, guns, medicine bottles, tools, tubas, and record players, are in the foreground, while reserved, watchful figures seem to be inside the walls that envelop us as we enter someone's long abandoned home.[6]

A photograph from 2005 of Lovell on a stepladder, preparing the installation *Storyville* (p. 171), points to the temporal-spatial slip-

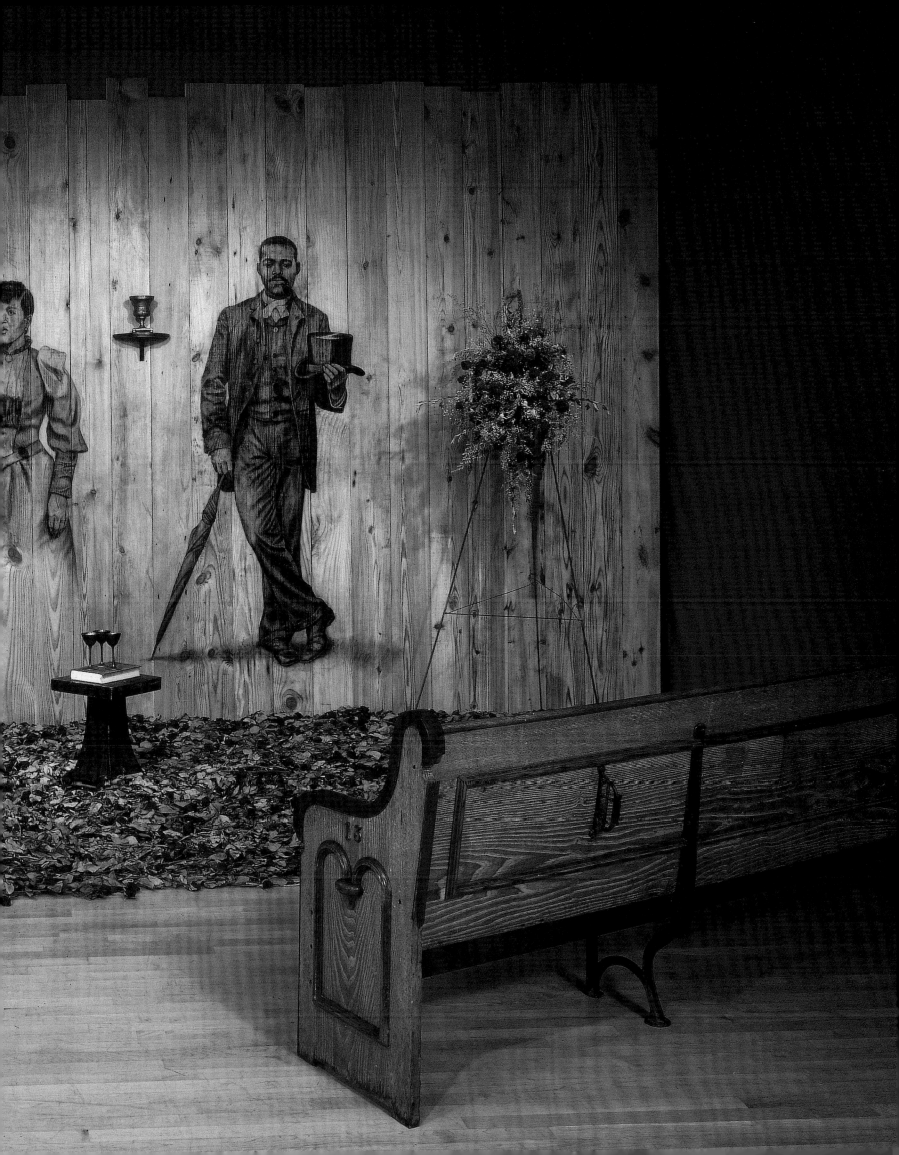

pages his work masterfully conjures.[7] Inside the boxlike volume that will become *Storyville* are Lovell, who is drawing, a vintage tuba placed bell side down, a collection of glass bottles, and a smaller ladder. Working on the life-size drawings that comprise the back wall of *Storyville*, the artist is both in the picture, seemingly part of the group of standing musicians he has drawn, and outside their historical time. As Otterness intimates, we symbolically enter the interior life of Lovell's "object" as the individuals brought to life by the artist observe us. Evident in the completed installation of *Storyville*, the tuba is the hub around which the other elements radiate.

In Lovell's work, interiority is no simple matter. Some of Lovell's installations have been sited within historically loaded interiors, including a nineteenth-century slave trader's villa in Italy, an abandoned shotgun house in Houston, and the former barracks of a sixteenth-century Spanish fort in Havana, while others include physical structures, built interiors that function as secondary installations, as with *Whispers from the Walls*, 1999 (pp. 22–23).[8] It is apropos to consider Lovell's installations as theater and the artist as dramatist, scenic designer, and stage manager. While Lovell's tableaux, such as *Libations*, 1998; *Missoura*, 2001; or *Autour Du Monde*, 2008 (pp. 204–5), establish microenvironments, the large installations—*Visitation: The Richmond Project*, 2001 (p. 13); *SANCTUARY: The Great Dismal Swamp*, 2002 (pp. 151–53); *Grace*, 2003 (pp. 172–73); and most recently *Deep River*, 2013 (pp. 176–79)—all offer immersive environments in which viewers are invited to commingle with "Lovell's people," as Lucy Lippard christened them.[9]

For *Storyville*, Lovell created the ambience of a speakeasy: music and drinking are the pleasures of the day. The five standing musicians that appear on the back wall have stilled their instruments. "I wanted to create music out of the silence, without the use of recorded sound; I wanted to create an environment where you could sense or feel the music," Lovell said.[10] The arrangement of variously sized empty bottles on the wood floor of *Storyville* creates a series of cross-rhythms or crisscross axes that are polyrhythmic: up, down, side to side, turning this way and then around. We might even see the bottles as demarcations for dance steps or supplementary musical instruments—closed air end columns (like clarinets and organ pipes) for resonating air. Radiating around the tuba, the bottles orchestrate sight lines across the installation. The flanking walls of *Storyville* allude to a less public

and more private space inhabited by female figures and decorated with clothes hooks, narrow shelves, and empty bottles of smaller size and varying shapes. In the illusionistic space Lovell has created, the women occupy a plane different from that of the musicians. Punctuating the central ground, the prominently placed tuba reinforces the differing spatial elevations of the speakeasy and the intimate chambers.

Storyville recalls the restricted red-light or vice district on the back side of New Orleans' Basin Street, near the French Quarter, in operation from 1897 to 1917. Named after alderman Sidney Story, the dance halls, social clubs, saloons, and houses of prostitution provided entertainment for locals and tourists alike, including servicemen. Storyville was a haven for jazz musicians, including Jelly Roll Morton, Sidney Bechet, Buddy Bolden, Joe "King" Oliver, and Louis Armstrong. The era was memorialized in the 1925 song "Farewell to Storyville," also known as "Good Time Flat Blues," by Clarence and Spencer Williams. Louis Armstrong and Billie Holiday perform the song in the 1947 film *New Orleans*, in which he plays a bandleader and Holiday a domestic worker who moonlights as a singer.

Alcohol sales in the vice district generated the most revenue. Inspired by vintage liquor storage cases, the "fourth wall" of Lovell's *Storyville* is made from chicken wire and includes an open "doorway." This enclosure sets up contrasting views of an interior, one clear and the other modulated—a strategy Lovell favors in his installations. As containers for alcohol, the empty bottles emit affecting aromas. In Lovell's oeuvre, vintage bottles, decanters, and goblets associated with liquor assume important formal and allegorical roles alongside their aromatic role. The uses and consequences of alcohol—a potent spirit—are mercurial, and its multivalent nature, at once medicinal and intoxicating, is well-suited to the overlapping concepts inherent in Lovell's work.[11]

Vintage liquor and perfume bottles, soil, old clothing, and dried flowers (more than 2,000 roses for the installation *Grace*) are among the many objects used by Lovell for their formal, representational, and olfactory qualities. Aromatic and acoustic ambiences are critical components of his immersive environments. The presence of sound in Lovell's installations and tableaux dates back to *Echo*, his 1995 work for Project Row Houses in Houston (p. 20). In *After an Afternoon*, 2008 (p. 182), Lovell

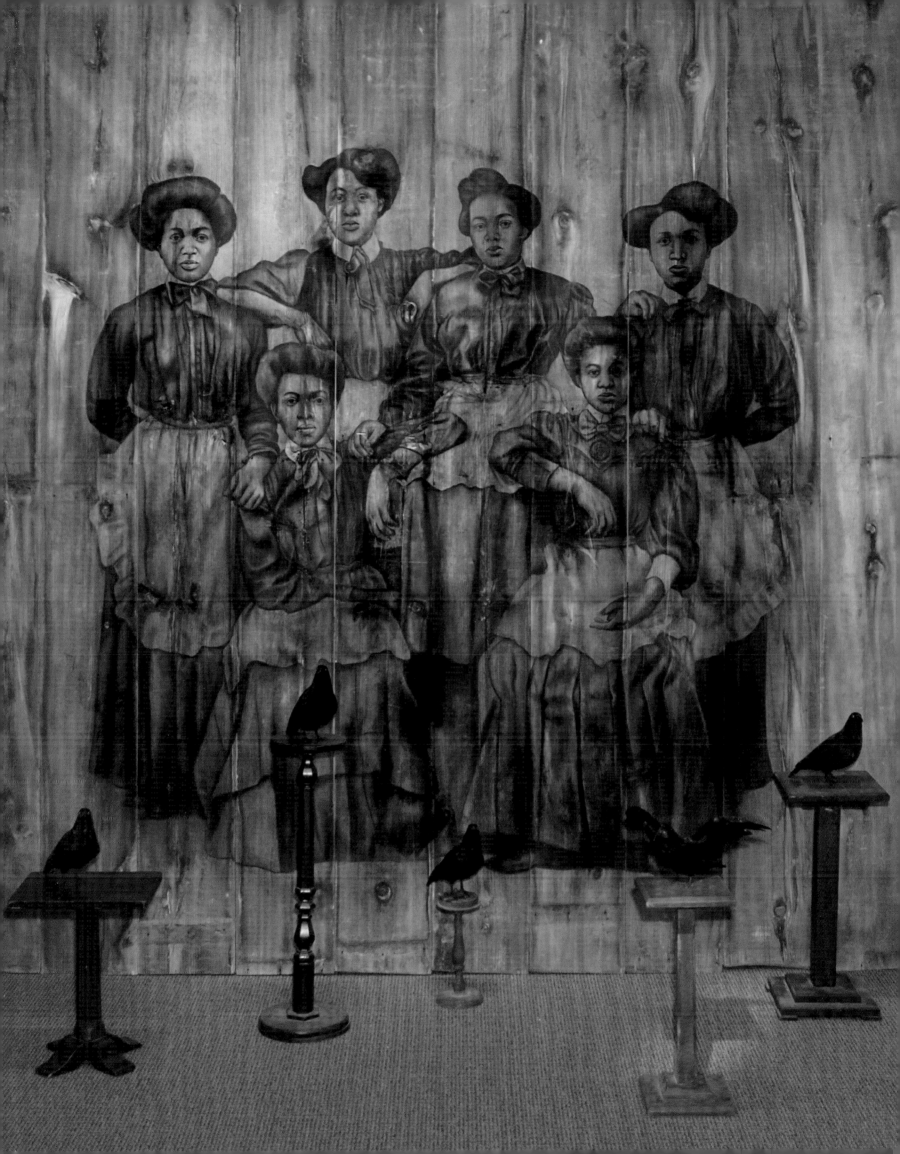

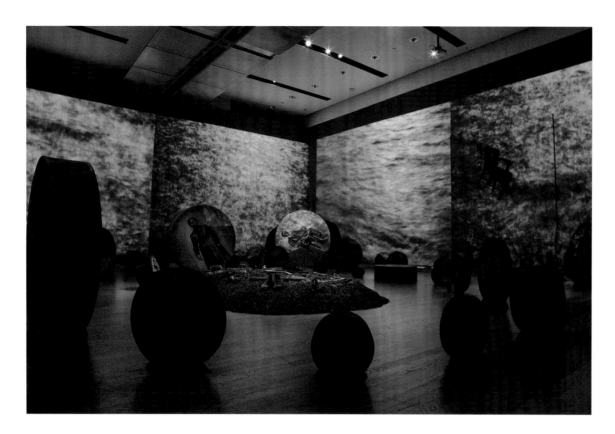

dispensed with figure drawing altogether, allowing antique radios (a few with stopped clocks) and recorded sound to invoke an aural past and evoke human presence. Thirty-seven stacked vintage radios are the resonators for three sound tracks: excerpts from the 1945–54 CBS radio program *The Marlin Hurt and Beulah Show* (in 1946 retitled *The Beulah Show*), World War II–era news read by Walter Winchell, and Billie Holiday singing "Yesterdays" and "Strange Fruit." The sound recordings of *After an Afternoon* overlap intentionally and connect divergent lives, spaces, times, and histories in one melodious yet cacophonic sculpture.[12]

Capable of awakening all our senses (hearing, sight, touch, smell, and taste), bodies of water hold a particular attraction for Lovell. Elemental, reflective, immersive, and fluid, rivers, oceans, and creek beds—nature's gifts—can be nurturing, healing, and cleansing, as well as capricious and destructive. In *SANCTUARY*, Lovell's experiential landscape included trees, mulch, basins of water—intentional visual occlusions of the drawn figures—and sounds of crickets, cicadas, and barking hounds.[13] A vast wetland between southeastern Virginia and northeastern North Carolina, the swamp was once home to resistance communities of African Americans and Native Americans escaping enslavement and colonialism.[14] Describing his field research for the installation on visits to Lake Drummond at the center of the Great Dismal Swamp in Virginia, Lovell remarked, "Most important for me were the moments when I stood silently in the swamp and just listened to the sounds and felt the ambience."[15] Lovell's gift is the invocation of the experience of being inside the swamp and its history—emotionally and sensorially.

A similar act of conjuring occurs in Lovell's most recent installation, *Deep River*, 2013, as it bears witness to submerged histories of Camp Contraband on the Tennessee River near Chattanooga. Lovell's most immersive installation to date, *Deep River* integrates projected video of rippling water, audio tracks of lapping water, chirps from crickets and the occasional bird, and four different versions of the African American spiritual "Deep River," with his drawn figures and sited objects.[16] One is intended to experience it from within; there is no gallery perimeter, no safe viewing distance.

The term *contraband* became the nomenclature for African Americans fleeing the slavery of the Confederacy, many of whom sought refuge in Union army camps during the Civil War. For myriads who undertook this dangerous journey, the Tennessee River near Chattanooga coursed between the slaveholding South and the protection of the Union army site called "Camp Contraband." While *Deep River* speaks directly to fugitive crossings near Chattanooga, it presents an amalgamation of histories and migrant stories expressly intended to transcend time and place. Beyond history, *Deep River* honors the magnitude of the exodus; it is a meditation on faith, vision, courage, and determination to be free.

One experiences *Deep River*, created as a site-specific installation for the Hunter Museum of American Art in Chattanooga, through spatial and aural immersion.[17] Entering, one crosses over an invisible but palpable threshold, from the space of the "art gallery" into the alternate terrain of the installation. As though in a waking dream, attributes of the everyday secular world dissolve in *Deep River's* embrace. The sensation of difference in aroma, sound, and illumination is immediate. The installation's arrangement is theatrical, like an arena stage; the gallery interior is dim, requiring a momentary pause for ocular adjustment. A long, broad, elliptical earthen mound that releases a rich organic odor provides focus and an axis for the central installation. Placed near

and spiraling out from around the mound are several wooden disks—or tondos—of varying sizes, each with a beautifully rendered, tonal drawing of a man or woman. Used since antiquity, and popularized in fifteenth-century Italy, circular paintings and sculptural reliefs became archetypal forms for commemorative portraiture and holy figures.[18] Alternating in scale and position, the tondos delineate an invisible but traceable path that moves from the mound outward, into the expanse of the installation, wrapping around again and then again. In Lovell's installation the tondos seem commemorative, if not holy, and their collective presence seems congregational. The orientation of the disks are all different, as though the "wheels" were spinning, rolling, or tumbling. The effect is that of turmoil, destabilization brought on by the precariousness of the lives of those depicted, their treacherous journey through history.

There are fifty-six tondos, ranging from ten to seventy-eight inches in diameter; the largest—life-size—are of three-quarter and full-length figures; the smaller ones have single countenances and bust-length images. Working from a range of vintage black-and-white photographs—tintypes, cabinet cards, and ID photos—Lovell reincarnates his figures with loving attention to detail and nuance. No figure appears twice; the comportment, expression, dress, hairstyle, and gaze of those depicted are both distinctive and individualized. Drawn on and seemingly into the wooden rounds, the individual likenesses appear embodied. The tondos bearing Lovell's drawings double as sculptures, mapping the space. The refracted, flickering light of Lovell's projections—rippling water imagery that transforms the gallery walls into scrims—further modulates the appearance of the tondo drawings.

Through its arrangement, Deep River allows for an intimate engagement with the objects contained in it; viewers witness at close range the dexterity of the artist who has, with charcoal, breathed life into his source images. Arranged purposefully around the mound, with male and female figures alternating, the tondos suggest a sequence of viewing and of experience, a method of circumnavigation. Viewers enter into the mise-en-scène and glance left, right, across, and around, just as Lovell's figures do. The viewing is synergistic and reciprocal; entering the core of Deep River thrusts one into the space and conversation of the figures that encircle the earthen mound that symbolizes Camp Contraband.

In many ways Deep River operates as the Kin works do, individually and collectively, albeit on a more expansive scale. Inspired and underpinned by tangible histories, its metaphorical and chronologic scale precludes containment by a single narrative or place. As with much of Lovell's work, an artful unruliness, a refusal of tidy references, allows it to hover above both chronicle and narrative while it borrows liberally from recorded histories across time and place. As an artist who draws inspiration from the past and its material culture, Lovell does not set out to teach us history, but the subjects and objects he brings together encourage us to deepen our knowledge of history and culture.

With the Kin series, each work becomes a contained ensemble, a reliquary of sorts, which petitions our senses. The drawn image and its corollary—a sharp edge, a pointed needle, the sole of an old shoe, a spigot, an alarm, a pearl necklace, a parenthetical title—invite us to imagine. "No one knows where we go when we're dead or when we're dreaming" as the secondary title for Kin XIV, 2009, says. Like the invented letter inspired by Kin LVIII (Heaven), Lovell's Kin cultivate our mind and enchant our eye. The proscenium wall is stripped away and we are invited inside, to suspend clock time and linger with the artist and his imagination.

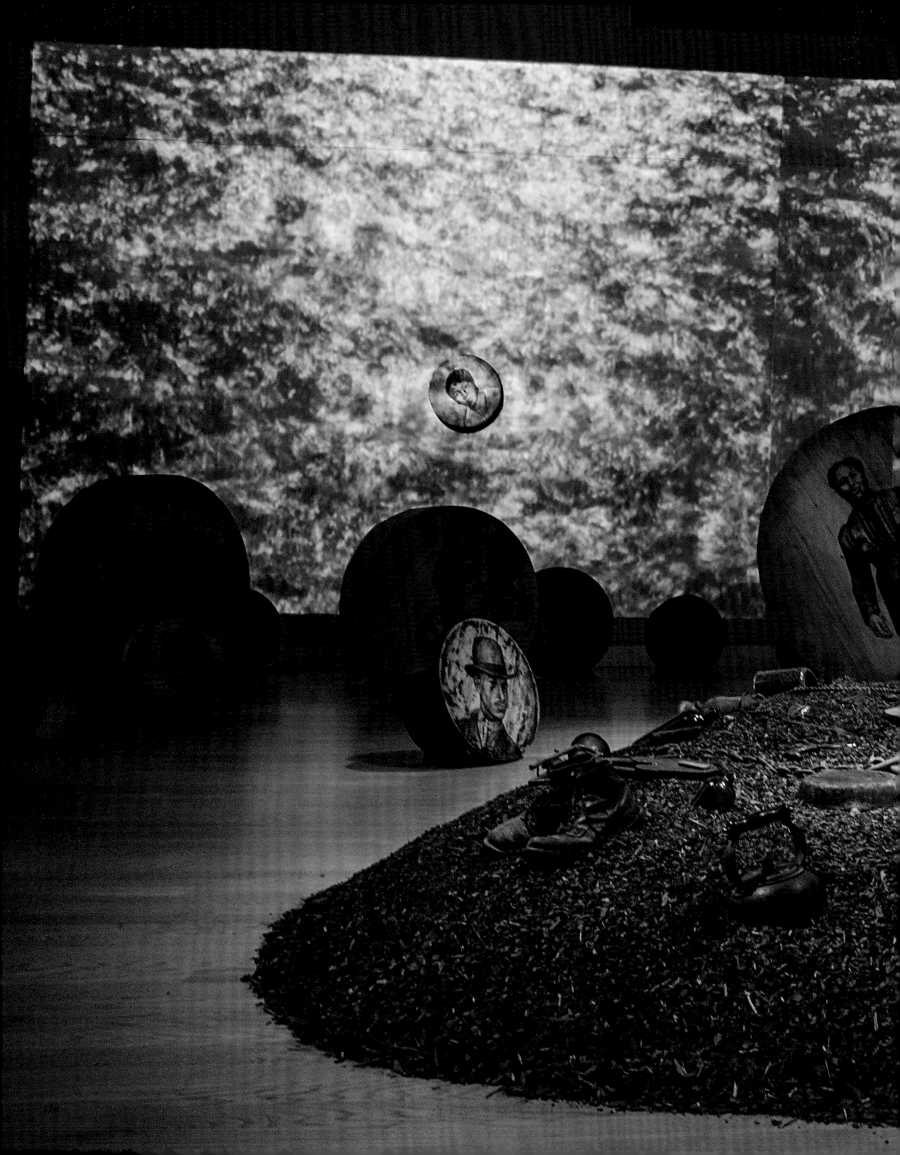

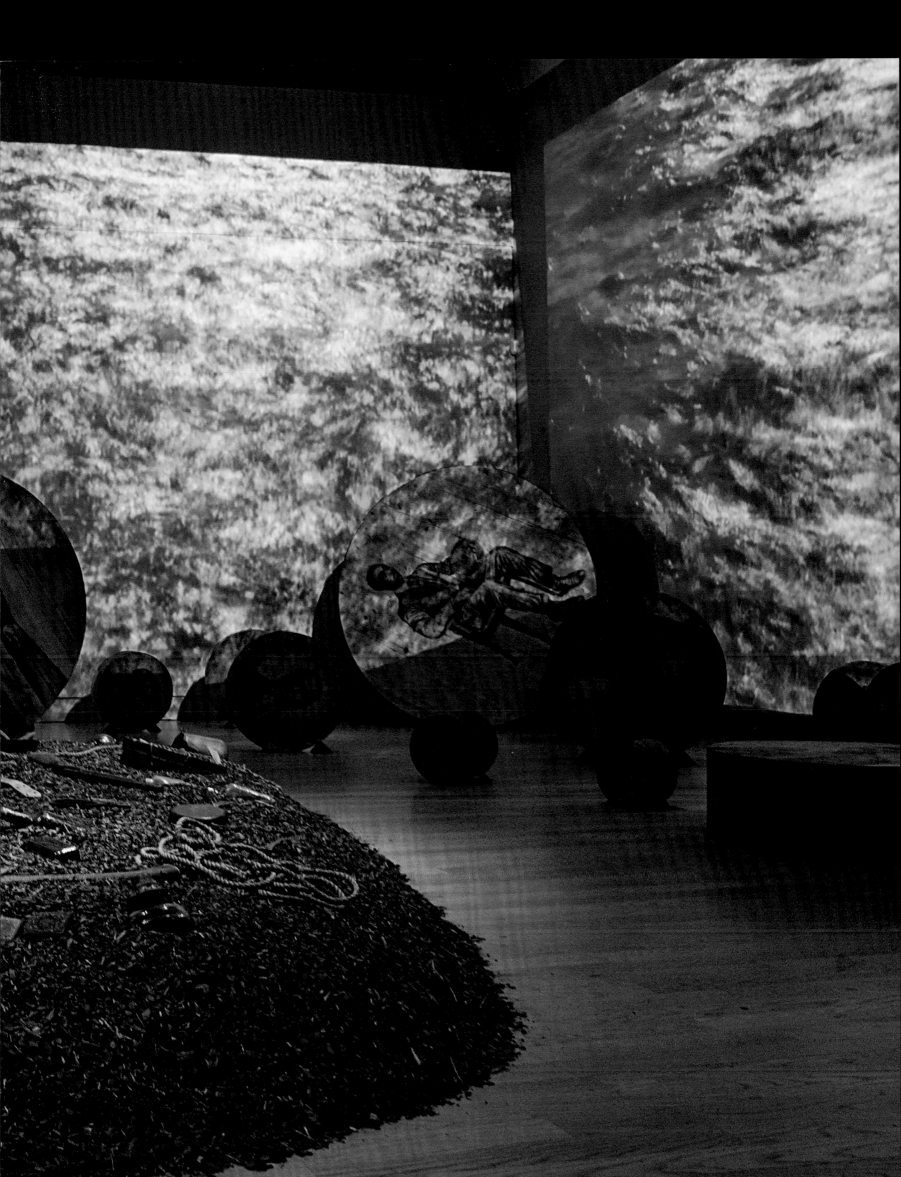

Deep River, 2013.
Installation view (detail
with curtain, suitcases)

1 For extended remarks on the Kin series see Julie L. McGee, "Whitfield Lovell: Autour Du Monde," Nka Journal of Contemporary Art 26 (Spring 2010),: 54–59.

2 As perceptual psychologist Rudolf Arnheim noted, "visual perception is not a passive recording of stimulus material but an active concern of the mind." Visual Thinking (Berkeley: University of California Press, 1969), 37.

3 English translation from The Universal Edition score of 1911 for Das Lied von der Erde.

4 Stendhal is the pseudonym of French author Marie-Henri Beyle (1783–1842). The novel is a historical satire on monarchic life—the French social order under the Bourbon Restoration (1814–30). Its protagonist, Julien Sorel, seeks social and psychological advancement from his rural working-class status.

5 Pierre H. Dubé, "Reflections on Chapter Titles in Le Rouge Et Le Noir," Dalhousie French Studies 30 (1995): 45–54, Patrick Pollard, "Colour Symbolism in 'Le Rouge et le Noir'," The Modern Language Review 76, no. 2 (1981)

6 Tom Otterness, "Whitfield Lovell" in the section "Art: Artists on Artists," Bomb 91 (Spring 2005).

7 The photo appeared in the Bomb magazine essay by Tom Otterness.

8 Whispers from the Walls, created during a residency at the University of North Texas Art Gallery in Denton during spring of 1999, was Lovell's fourth major installation. Others include Visitation: The Richmond Project, 2001, at Hand Workshop Art Center in Richmond, Virginia; SANCTUARY: The Great Dismal Swamp, 2002, at the Contemporary Art Center of Virginia in Virginia Beach; Grace: A Project by Whitfield Lovell, 2003, at the Bronx Museum of the Arts in New York City; and Deep River, 2013, at the Hunter Museum of American Art in Chattanooga, Tennessee.

9 Lucy Lippard in The Art of Whitfield Lovell: Whispers from the Walls (San Francisco: Pomegranate Press, 2003), 14.

10 Whitfield Lovell, communication with the author, April 17, 2016.

11 See for example: Bliss, 1999; Restoreth, 2001; Whispers from the Walls, 1999; Visitation: The Richmond Project, 2001.

12 For an extended discussion of this work see McGee, "Whitfield Lovell: Autour Du Monde."

13 Whitfield Lovell in The Art of Whitfield Lovell: Whispers from the Walls, 121.

14 "For 250 years prior to the Civil War...it was also a protective refuge for marginalized individuals, including Native Americans, African-American maroons, free African Americans, and outcast Europeans." See recent research of Daniel O. Sayers, A Desolate Place for a Defiant People: The Archaeology of Maroons, Indigenous Americans, and Enslaved Laborers in the Great Dismal Swamp (Gainesville: University Press of Florida, 2014).

15 Lovell in The Art of Whitfield Lovell: Whispers from the Walls, 121.

16 For his installation, Lovell invited mezzo-soprano artist Alicia Hall Moran to sing "Deep River." Moran's great-great-uncle was Hall Johnson (1888–1970), a legendary composer and arranger like H. T. Burleigh, whose work adapted and preserved the spirituals for contemporary audiences. Moran sangs "Deep River" without instrumentation and provided two vocal adaptations, one rather intimate and another befitting a concert hall; two additional versions were created, both audio enhancements of Moran's originals.

17 At the Hunter Museum of American Art, Deep River was installed in a large gallery adjacent to a smaller entry gallery exhibiting a selection of Lovell's tableaux, such at Autour Du Monde, 2008, and Pago Pago, 2008, a few assemblages, and eleven works from the artist's extensive Kin series.

18 The round wooden disks used by Lovell in Deep River first appeared in his exhibited work Visitation: The Richmond Project, 2001, for the Hand Workshop Art Center in Richmond, Virginia.

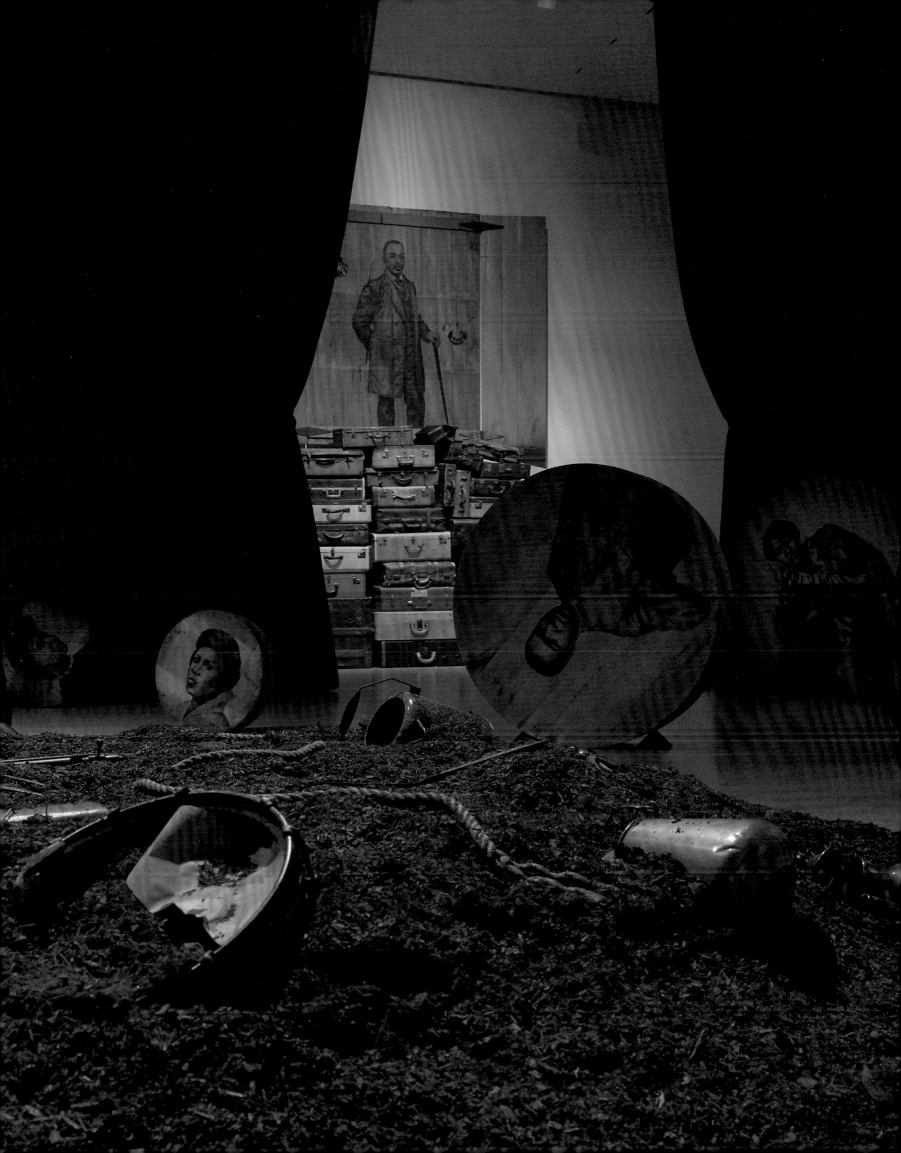

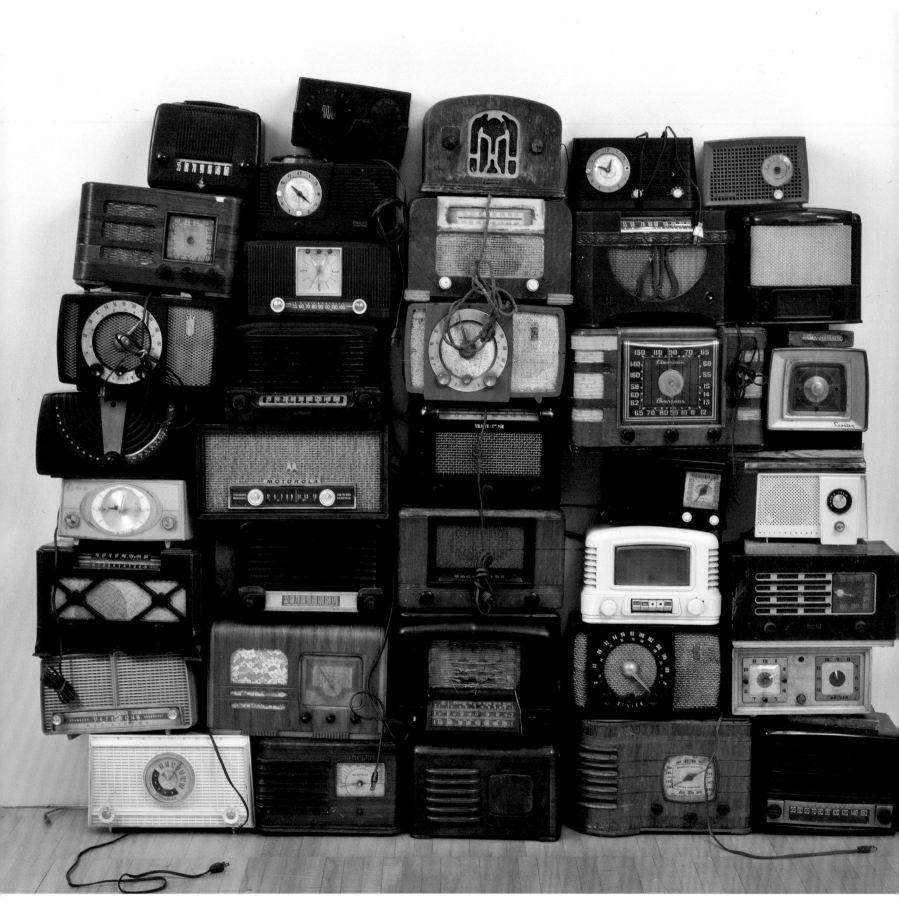

After an Afternoon

Whitfield Lovell in Conversation with Julie L. McGee

This conversation between artist Whitfield Lovell and art historian and curator Julie L. McGee began in September 2010 and continued into the spring of 2011; several passages have been updated. The first meeting was in the artist's studio, on a late afternoon. The day was crisp—the beginning of autumn—and the conversation easy; the quiet, reflective moments were punctuated by ambient sounds and instrumental and vocal melodies emanating from the artist's stereo. It was precisely the kind of moment suggested by Lovell's installation *After an Afternoon*, 2008 (opposite), and embodied by the *Kin* series: one of *longue durée*, of slowly moving historical time and plural temporalities. Masterfully and lovingly orchestrated, Lovell's *Kin* series brings union to disparate histories, voices, and likenesses, constructing family across time and place.

Julie McGee: It was some time ago, when we first sat down for a long afternoon chat about the *Kin* series. The series has grown considerably, not only in number, but in its significance to your oeuvre. When you consider this body of work now, what are your overriding thoughts?

Whitfield Lovell: It has been a labor of love and a pivotal point in the journey.

JM: I can certainly see that. I have followed your work and witnessed aspects of your development since 1989, when we first began corresponding. At that time I was interested in your large oil-stick drawings on paper, such as *Tree* [1989; p. 185]. Since that time, though, you have been doing installations, freestanding tableaux, working with found objects, and drawing on rough, wooden planks. The *Kin* series has a different physical feel and a more delicate approach. What made you decide to begin the *Kin* series?

WL: I never planned to do the *Kin* series. Much like most of what I do, the series began and evolved by accident. I think a series begins when you do something peripheral that is outside of your own box and it makes you stop and think about examining what works about it, and you want to investigate the experience further. *Kin I (Our Folks)* [2008; p. 27] was one of those experiences for me. I was so taken with the face of that young boy in the photo that I just wanted to capture the emotion. I didn't know why, but I wanted to make a drawing that communicated as much feeling as the photo I was looking at. So it became important to do the drawing on paper, because that amount of detail is impossible on wood, or on any scale smaller than life-size.

JM: In the *Kin* series your source material is different from your usual cabinet cards and tintypes, seminal for such works as *Shine* [2000], or *Autour Du Monde* [2008; pp. 204–5].

WL: Yes. The images of the *Kin* series are from ID photos. They are close-up headshots that have a kind of rawness because the purpose of taking them was very different from the usual studio portraits I work from. Studio portraits were created, posed, and often retouched for the pleasure and posterity of the sitter. ID photos were taken for the purpose of establishing one's identity. A person in an ID photo is not able to powder their nose first, or otherwise present themselves in a way that they would want to be seen.

JM: What do you mean, "ID photos"?

WL: Some are from passport photos, some are work IDs, and some are mug shots—like police mug shots. They were different because the people were more harshly lit, not made up, and the photos were not retouched. Some of the images are photo-booth pictures, but these fall in a different category. They are photographs that individuals elected to make, taken for their own pleasure or other reasons. However, the harsh lighting and the lack of a photographer's eye made them so unique and exposed other aspects of the subject so much more.

JM: How do these things end up on the market?

WL: There are photo dealers, ephemera dealers, and antiques dealers who will sell anything. Anything you leave behind, or

cast aside, can end up on the market—love letters, immigration and work papers, ledger books, and canceled checks. People do enjoy collecting little snippets of lives. If celebrities wrote the letters, they can sell for lots of cash, or if they were by ordinary people, then any of us can have at them. Someone gets their hands on it, sees a market for it, and puts it out there. I've seen some incredible things that are so personal it doesn't seem as though we should be looking at them—such as postmortem and forensic crime scene documentation, nude medical photographs of soldiers taken by army doctors…

JM: Does this quality of being left behind, something so familiar, or personal, affect your relationship to the object?

WL: Well, in a way…It makes it seem that much more urgent to get the story told, but at the same time, the urgency is to humanize the subject—to respect someone's moment of pain or difficulty without judgment. If someone's image is being used in art, there should be a reason that goes beyond the material or the commercial.

JM: Besides the visual differences between the ID photographs and studio portrait photographs, there are obvious differences in connotative meanings. Do you think about the photographs differently?

WL: No, I don't. I started using mug shots a long time ago because it's rare to find a profile image in vintage photographs and I love working with profiles. In terms of my body of work, anytime you find a profile, the chances are that image came from a mug shot. The fact that the person photographed may have committed a criminal act doesn't influence my attitude towards that person, and certainly doesn't influence the direction the artwork takes. That is the most important point and the most instructive point. There is an assumption of guilt that is unfair to the sitter, and tends to create a wow factor when people learn the source. I anticipated that the knowledge that some of the *Kin* works were from mug shots would overshadow what is there in the artwork, so initially I decided not to tell people they were developed from mug shots. People say things like, "Oh, she has such a nice face, I wonder what she did," which is not the point, and not how I want anyone to approach my work. After several of the works were completed, I realized there was no point in holding back the truth. The source material is part of the work, and so that would just have to become part of the dialogue.

JM: The *Kin* series is not about erasure of misdeeds or the rehabilitation of the individuals who have been photographed institutionally. But they are nonetheless reconstituted therein. Do you view the *Kin* series as providing a resurrection of sorts? You do give a new life to what was once captured by a camera.

WL: I wanted to capture what was beautiful, and endearing, and enduring about these faces. With each drawing, it was important to capture, not so much an exact likeness, but the essence of the sitter's countenance. So in a sense I am seeing them as they appear on the exterior, yet because their self-image, and if I may say, their inner being, is so compromised, it is important to catch that also. In short, one can appear to be a total beast on the outside, and be the most tender and exquisite soul on the interior! The reverse is so as well. That fascinates me. I think it is one of the great tragedies in terms of how we treat one another, how we negotiate, and trust and accept.

I was looking for the qualities that make us human, regardless of how we behave. A facial expression; the smirk that says, "I'm discontented" or "I'm angry"; or the turn up at the edge of a lip that says, "I am confident and in control of this situation." Whatever common emotion I could recognize was what made them more like real people, and I saw myself in them.

JM: As you mentioned, the series begins with *Kin I (Our Folks)* [2008]. Is "Our Folks" a specific reference, more generic, or both particular and broad at the same time? I have found various historic usages, some playful and others quite profound. At least since the eighteenth century, the word "folks" has had a colloquial usage, as in "people of one's family."[1]

WL: I had no idea that this expression was so widely used. I had only heard it from individuals such as my grandmother and her "people." I went back and forth between "Our Folks," "Kinfolk," and "Our People." I wanted to set the tone for the series. "Our Folks" was often used to lovingly refer to cousins and other such blood relations, and sometimes used to reference black people in general. Sometimes peculiar attributes that might be considered particular to African Americans would be summed up as "Well, those are our folks." I suppose that I never heard any others outside of the African American community use such an expression because it would not have been addressed to me if they had.

JM: Let's talk about some of your other individual titles.

Tree, 1989. Oil stick
and charcoal on paper;
69 x 50 inches. Collection
of P. Bruce Marine and
Donald Hardy

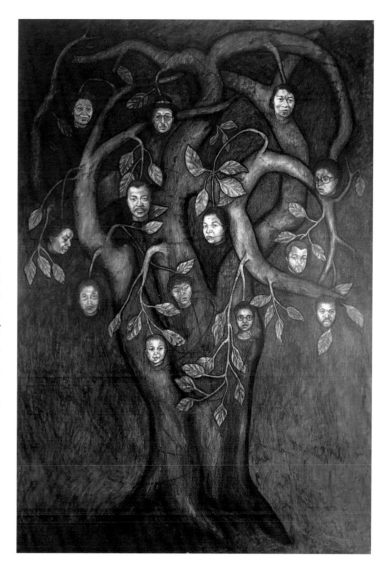

WL: The title for *Kin II* (*Oh Damballa*) [2008] came from a Nina Simone song that always intrigued me because of the strong Voodoo imagery it suggests. Upon completing the work, the name of the song seemed to stick. Later, I was totally excited when I researched the song's title and learned that it was the name of a serpent deity. The placement of the flags happened before the title, and so it seemed to be a lucky accident that the title was such a perfect fit. I am a believer in the idea that a higher power (the muses?) sometimes hovers around to make sure these loose ends fall into place!

JM: How does the titling process evolve—while you are working on the drawing, when you are collecting vintage objects, once the pairing [of drawings and objects] has been decided?

WL: Any of the above, depending on the situation.

JM: You tend to assign titles that defy literal interpretations of the works.

WL: I have always hated titling. People tend to rely too much on titles to tell them what to look for in an artwork. The *Kin* series has been the most fun I've ever had titling because I was freer with the titles. That is why I used Roman numerals to identify the works, and then I added the various words and phrases, in parentheses, to "name" them but not explain them, or give clues to the meanings of the works. I say they are names in that they "fit" the pieces, like "Whitfield" fits me and "Julie" suits you. But if you name a person "Rose," that doesn't mean that she, the girl, is a rose—it is her name. She might be like a rose, the name may otherwise suit her personality, but it is not the answer to what she is or *who* she is inside.

JM: Why did you use parentheses instead of colons in your titles?

WL: I felt the parentheses somehow made the phrase seem less like a title and more like a poetic attachment that complements the artwork. I didn't want them to be viewed as titles to be read in literal terms. In fact I dread literal interpretations most of the time. That can be so limiting...

JM: Many of the *Kin* series works refer to music, vocal or otherwise melodic.

WL: At times a musical title or a song lyric might work well as the title of an artwork, for various reasons. I might be drawing similarities between the emotion and subject of a song. Also, it could be that I'm intrigued by the metaphors and associations that a particular phrase suggests when used as a title.

JM: Can you talk a bit about how music comes into the works for you?

WL: Music is very important to me. I once aspired to be a musician. I studied voice and piano and also wrote music. So my practice of making things is naturally open to engaging with music and making connections between the two. I think musicians, visual artists, and poets are all in the same boat, working with art forms that are intrinsically related and feeding off one another.

Sometimes I use actual sound, such as recorded music, in many of my artworks and installations, where the sound emanates from vintage radios or gramophone horns. But I'm always inspired by the music I listen to while I'm working.

JM: You favor female vocalists, I think. Is there any reason for this that you have been able to pinpoint?

WL: Well, women tend to have such incredible range, both vocally and emotionally, and no fear of using it. But I also like male voices at times, especially deep, rich baritones. I love instruments as well, like solo viola or piano.

JM: You have always loved jazz and blues and your early musical studies and abilities certainly naturalize music for you. It is never distant; it is perhaps always already there, in your mind, in your emotional makeup, in your work in nonvisible ways.

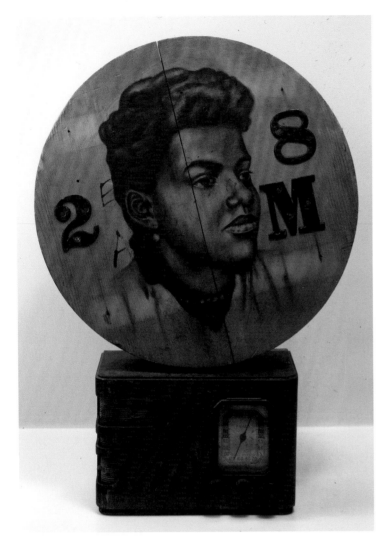

Left: **2 8 M,** 2008.
Conté on wood, radio;
27 x 18 1/2 x 8 inches

Right: **All Things in
Time,** 2001. Charcoal and
gouache on wood, found
objects; 81 x 56 1/2 inches

WL: Nina Simone and Billie Holiday are my favorite artists, but I have very eclectic taste in music. I listen to everything from Son House to Brahms, from Mercedes Sosa to show tunes. [When I was] growing up, my parents listened to jazz and supper club music; my grandparents loved gospel and blues; while one of my cousins introduced me to classical and opera. My West Indian relatives also played calypso, and Latin American music was heard regularly in our neighborhood. All of this crept into my consciousness as a child, and so having an ear for music of all kinds comes easily to me.

JM: Were there or are there any traditions with regard to music in your family history?

WL: Oh, yes, we sang together, as most families do...but dancing was the big deal. At holiday gatherings after a big meal, the tables were moved to clear the room for dancing. It was referred to as "shaking down the food." And everyone was expected to participate, from the toddlers to the elderly grandparents! That's where I learned to dance to calypso, Latin, Motown, the Twist and the Limbo.

JM: Does your family still dance together?

WL: No, that was another of those customs that fell by the wayside when the elders grew too old. Each generation knows fewer and fewer of those familiar things people brought from "down home." It also seems my generation is the last to have close-knit

cousins. Over the years people got acclimated and they stopped clinging to their kinfolk as much.

JM: Can we talk for a moment about community and kinfolk? You have a very close-knit family and you seem very much to be rooted to each other's lives. Can you talk about your family history a bit?

WL: Both sets of grandparents migrated to Harlem, in New York City, in the late 1920s. My mother's folks were farmers from rural South Carolina. They were very modest and practical people. They were also very quiet and decent. My father's father was a businessman from Barbados who was into real estate. He owned a small hot sauce company and a candy store. That side of the family was equally decent, yet driven to succeed in very different ways. They were all very spiritual, and very much into family. They clung to those relations who had moved up north also. Their cousins and in-laws were their friends, or the people they hung out with in their evenings and weekends. Their neighbors became their extended families.

JM: In *Create Dangerously,* Haitian American writer Edwidge Danticat describes seminal touchstone events that feed and nurture her artistically. She wrote: "All artists...have several stories—one might call them creation myths—that haunt and obsess them."[2] Do you?

WL: In that regard I would have to say my raison d'être would be the losses of my sister and grandfather, but more importantly, the fact that I had them in my life before we lost them. I was nineteen when my sister Reva passed away from a rare illness at twenty-two. I had never before that known anyone who died, and as you can imagine, the void was profound.

My mother showed me a sheer white gown she had bought to have my sister dressed in. It looked like an angel's robe, and I couldn't bear to view her dressed in it. My younger sister Yonna, who had just turned six, did view Reva's body, and soon after announced she wanted to be an undertaker, because the undertakers had cared for and presented Reva so well.[3] When I was twenty-four, my grandfather was killed in a mugging. Ironically, his brother had been murdered fifty years earlier.

JM: Does that play a role in the incorporation of guns and knives—elements of violence—in some of your work?

WL: Yes. Every target, every bull's-eye, every gun and knife holds a personal resonance for me, although I am rarely thinking of or

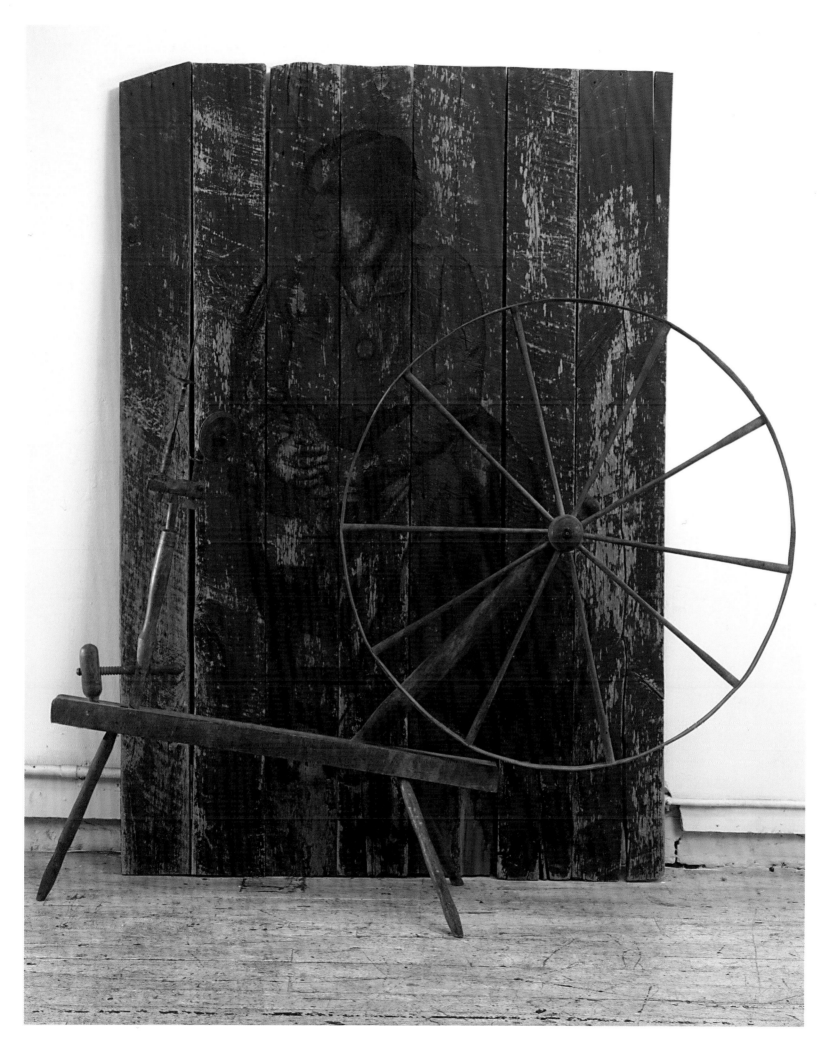

reliving those losses, but rather using these [objects] as symbols for the losses of everyone, the violence we perpetrate upon our fellow human beings, be it physical or verbal, political or psychological. We are always, as a society, throwing darts, aiming bombs and missiles at one another, and using people as target practice. The urgency to make good our time here is lost on most of us.

One thing I think about all the time these days is the fact that people are the glue. We love, we hate, we move on, but our time here is so temporary. As we contemplate history and marvel at what and who came before us, it won't be long before everyone here is gone, and there is another crop of people making drama, dancing the jig, and marveling over whatever you and I managed to get done while we were here. It makes the urgency to race against time and make a mark or figure it out so that whatever we came here to do, should we figure that out, is done right.

My family has seen many, many, relatives die off over the years. The clan has actually dwindled down quite a bit. But having had the opportunity to know all of those great people and call them family even for a time was a real privilege and a blessing. So perhaps I'm working through a need to recreate or reevaluate what family is. I never tire of finding new faces that call out to me. What inspires you to do something, what gives you a reason to go into the studio has to be the love of life, or of color or the sheer pleasure of the smell of wood and paint. But I do believe it is about love.

JM: You have also traveled extensively outside the United States and these experiences resurface in your work; you cross borders emotionally and physically and allow your work to do so as well, though it remains rooted to your own sensibilities, references, and blackness perhaps?

WL: Well, my human-ness. My background, my culture is a given, and my work always refers to who I am, but emotion is human and universal.

JM: It would be stating the obvious to note that you select, work with, and respond to imagery and histories that are most notably black and African American and from a very particular period of time: 1850 to 1950. The kith and kin of your work are black, like you.

WL: It's natural for me, as an African American, to make art of black people. If I were Chinese, I would probably be depicting Chinese people. If I were a white artist, most likely my works would depict white people. I'm just trying to make good art. That is my agenda. I didn't choose the "black experience" as the basis of my oeuvre any more than I chose the very race I was born into. The art comes out of your pores, and my pores happen to be black.

JM: If you were a white artist working with white imagery, this fact and indeed "whiteness" itself might remain under-theorized and historicized, or viewed as otherwise normative. But as a black artist, you bear extra burdens that can easily overshadow the aesthetics, efficacy, and meaning of the individual works of art...

WL: Yes, it's true that the art is constantly viewed through the "racial filter." It is a cross to bear, as my grandmother used to say. I find myself always having to comment on being black in America, or being a black artist. People want to know—if it is "of," "for," "by," and "about" black folks—then how does it relate to them? It's a burden, and it is very tiring.

As far as the normalcy of "whiteness," I have to say that not everything evolves around whiteness. In fact, I decided long ago that I was not going to expend my artistic energy trying to show white people that we are the same or as good as they are, or our art is as universal as theirs. After all, if there is such urgency to survive and make a statement about the human experience based on the here and the now, there is no time to try and convert anyone to thinking the way I do!

Being an artist of color brings on many issues, but it is also a blessing to have a rich and dignified heritage, and I get my material, as well as my genes, from there. In the end, we are all in the same boat. In spite of our racial, cultural, and religious differences, there are many similarities and parallels as well. If I could find a way to make everyone realize this, I would probably be canonized while I am still alive! (laughs)

JM: In terms of transgressing boundaries, a number of your titles in the Kin series are in other languages, such as Kin XII (Fakarouni) [2008], Kin XXII (Chove Chuva) [2008], Kin XXVI (Adorada) [2008].

WL: I sometimes use non-English titles because the words feel more expressive, sensual, and poetic. Fakarouni, for example, is taken from a song sung by Egyptian vocalist Oum Kolthum, meaning, "I remember" or "it reminds me." That work evoked, or reminded me, of the song.[4]

A 79 year old retired bronx man who had just cashed his social security check, was robbed and fatally shot yesterday while trying to fight off a mugging at the door of his apartment building in the East Tremont section, police said.

Eugene Glover of Crotona Park North, died in St. Barnabas Hospital after surgery for removal of a bullet from his left side... Police said Glover had left his wife, Mary, in their first floor apartment at 10:30 ... and walked about five blocks to a bank, where he cashed his social security check and one or more other checks for a total of $569. With the money in his pocket Glover walked back to his building and was in the foyer, entering a second door when he was grabbed by one or two according to cops, Glover apparently put up a struggle and was shot once, police said. One or possibly two muggers fled with the money. Glover's wife, and some neighbors went with him to the hospital, where he died at 2:55 p.m. Byron Hartley, 19, a high school student and a resident of Glover's building said he "was a nice quiet man who liked to take long walks in the park, who used to talk about ... Gladys Lovell, the victim's daughter and his three grandchildren called "Pop" as he was affectionately called, "was a strong and elegant man — he was always willing to help people — he was everyone. He was the patriarch of the family.

189

JM: There are some great clips of her singing on YouTube. What I find truly compelling is your use and rendering of the headscarf, suggestive of modesty and undisclosed beauty.

WL: Yes, but also I often use non-English titles to broaden the scope of reference. Using titles that take us outside the United States further underscores my desire to show that emotion is not national or bound by language. Other things outside of blues tunes and spirituals have relevance and poignancy when juxtaposed and cross-pollinated. A title derived from another culture, country, or language can convey the same, or stronger, emotional statement.

JM: You have said that Akira Kurosawa's film *Rashomon*, with its overlays of disparate music, story line, and chronological references inspired you to cross boundaries.

WL: There's a particular scene in *Rashomon* that is very powerful. During the part when the woman is telling her version of the crime of her rape, she describes looking at her husband, who witnessed it, and at the height of her fear and anxiety a bolero starts to play.[5] Kurosawa used it here in a scene depicting feudal Japan, and the combination of this music that is so clearly of another time, culture, and continent really set the scene off and gave it an incredible edge. It makes one hyperaware that something really powerful and meaningful is happening. It was like, what if you put some Wagner soundtracks over Oscar Micheaux's footage? Or, conversely, what if we heard Lead Belly in relation to Jane Eyre, or legong music with Shakespeare? But it has to be the right footage and the right musical choice; you can't just slap any soundtrack over it and expect it to work. Just like the objects I put with my drawings, it either clicks or it doesn't.

JM: At first Kurosawa himself thought the bolero might not work, that the scene and the music were at odds with each other. But then he described the moment when it all "clicked":

> We kept going. The bolero music rose yet again, and suddenly picture and sound fell into perfect unison. The mood created was positively eerie. I felt an icy chill run down my spine, and unwittingly I turned to Hayasaka. He was looking at me. His face was pale, and I saw that he was shuddering with the same eerie emotion I felt. From that point on, sound and image proceeded with incredible speed to surpass even the calculations I had made in my head. The effect was strange and overwhelming.[6]

WL: That juxtaposition really lends such an eerie feeling, because we think at first that something doesn't fit, but it's more because there is something odd about the whole picture, and somehow something new manifests itself.

JM: It challenges notions of what belongs and what does not belong.

WL: I've heard music used as a similar device in other films as well, like John Jacob Niles's tunes in Harmony Korine's *Mister Lonely*. Also, the Middle Eastern music in *Dead Man Walking*.[7]

JM: This idea you are presenting seems key to your working philosophy and to human emotional and sensory experience—that is, we allow for dissonance, for illogic, for contradiction in our emotional, sensory lives. We can cry when the national anthem is played, even though we are disappointed, disenchanted, or alienated by our country, because we understand the desire to love and be loved, fidelity, desire, and belonging. What touches us emotionally extends beyond intellectualized or rationalized history, space, and time. Your work draws directly from this sense of knowing; issues of the heart and soul are not bound by nation, time, or culture.

WL: I think it also speaks to one's point of view, one's perspective, based on one's own location. It's like pulling the cameras away from the close-up and exposing the rest of the world. It's like learning to look through a wide-angle lens.

JM: As with music, you are a film aficionado, and filmic references often find their way into your daily conversations about seminal visual moments and your own work. You introduced me to Charles Burnett's *Killer of Sheep* [1977], an amazing movie, filmed in luminous black and white. The camera angles and the attention to light and shade, the significance of tonal variation to mood and story line, all reminded me very much of the mastery of light and shade evident in your charcoal drawings. Do you feel a kinship with black-and-white film as with black-and-white photographs? In other words, do you think your virtuosity with tonal modeling, pushing the emotive potential of monochrome, is nurtured by film?

WL: Absolutely! We had a black-and-white television until I was in my twenties. There was certainly no lack of color in the Bronx, but I do have vivid memories of everything in "true-life" being translatable into black and white in my father's darkroom, and that made it somehow artistic. Everything was presented in

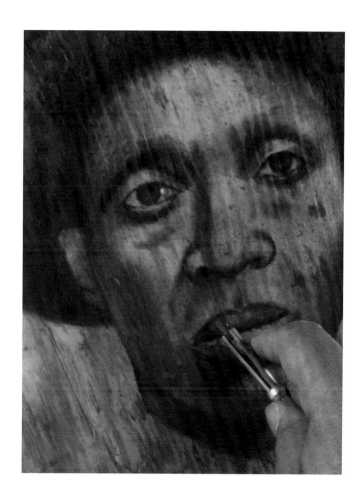

Lovell drawing on wood

lights, darks, and shadows. "True-life" is in color, though. The objects I use are real objects, some which have brilliant color, but they all speak of the tactile and the "touched."

JM: You have noted that your father, as a self-taught photographer, started with black-and-white photography and had his own darkroom. When the market demanded color photography, he followed suit but was never really as satisfied with the results as he was with the black-and-white images. Do you feel your own attraction to shading and monochromic drawing bears a relationship not only to your source material but to this formative, personal visual experience you had in your childhood home?

WL: The first images I ever saw and considered on any aesthetic terms were black-and-white images in my dad's darkroom. I think the switch over to color photography was more of a disappointment to me, in that the film was sent out and prints were made elsewhere. Everything took on a manufactured, generic feeling. Early color was a real problem for self-taught photographers. Unless they were really committed to black-and-white for aesthetic reasons, they had to adjust and learn to shoot in color.

JM: You have long been incorporating found objects into your work, be they tableaux (charcoal on board) or drawings on paper, such as the *Card* series. What motivates your choices in the *Kin* series and how do these choices differ from those you make with the larger tableaux?

WL: Again, I didn't know I would incorporate objects, because I only started out to do a simple Conté drawing. Somehow I felt driven to introduce that garland of flags in *Kin I (Our Folks)*. It brought the piece to life! That was a good turn that seemed to deserve another, and so I simply went with the urge.

JM: Does your work *begin* with a source image—vintage photograph—or with a found object, or is your creative ignition process more fluid, cumulative, and seamless—that is, one without obvious beginnings but continuous selection and execution?

WL: It can happen either way. It is possible for me to be initially inspired by a photo, or an object, or even a song or poem. The number of components in an artwork or an installation is determined by that particular piece. I have to be thoughtful, though, and not rush things to completion. You never know when the right item, or the right idea or connection, will present itself. That is the exciting part of the process for me. I need to be constantly open to whatever penetrates. I'm surrounded by photos

and things and books and sounds. Any object is a potential solution to an unfinished piece. My friends have to guard their belongings!

JM: Speaking of inspiration, I have often felt that there is a somewhat porous boundary between what is your living space, what is your studio space, and the work within. You work amidst those things (and people) that have deep meaning, be they visual, aural, tactile, or sensual in other ways. Your studio is in a loft space that was once a piano factory, right? How do you cross over, from the zone of creation back to the world of the mundane day-to-day activity in such a resonant space?

WL: I don't think I do...in that regard I am always working. I have to be surrounded with things that I love and things that hold meanings and memories. I don't think there is any boundary between my creative and noncreative space. I have been known to use my own dishes, my own bedding, etc., to be nailed or glued onto artworks.

JM: The tangible aspects of the *Kin* series, the drawing and attachment, raise symbolic, formal, and psychological questions. The found objects literally are "attached," they become the objects of the drawn figures. Formally, they "belong" to the final composition, but they don't belong in straightforward narrative ways to the image they accompany.

WL: The objects, the accoutrements, sometimes "own" the figure as well. Depending on what they are, and what kinds of meanings we attach to them, *they* can set the tone for how we should, or could, view the figure. There is one case, the piece called *Kin III (Canto)* [2008; p. 31], which has the bullets...; at first I had

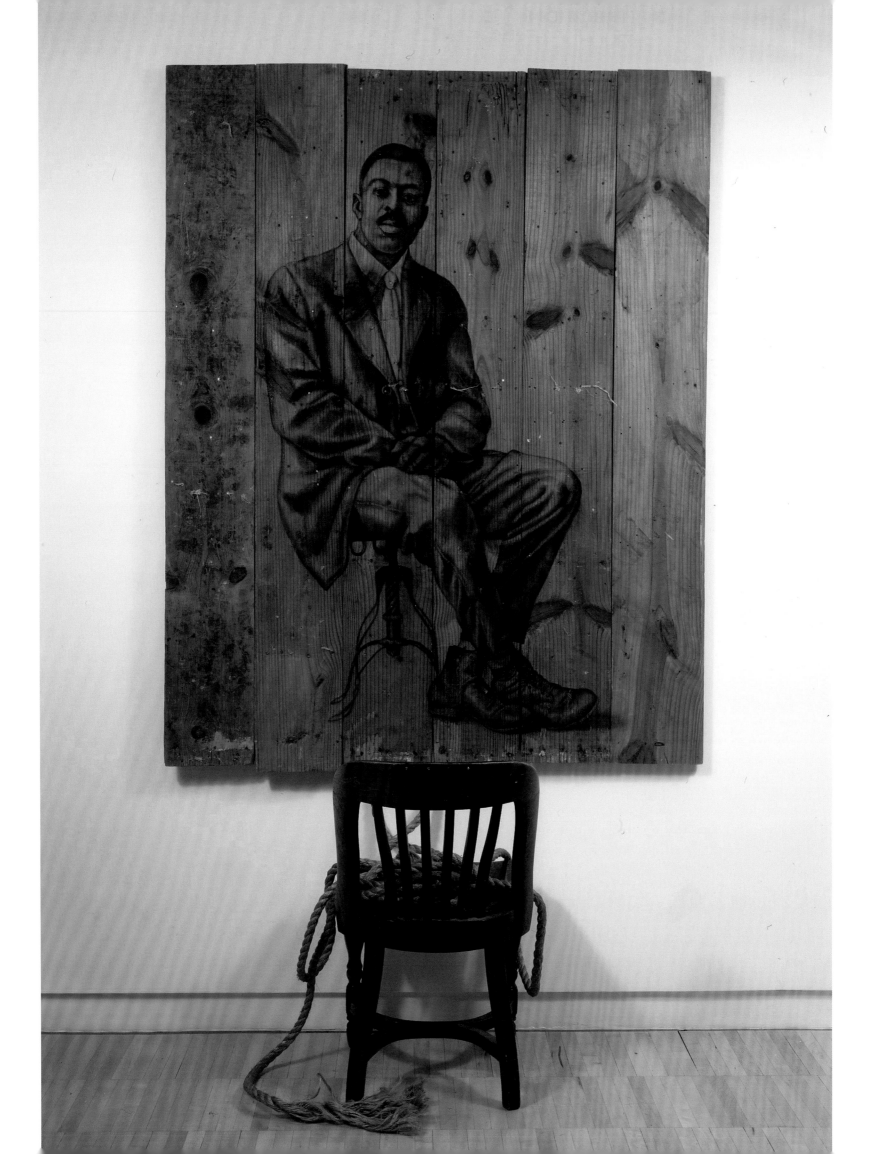

placed a wreath of flowers on that piece, and it was amazing how effeminate and gentle his face became. His expression was almost drag queen–like. Then when I made that sort of necklace of ammunition, by comparison he became very masculine and frightening. He was transformed, empowered, and emboldened. He became the feared, the hunted, the dangerous, embodying the plight of the endangered black male.

The wreath of pink and purple flowers ended up going into *Kin VII (Scent of Magnolia)* [2008; p. 39]. That gentleman has a very crisp and solid profile, and so the flowers seemed to lend a memorial feel rather than speaking to sexual or gender identity. That is one of the meanings I wanted for the flowers. The pairing creates both disruption—a break in potential for a literal narrative reading of the work—and solidity. The object completes the composition.

JM: And that is when the poetry happens. I love the idea of the objects owning the figure; I had not really thought of it in quite this way before.

WL: I can't stress enough the importance of finding the right object. I go to great lengths; it has to feel right. There is this space between image and object that is active and made active by placement and the relationship between the objects and the drawings. I will search high and low; I will wait two or three years before completing something if I have not found the right pairing. The work is not done until the right object is found. It is not something that can be replaced without disrupting the balance...It is like a brushstroke on a canvas. When all the brushstrokes of a painting work together, it is good, but if they don't, it is off.

In one of my tableaux, *Cut* [2008; p. 197], there is a 1940s woman staring off into space with a kind of bitter determination on her face, and an actual axe that floats in close proximity to her face. The placement of the axe was crucial because it was meant to empower the woman. I knew that if the axe were placed higher up over her head, though it might have worked out compositionally, it would have been read as menacingly coming down toward her head, to harm her. I spent hours with an assistant moving the axe up and down, and from place to place so that I could visualize the right spot for it. I chose the axe because I felt it brought out her fierceness—it was as if her eyes could cut you, because she had had enough! Or because she wasn't going to take any stuff!

In the *Kin* series, on the other hand, the objects take on even stronger metaphoric meanings because of the range of objects and textures and the very scale that allows the object to share center stage with the drawings. Many of the objects weave in and out of the picture plane, which in this case is the creamy purity of the pristine paper. The objects all look great against the paper. The paper provides a neutral context for the objects and images to interact with the figures. Each work alludes to its own reality and its own physical place, depending on the object and the placement.

One piece that is interesting in this way is *Kin XI (Play It a Long Time)* [2008; p. 47]. Whereas some would read the man's head as the target being shot at by the toy soldiers, I've always thought of them as shooting at each other and of the man as existing on another plane, calm in the midst of the violence. What I mean by "another plane," which I enjoyed playing with in some of the *Kin* pieces, is: imagine the man's face were a huge drawing in the sand at Nazca, Peru, for example, and the soldiers were visitors to the site of the drawing, perched at their various positions nearby. There is the picture plane, upon which the illusion of the man's image exists, and there is also the physical "paper plane" upon which the sculptural items exist (the space where the action of warfare takes place). The play is with the ambiguity of the space and the illusion within the artwork, the flat and the three-dimensional.

Each *Kin* piece posed a specific challenge in terms of resolving and then adhering the objects. It was important that I listened to each one and I went wherever that piece would take me. Each one resolved itself—like the lemon tree, the brooch in the mouth, the pearl tears, the recessed knife, and the waves of crumpled fabric that fill the artwork like flooding water in *Kin XXXIV (Deep Blue Sea)* [2008; p. 93]. And again, as I said before, I never plan them out, I simply let them develop and follow their leads.

JM: One of the ultimate joys I have in encountering your work is in discovering its orchestration. After being seduced by the rendered image and drawn into the conversation between image and object, one then sees again the whole: the balance between literal and abstract, history and artistry, the exactitude in placement, cadence, visual alliteration or dissonance. Are there any of the *Kin* series works that appear without objects?

Gin Song, 2004. Conté
on wood, found objects,
89 $^1/_2$ x 45 $^1/_2$ x 13 inches.
Pennsylvania Academy
of the Fine Arts, Philadelphia.
Mary W. F. Howe Fund

WL: Yes. *Kin XV* (*Seven Breezes*) [2008; p. 55]. I decided the empty space was the object. There was no need for an actual object there because that particular piece gave off so much raw emotion that the absence of an object was like the silence at the end of a huge epiphany. The unexpected item was the mystery of the absence of an object.

JM: There is amidst the *Kin* series a work that stands out for its more obvious inclusion of "whiteness," *Kin XLVII* (*Rimshot*) [2011; p. 119], in which you have attached an image of a white woman (Miss Venida) in three-quarter view below an exquisite profile image of a bald black man. The contrast is [on the one hand] severe: the woman is all curves, neatly coiffed waves, pearl choker, arched eyebrows, and she is placed just below the severely truncated neck line of the black figure above. But then again, there is a graceful visual alliteration between her curves and the physiognomy, head, neck, mouth of the rendered man and a call-and-response between the tonal gradations within the cardboard advert and the dark and richly shaded male face. As much as there are echoes, there are strong contrasts.

WL: I set up a strong dichotomy at the center of this piece. This is so obvious, and so much a part of our collective subconscious that we tend to submerge, and not acknowledge, that we still have sexual tension between the races. Implied in *Rimshot* is the age-old sexual tension between black men and white women. The "Jungle Fever" syndrome, to borrow a phrase from Spike Lee, and particularly the *Dutchman* issue (to pay homage to Amiri Baraka/LeRoi Jones), which insinuate that the woman's whiteness, which he may have admired and lusted after, or revered over his black female partners, as a result of conditioning, was what led to his own demise. One cannot ignore that these issues are present in this piece. There are also the numbers written across her face, prices: 10 cents, or 2 for 25¢, that could allude to prostitution, or they could allude to the very value of "whiteness," or the "attractiveness" of a person as being a valuable thing; a thing that is "better than," or even gaugeable!

The culture I grew up in placed a lot of importance on marrying well, which focused, though not entirely, on finding mating partners who had whiter features and attributes, such as light skin, straighter hair, and all the rest. Fortunately, this is not as prevalent now as it was back then. Ideally, one day there will be nonracial ways of quantifying the value of one's life, one's im-

portance and relevance! In fact, I think it is dangerous to ignore that these inequities still exist in our society.

Also, I must mention there are issues resulting from this juxtaposition that are not all about race. His head is balanced over hers, and no matter how much we try to equate it with basketball (because of the title), it seems she is supporting him, holding him up. I always say there is more than one way to read something, and that says as much about us as it does about the work.

This is what I love about working with juxtaposing the images and the objects. Everything is loaded, and so when you put them together, sometimes there can be a point where they crash. They explode! I always say, "Hey, I don't make the issues. I just bring them up so that hopefully people start to understand them." The danger is in ignoring our racialized culture, our customs, and the manifestations therein.

JM: I did a bit of hunting for Miss Venida; it seems she was used to advertise hairnets. Now this makes your use of her in *Kin XLVII* (*Rimshot*) really funny!

WL: This is funny, but I really didn't know it was for a hairnet. Your previous observations were more in line with how I was thinking while working on the piece. I liked the word *rimshot* for its musical meaning, a drum stroke in which the stick strikes the rim and the head of the drum simultaneously. It seemed to work for that piece for certain undefined reasons. It reminded me of a sort of "bada bing!"—that is, a sort of acknowledgment of a silent punch line when there has been no joke. After I chose the title, I learned of the basketball meaning. I asked several people what a rimshot is and they all thought it had something to do with basketball, but no one was sure what it was. No one had heard of it as a drumbeat, so I was in such a quandary over whether to call it that or not! I finally decided that even though most would think of basketball first, instead of my main definition that attracted me to the word, the name had to stick, and perhaps there would be other layers implied by the double meanings.

JM: In *Kin XLIII* (*C.P.T.*) [2010; p. 111], what is inside the attached book, *Black Fortune*?

WL: I found the book and the title called out to me so strongly, and I was so engaged with the piece, that I never looked inside.

JM: In her capacity as an academic dean, my sister received an email from a Southern white colleague in which the abbreviation

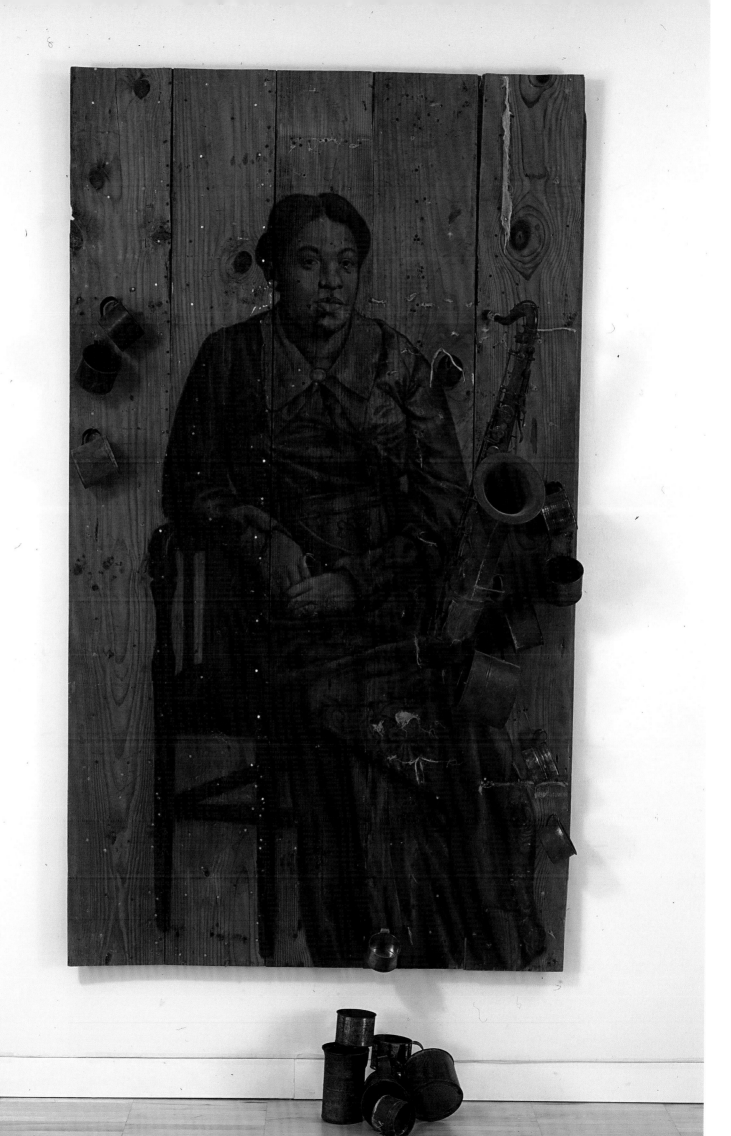

Cut, 2008. Conté and wallpaper on wood, axes, nails; 46 ¹/₂ x 37 x 4 inches

C.P.T. ("Colored People's Time") was used to refer to the working pace of a group of Toni Morrison Society scholars. My sister, who did not know what it meant, was appalled when she found out, and she asked me if I thought C.P.T. was indeed racist and/or was one of those words that only an African American could use without prejudice. Her faculty colleague told her she was using it to be funny and felt entitled to do so.

WL: I don't know about that!

JM: What is your take on C.P.T. usage, by insiders and outsiders?

WL: I never thought of that before because it is an expression I never really appreciated blacks using! I always felt it was just another way that blacks put themselves and one another down. I know many people who have issues with time, and they are not of any particular race. It would certainly be doubly offensive to hear a non–African American say that.

JM: In conjunction with the title of the book *Black Fortune*, it may suggest that black fortune is running on C.P.T.—slowly. What may at first seem funny is rebuked by the poignancy of the rendered image of the woman, as if to say this is closer to truth, not satire.

WL: That is actually very much along the lines of what I was thinking about when I did that work.

JM: You have written about this earlier with regard to the *Card* series:

> A drawn image can sometimes benefit from an element of distraction because of what that distraction can add. The viewer is led to another level that goes beyond the conventions of experiencing portraiture and drawing. Associations that we attach to ordinary objects (as in this case, playing cards) can be as suggestive of narratives as the garments one is wearing, how they style their hair, or the environment one chooses to be portrayed in.

I think this plays out just as powerfully in the *Kin* series, where one has an even wider array of potential associative or disassociative values.

WL: They're also related to the tableaux pieces.

JM: I don't want to make the association too literal or neat, as it were, and confine or curtail the distinctive agency of either the *Kin* series or the *Card* series, but there is certainly a very compelling relationship between them. One might think of the *Kin* series symbolically, as family album cum deck of cards. Certainly, the individual *Kin* images converse and play amongst themselves (as cards do) and not just with the viewer.

WL: The *Kin* series came out of the *Card* series. I had been making these little drawings on tan paper long enough that when I found the photo-booth shot of the *Kin I (Our Folks)* boy, it was natural to bump up the scale and proceed from there. I just wouldn't have started the *Kin* series had I not been working on the *Card* series for so long. Drawing with that degree of detail is not something I would start doing suddenly overnight.

JM: When we first sat down to discuss the *Kin* series, it was ongoing, in medias res, as it were. They had possessed you and you them, and you were not sure how or when the series would come to an end. How many have you completed and has the series concluded in your mind?

WL: I've completed sixty *Kin* works. Although I have since moved on to other projects, there are some newer *Kin* pieces that I've started and hope to complete someday. The *Card* series was meant to have a cap of fifty-two, because I had decided to do the entire deck, and so there would be a logical end to the series. But I enjoyed doing them so much that I was sorry when I got to the end of the deck. Then I started the *Round* series when I came across a great full deck of round playing cards. That gave me an opportunity to make another card series without it being exactly the same as the first series. The round cards also brought up several compositional challenges that hadn't occurred with the rectangular cards. Also, since the first *Card* series had been sold and was dispersed all over the country, I was determined to keep the *Round* series together as a unit. I took five years to complete the whole *Round* series. There are fifty-four of them, including the two jokers.[8]

As far as the *Kin* series ending, I don't know when it will end. As long as I have a desire to make them, I will, and when I lose the desire to make them, then it will end itself naturally.

JM: *Kin XL (Breath)* [2010; p. 105]—there is just so much that this work conjures: the Middle Passage, ancestral voices, souls lost and found at sea, winds of the gods and ungodly that fill the sails of the boats that transported precious cargo as slaves...I have been trying to find the right words to describe the rendered images in the *Kin* series. To call them drawings is to unduly oversimplify or misinterpret the overall effect you give to the images. Can one call something that is so beautifully shaded a drawing? Perhaps it is a kind of Conté painting, as though you

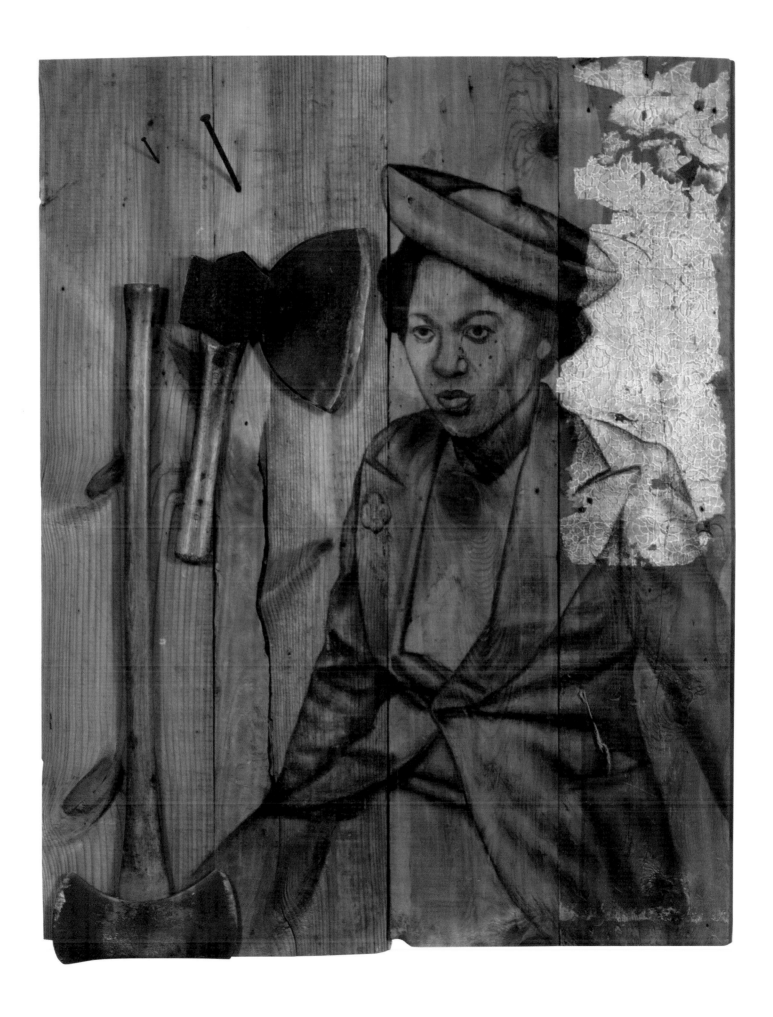

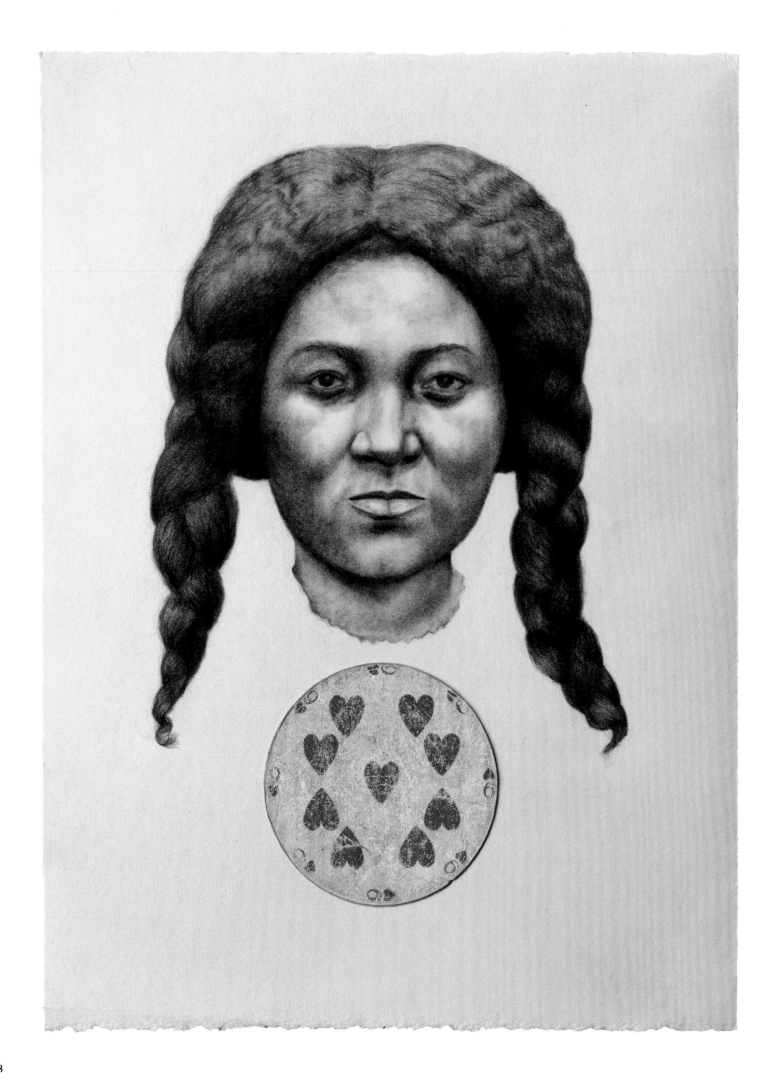

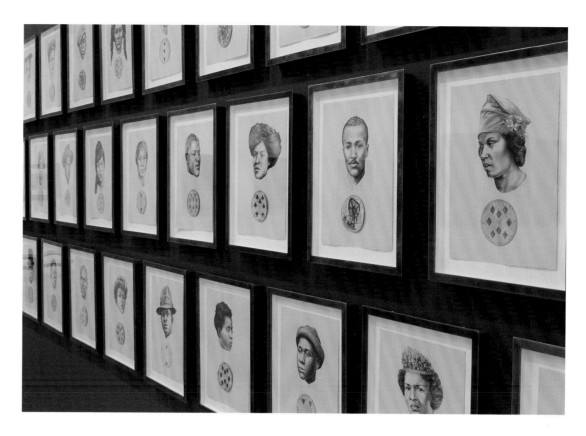

were using cotton balls filled with charcoal to render depth of field, the skin, the fleshy lips. When I had a chance to see more of them at DC Moore Gallery, it struck me how much they were a cross between a photograph and tactile, three-dimensional image. In other words, the rendered image imitates the smoothness of the photographic paper, but renders the image so much more sensuously, and in a way untouched photographs rarely do or can. Mark-making typical of drawing, even the most virtuosic or related to verisimilitude, still has a quality of drawing. Your rendered images seem to have the quality of life breathed into a black-and-white photograph. This aligns them more closely with black-and-white filmic images—animated life.

WL: I have to say that I did not want to make average or ordinary drawings. I wanted them to look as "real" and alive as possible without having a "super-realist" feel. I think being aware of every edge and every nuance of tone is very important, not to mention stepping back and taking it all in to be sure the emotional character is right.

JM: When you developed this method, were you thinking of any particular portrait tradition?

WL: I wasn't thinking of imitating any particular portrait tradition. When I started the *Card* series, the only thing I consciously wanted to do was make the drawings with no lines, just shading delicately. Shortly into the series, I became obsessed with details like threads on a hat, or strands of hair, but with minimal outlining. I really enjoyed that indulgence. By the time the *Kin* drawings happened, with more space on the page and larger heads, I found myself working for hours and hours on surface textures like blemishes and freckles and pores. The skin tones are also very important. I worked with two erasers and two charcoals in each hand.

I agree with you that it is not drawing in its simplest form because I'm removing any evidence of my hand. My process involves a back-and-forth method of adding and subtracting tones and markings that then get rubbed in or scrubbed out. This part was on purpose, because I didn't want these pieces to be *about* drawing.

JM: This leads me to my next question, about portraiture. You have never felt your work properly belonged in the traditional category of portraiture. Why is this?

WL: I don't think of my works as portraits. I think of a portrait as being an artwork whose primary function is to depict a person's physical appearance. According to the dictionary definition of the word, any depiction of a human head or figure can rightfully be referred to as a portrait, yet as far as art-world lingo goes, I feel the word, if used routinely to describe the artworks, can be limiting in terms of the way the viewer can approach the work. There is such an enormous history of portraiture that I believe it doesn't serve the works well to refer to them as such.

I do work from "studio portraits," and I do employ techniques and formats that are born out of traditional portraiture, but I think of my works as artworks and not portraits. Now I kind of cringe when I hear them referred to as portraits because I feel I'm working outside of that realm. Chuck Close said during a public interview at the Ideas Festival in Aspen a couple of years ago that he doesn't think of his works as portraits, but rather paintings of heads. And Philip Glass was quoted as saying that "if you think [Chuck's] work is about a portrait, then you've missed the work."[9]

JM: I can understand your point, that it never really feels right to call them portraits because it is reductive. To call them portraits may cause one to focus on the drawn image only—though, as you note, they too are not portraits in your approach to them. That

said, art historically, the history and tradition of portraiture is expansive, and we even use it for nonrepresentational imagery. This is not to say or convince you to see your works as portraiture, but to perhaps shed light on a quite interesting topic. Early photographic portraiture was clearly informed by the portrait image that was first seen in painting, drawing, or some other medium. So there are some very deep roots to unearth and disentangle. This could be an interesting conversation to have. As you say, photographic portraits may be source material for you, but your work is not portraiture.

I have been contemplating the place of your work within the history of photography, how important it is to this history, not only through your collecting of vintage photographs—and not as salvage work—but additionally the ways in which your work extends our knowledge and desire for knowing earlier forms of photography. For me, the history of photography would be incomplete without a reference to your work or that of other artists for whom photographic source material matters deeply. Does this seem strange to you?

WL: I understand what you're saying. Certainly, a drawing has a kind of impact that a photo doesn't have, especially a tiny tintype or an old faded cabinet card. But if my work may have made more real the lives of the people in those old photographs in the eyes of history, then I would feel really good about that. But that was never something I set out to do. Initially I was just responding to the old studio photographs in my grandmother's albums because they spoke to me and they fed into my interest in history and family. I think we all owe so much to those people who went out to have their pictures taken, and the photographers who posed and shot them. They are the ones who made the most profound contribution by just making the images and leaving them behind. That's why I feel it's important to respect their images, to be careful how they are used. They weren't making them for any grandiose purposes, aside from saying, "This is who I am—this is who I was, and I was here."

JM: Yes, and this is immensely important. As Toni Morrison has said of her fiction: "I am looking to find and expose a truth about the interior life of people who didn't write it (which doesn't mean they didn't have it) . . ."[10] She points therein to crucial distinctions between fact and truth.

WL: The fact that those images now have a new life seems predestined and almost magical in a way. They were like time capsules left out there to be rediscovered one day. No one really looked at them back then. No one really *saw* them for how beautiful and human they were when they were alive. The [possibility] that we would learn from them, muse and mull over these people and who they were, was perhaps always already part of the spiral, part of the plan.

I just love the fact that none of them ever dreamed their image would be picked up and used by an artist and perhaps hang in a museum one day. Never in their wildest imaginations could they have foreseen that when they looked into the lens of that camera. I think about this every time I make an artwork. I also think about it whenever I pose for a photo. You really never know.

JM: You reference here a kind of intangible spiral, or connective tissue, that weaves you and your work to the individuals within the photographs. This relates to what I believe to be seminal themes in your work: concepts of time, space, and spiritual residue; the function of both the act and thingness of memory, or the visual trace in the re-embodiment of past spirits. In the *Kin* series these spirits come to inhabit the space of the paper and thereby our and the viewer's space. The ever present and the always past thus commingle.

In her essay "The Site of Memory," Morrison acknowledges the significance of emotional histories that remain alive, to be passed down, generation to generation ("the skin remembers")—emotional histories that are there to be articulated and given form by artists.[11] These are the truths awaiting the artist's creative hand. I feel your body of work, inclusive of the *Kin* series, partakes of similar evocations and invocations. Your work and that of Morrison evoke a holographic world: reality and super-reality, alternate worlds and histories, come together simultaneously and concomitantly. You bring multiple possibilities of time and space into communion within one field: fictions wedded to concrete truths.

WL: There is a certain attitude toward life that I think I inherited, or more probably developed from watching my parents and grandparents, and aunts and uncles. Somehow having studied the ways that they looked at things has formed the way I look at life. Some call it a cultural memory. I once learned about, I think it

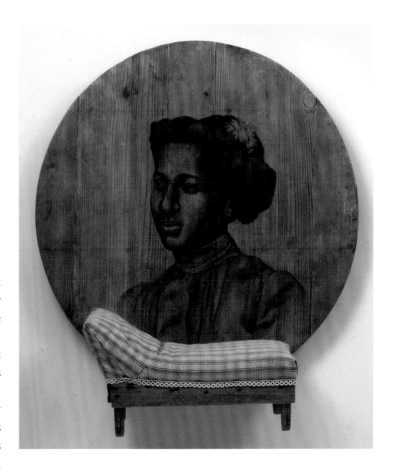

was the Iroquois, who believed you had to consider the well-being of those seven generations into the future, because that generation will be affected by how you live today. When a major trauma befalls a community, it takes seven generations before the ill effects of that trauma can go away.

When you look at it that way, and it makes perfect sense, it helps put things into perspective. Certainly the effect of slavery is something I can feel in my bones; it's a feeling I understand because I felt it coming off of my parents and emanating from my grandparents. I know so well how profoundly my grandparents influenced me; well, their grandparents were slaves, and that is a fact that had to have had a huge impact on my grandparents, whether consciously or unconsciously. You can't just shake all that stuff off. Yes, the skin remembers. I believe that is why so many African American artists work with imagery from a generation or two behind them. Our cultural memory and our identities are intertwined with a difficult history.

JM: Though I have focused on Toni Morrison's kindred spirit or affiliation, I know there has been some interest in connecting your work to the chronotope, or spatio-temporal matrix, as laid out by Russian philosopher and philologist Mikhail Bakhtin.

WL: Well, I have thought about my work as having some similarities with the idea of *sacra conversazione* and [its] presentation in Renaissance art, particularly in *Whispers from the Walls* [1999; p. 22–23]. The idea of the *sacra conversazione*, as I learned it, is that the paintings depicted meetings of saints and other persons who all lived at different times and places, making it impossible for them to all appear in the same room together at the same time. It is a spiritual gathering of sorts, an engagement in a "sacred conversation" among those depicted. Certainly in *Whispers from the Walls*, the people who converged in that room conversed from across time and place.

JM: What is your feeling about simultaneous histories and personalities coming together in your work? Is it intentional on your part or more a by-product of your working process?

WL: Oh, definitely a by-product. I try not to predict or predetermine the final outcome of what I'm doing. You really have to feel your way toward whatever the work wants to be.

JM: Can works of art, be they fiction, drama, or visual art, take one *back* to a time one is not already familiar with, or is it that these alternate times and spaces are conjured up by the artist,

brought *forward* and into the present and thus the presence of viewers and readers?

WL: I believe a work of art can transcend time. And if that is true, I think there is no reason to adhere to chronological timetables. How logical is the way we experience time anyway? And how logical is art, or the experience of receiving art?

JM: Your works do ask us as viewers to move in time, certainly. Do the works exist in a separate time and place from your own or are they rather a reflection of the time and place in which your creative soul is situated?

WL: I think that is the key, Julie! It is all about the point of view, the vantage point of the artist. I am coming at my work from the point of view of what I know about life, about the world, and about the human experience. What I know is not organized or restricted by a timetable. We have "history" to ponder, and we contemplate the future through our ability to imagine…How we do the present, how I do the present is so intertwined…

JM: But even more importantly, these figures are converging across time and space and having that *sacra conversazione* with you in your studio!

WL: And they are such welcomed guests! (laughs) A student recently asked me what did I think I am doing for the people from the past, whom I draw. My response was that I didn't know if I was doing anything for them, but I know what they have done for me. The effect they have had on my life and my work has been tremendous! I hope they always continue to convene with me, because they give me strength and a sort of purpose.

Right: **Pago Pago,** 2008.
Conté on wood with radios
and sound; 97 x 66 x 13 inches.
The Cummer Museum of Art &
Gardens, Jacksonville, Florida.
Purchased with funds from
the Morton R. Hirschberg
Bequest and funds provided by
the Jacksonville Community

Overleaf: **Autour du
Monde,** 2008. Conté on
wood panels with globes;
102 x 189 x 171 inches.

JM: But if we take the entire body of the Kin series and imagine them exhibited as a whole, or even in part, do they come together in one *sacra conversazione* for you or a family reunion of sorts?

WL: I think they do.

JM: I think the question really is about time and how important it is to you. Perhaps this is an unnecessary question; it is obvious in some ways and reflected in your own work and spirit—you have a vintage soul, which loves to coexist in a time that is not the immediate present but the magical past and its continuity in the present.

[1] *Our folks* seems to have had particular currency in the nineteenth century and was used for various publications, such as the illustrated tutorial for American youngsters *Our Folks at Home: Or, Life at the Old Manor House* by Edward Toliver. *Our Folks* is also the title of a 1967 Polish film (*Sami Swoi*) by Sylwester Checinski. A beloved Polish comedy, it focuses on two feuding families, expatriates from the eastern part of Poland, who settled on neighboring farms after World War II. In 1969 the Art Ensemble of Chicago titled their new album *Message to Our Folks.* Recorded in Paris for the French BYG Actuel label, it features performances by Lester Bowie, Joseph Jarman, Roscoe Mitchell, and Malachi Favors Maghostut. More recently, a 2009 publication by Dr. Deborah Y. Liggan was entitled, *Taking Care of Our Folks: A Manual for Family Members Caring for the Black Elderly.*

[2] Edwidge Danticat, *Create Dangerously: The Immigrant Artist at Work* (Princeton: Princeton University Press, 2010), 5. "All artists, writers among them, have several stories—one might call them creation myths—that haunt and obsess them." Central for Danticat is the 1964 execution of Marcel Numa and Louis Drouin against the wall of the Port-au-Prince cemetery, the first public execution in Haiti in thirty years, under the dictatorship of "Papa Doc" Duvalier. Though it happened before her own birth, Danticat takes ownership of its history, which serves as inspiration and touchstone for her work. "Like most creation myths, this one too remains beyond the scope of my own life, yet it still feels present, even urgent" (p. 7).

[3] Lovell's sister, Yonna Lovell, went on to study mortuary science and thanatology. She has a master's degree in gerontology and is currently a bereavement counselor at a New York City hospice.

[4] The stage name of this internationally renowned singer and performer (1904–1975) is transliterated in a variety of ways including Oum Kalthoum and Umm Kulthum.

[5] The best-known version of a bolero, a piece of music for the Spanish bolero dance, is French composer Joseph-Maurice Ravel's ballet score *Boléro* (1928).

[6] Akira Kurosawa, *Something Like an Autobiography*, trans. Audie E. Bock (New York: Vintage, 1982), 186.

[7] Harmony Korine used John Jacob Niles's version of "The Maid Freed from the Gallows" (recorded as "The Hangman") during a railroad scene in the 2007 film *Mister Lonely*. Compositions by Pakistani musician Nusrat Fateh Ali Khan, often

credited with introducing Sufi music to international audiences, were featured in *Dead Man Walking* (1996).

[8] Lovell's "The Card Series II: The Rounds," 2006–11, was acquired in 2011 by the Smithsonian National Museum of African American History and Culture.

[9] "In Conversation with Chuck Close." Public conversation with Chuck Close and Anna Deavere Smith, 2009 Aspen Ideas Festival. For a video of the event, see <http://www.aifestival.org/session/conversation-chuck-close>; accessed February 1, 2016.

[10] Toni Morrison, "The Site of Memory," in Russell Ferguson et al., *Out There: Marginalization and the Contemporary Cultures* (New York: New Museum of Contemporary Art; and Cambridge, MA: MIT Press, 1990), 302–3.

[11] "Because no matter how 'fictional' the account…or how much it was the product of invention, the act of imagination is bound up with memory….You know, they straightened out the Mississippi River in places, to make room for houses and livable acreage. Occasionally the river floods these places. 'Floods' is the word they use, but in fact it is not flooding; it is remembering. Remembering where it used to be. All water has perfect memory and is forever trying to get back to where it was. Writers are like that: remembering where we were, what valley we ran through, what the banks were like, the light that was there and the route back to our original place. It is emotional memory—what the nerves and the skin remember as well as how it appeared. And a rush of imagination is our 'flooding.'" Ibid., 306.

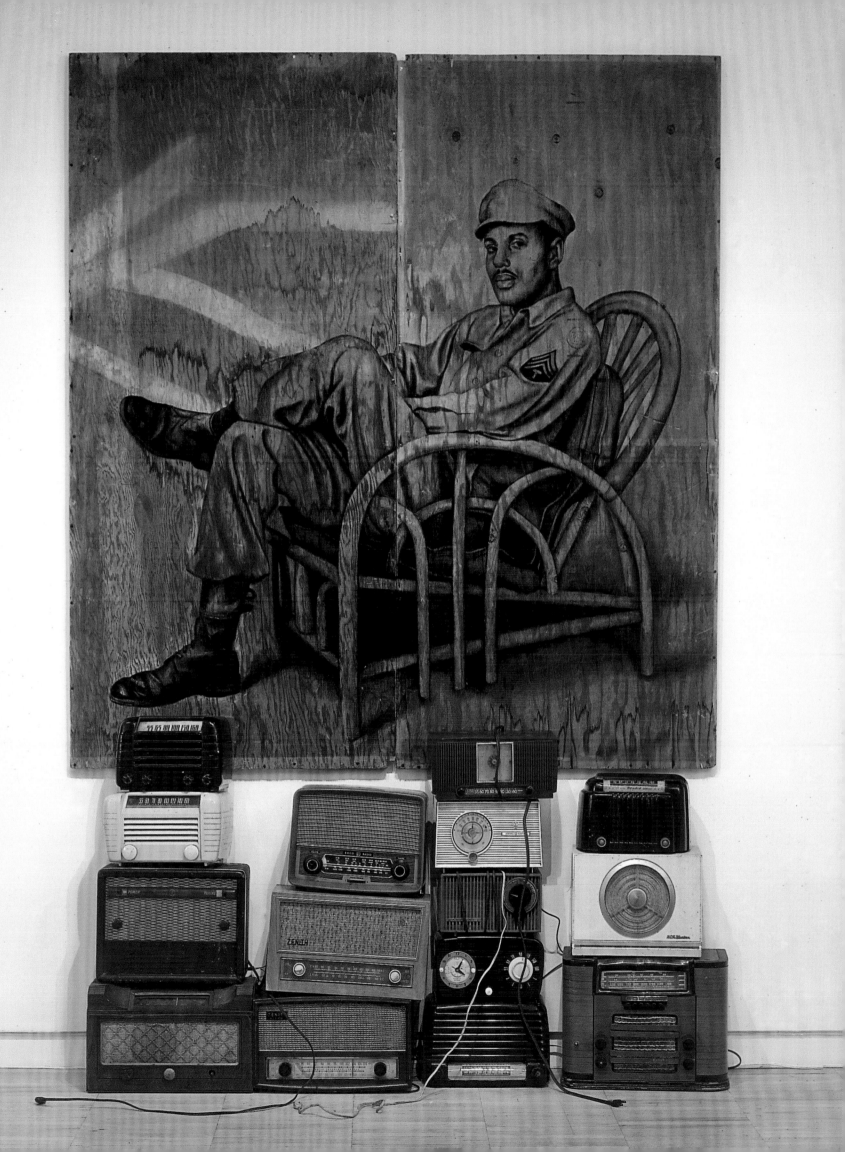

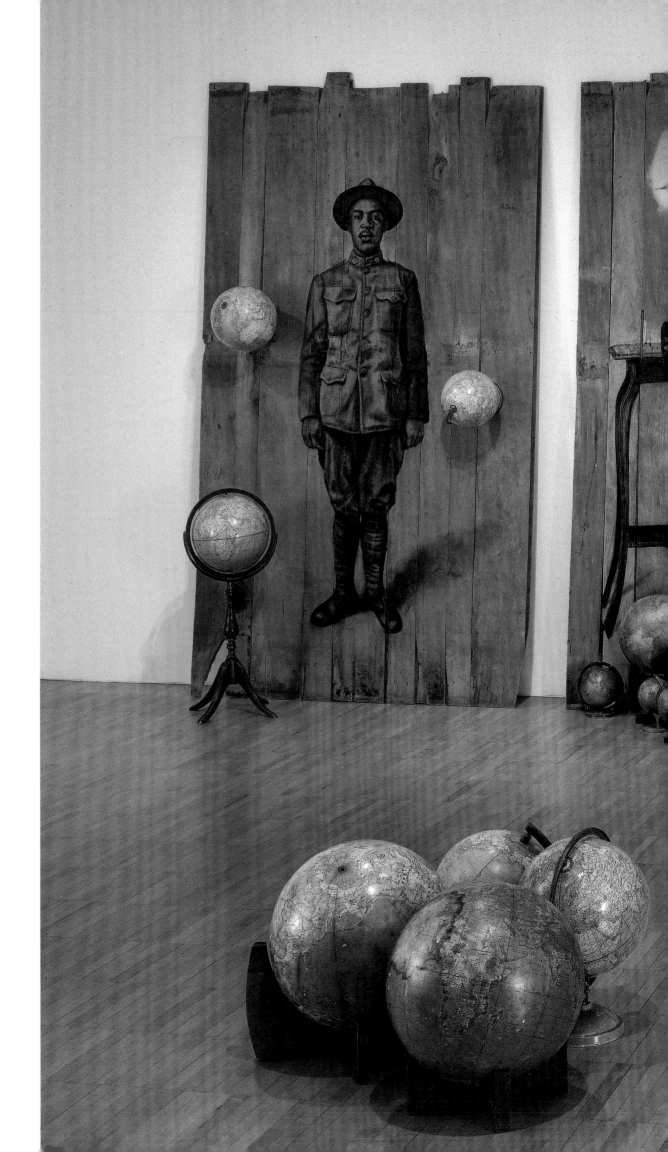

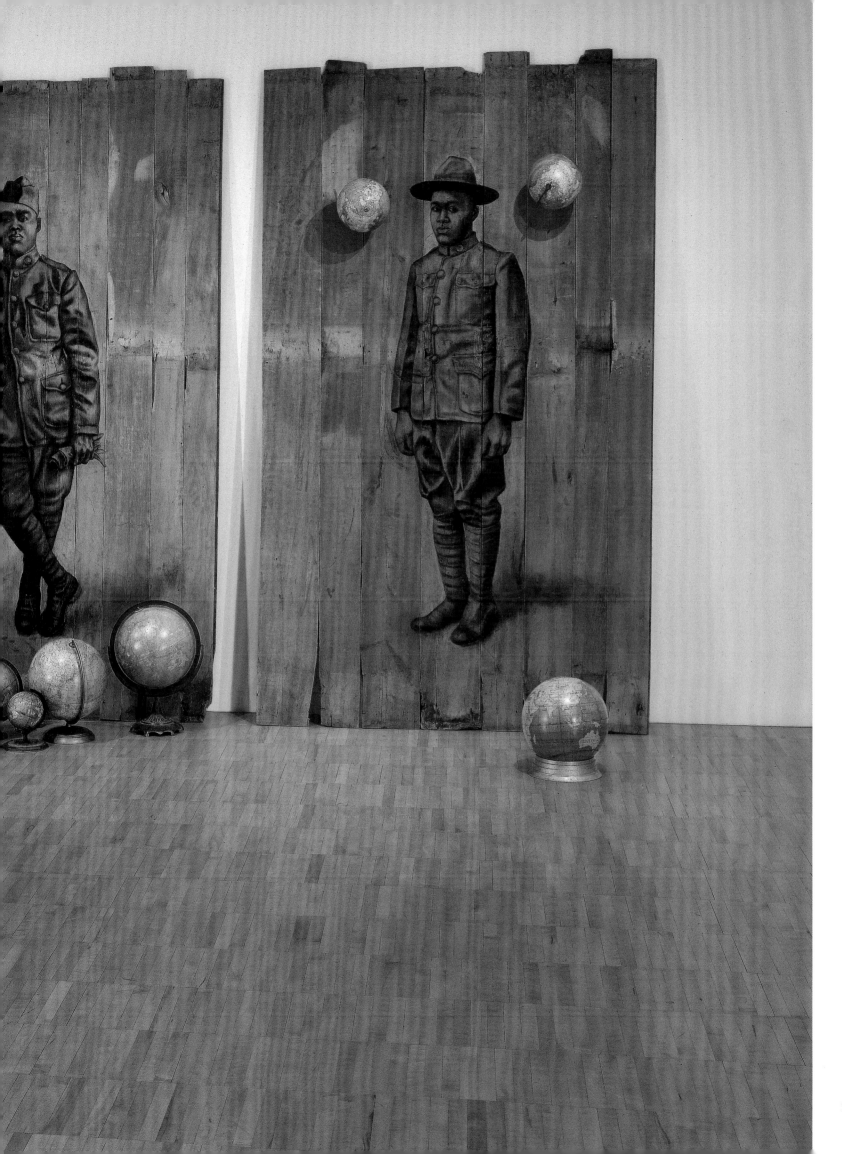

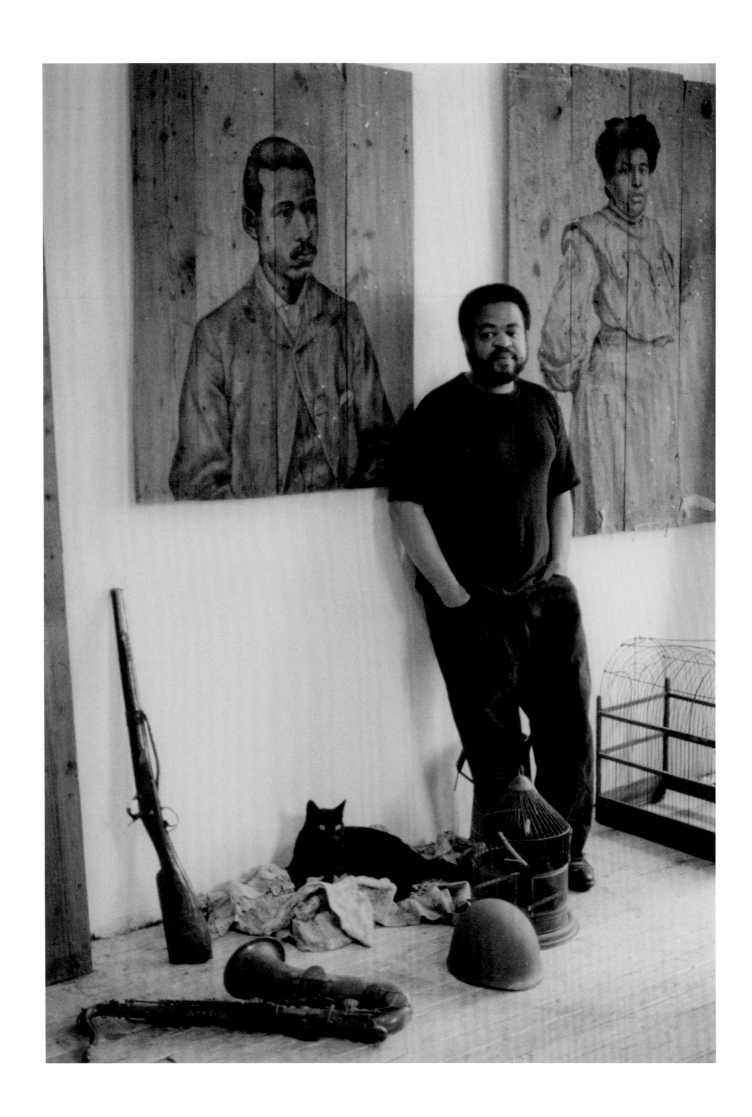

Chronology

With notes by Whitfield Lovell

1959 Whitfield Lovell is born on October 2 in the Bronx, New York, the third of four children, to parents Gladys Glover Lovell, an elementary school teacher from South Carolina, and Allister Lovell, a postal clerk and photographer of West Indian descent.

1965 Lovell attends P.S. 23, the Bronx. His family moves to Crotona Park North, in the South Bronx, which was then a popular residential area for African American and Puerto Rican New Yorkers.

1968 Following the assassination of Dr. Martin Luther King Jr., the artist is taught for the first time about the legacy of slavery and the civil rights movement. In July, Lovell accompanies his grandfather Eugene Glover on a visit to South Carolina, where he first experiences the rural South. This visit is repeated annually for four years.

I remember at that age being fascinated by how different southern African American culture was. My relatives there lived their lives in a way that was familiar to me only through the customs of my grandparents in New York. There were old wooden shacks lit only with kerosene lamps, outhouses, women with big straw hats hoeing their fields and waving to us as we passed by in the car, and handmade brooms that were made by wrapping and tying pieces of straw to thick tree branches. I remember going to church and watching the people "get the spirit of the Holy Ghost," something which I was at once enthralled with and terrified by.

My mother's first cousins, Jackie and Barbara-Ann, were schoolteachers there in Columbia. They took me to see the "white school," and they took me to see the "black school." Although I knew about integration, there I learned that the two schools were still separate in everyone's minds, one more privileged than the other in terms of supplies and the quality of teachers and learning environments. Jackie taught in a "white" high school. She said the "colored" students there always had to fight—particularly when a white student brandished the Confederate flag—apparently a real challenge at that time. They were very clear about the separations between the races. If a white student invited them to a party, they

simply would not go because one just didn't do that. I had been accustomed to many white and Latino friends at home in the Bronx, and so this attitude confounded me.

Many years later I returned to visit my cousins there, and I found that many of these customs had disappeared. Many of the "old folks" had passed on, and the younger generations had lost interest in farming and rural life. They moved to large cities and often fell to the same perils—such as drugs, crime, etc.—as had many of my friends in the Bronx. Though these cousins were really into education and progress, they lamented the demise of the old ways of life. These ways were alive only through stories told by the elders. I wrote down as many things as I could remember and thanked them for sharing it all with me.

1972 While attending Creston Junior High School 79, the Bronx, Lovell begins to draw. His art teacher Margaret Nussbaum spends her lunch hours critiquing his work and takes a particular interest in his artistic growth.

1974 Lovell enrolls at the Fiorello LaGuardia High School of Music and Art, Manhattan. He takes classes at the Metropolitan Museum of Art High School Program, where curator Lowery Sims introduces him to artist Randy Williams, who will eventually become his mentor.

1975 Lovell attends the Whitney Museum Art Resources Center, on Cherry Street, Manhattan, directed by artist/musician Laurie Anderson. He studies with artist Vincent Smith.

The artist's mother, Gladys Lovell, on Prospect Avenue, the Bronx, c. 1964, photographed by Allister Lovell

Lovell family holiday greeting card with a photograph by Allister Lovell; left to right: Allister, Reva, Gladys, Whitfield, and Kevin Lovell, c. 1968

Page 207: Whitfield Lovell's great-grandfather Thomas Glover and cousin Naomi Jennings in a cotton field, c. 1951, photographed by Gladys Lovell

Page 206: Whitfield Lovell in his studio, 2001

1976 Lovell begins to write poetry and short stories in his creative writing class with teacher Barbara Pollard. He attends the New York State Summer School for the Arts in Fredonia, New York, and the Cooper Union Saturday Program.

1977 Upon graduating from the Music and Art High School, Lovell receives awards for art, creative writing, character, and second prize in the City College Poetry Festival. He travels to Mallorca, Spain, with the Manhattanville College Summer Abroad Program to study painting and sculpture. He also visits Barcelona and then Madrid, where, at the Prado Museum, he decides to become a painter.

I knew I would go into some form of art, but I wasn't sure which. I was interested in fashion and advertising as options. But while I was standing in front of a Velázquez painting, I had an amazing spiritual experience. The painter had communicated with me through centuries and cultures, and I suddenly understood the role of the artist. I ran from room to room. Goya, El Greco, Rubens, Ribera, and Bosch all began to speak out to me. Whatever they were doing in those rooms was what I wanted to do with my life.

Lovell enrolls at the Maryland Institute College of Art, Baltimore. During this year, he has difficulty adjusting to the college environment and the pace of a smaller city, and he longs to return to New York.

By that time the Crotona Park area and surrounding areas had deteriorated drastic-ally. Every other night there was a fire in the Charlotte Street section about five blocks away. Landlords were allegedly committing arson to collect insurance on their tenement buildings, which were in poor condition anyway. Families moved out in the middle of the night, and then the building would mysteriously catch fire. President Carter actually declared the neighborhood a natural disaster area in order to secure funds to rebuild. There were a few buildings still standing, including our block, and we had a huge apartment with a terrace that overlooked the grass, hills, and trees of the park. On our block people just enjoyed the view and seemed to ignore the rubble we were surrounded by.

I wanted to leave home and find a new environment. Baltimore was just not the right place for me at that time. I was used to a city where there was always something going on and lots of cultural events. I'm sure there were things going on in Baltimore, but I wasn't aware of them, and everyone at Maryland Institute seemed to be drawing upon what was happening in New York.

1978 Lovell travels through France, Germany, Italy, England, Austria, and the Netherlands with the American Institute for Foreign Study. Returning to New York, he enrolls at Parsons School of Design, in the Fine Arts Department, where he studies with painter Jane Wilson and sculptor Phoebe Helman.

1979 The artist's sister Reva dies of scleroderma, a rare skin disease. He enrolls at the Cooper Union School of Art and studies painting with various instructors and photography with Larry Fink.

Cooper Union was a difficult place for me. It was an elite school that boasted having all of the best students. I definitely didn't fit in, and because of the loss of my sister, I was even more withdrawn than before. I had one well-known instructor who was certain that I was stupid and continually made racist and insulting comments in front of the class. During group critiques, rather than taking my work seriously, he talked about the "black world" and the "white world" and about anthropology being the "lies that little brown men tell to big white men." Because I was so young and in a troubled state of mind, I pretended not to understand what he was saying to me, which, I'm sure, compounded his belief that I was indeed stupid. At one point he said that because I was from a lower social and economic background than he was, he could not relate to my work. I stood up to him for the first time, and some other classmates spoke up as well. Art school can be such a battleground that it's often hard to see the line between personal perceptions and sound advice. And we wonder why many people don't maintain the self-esteem to finish school. Years later in the 1990s a number of students from that class told me that they always

remembered how bad that class was for me and that they regretted the situation. It took me a long time to trust instructors and to find people I could learn from at Cooper. I got more and more into photography, and Larry Fink was very supportive.

1981 During his senior year at Cooper Union, Lovell teaches draw-ing to high school students in the Cooper Union Saturday Program. Just prior to graduation, he begins to frequent the events and openings at Just Above Midtown Downtown Gallery, then a gather-ing place for artists such as Lorraine O'Grady, David Hammons, Dawoud Bey, and Candida Alvarez. He begins to develop a net-work of friends within the alternative spaces in the New York art world. He meets artist Fred Wilson, who soon becomes his com-panion. He works for Red Grooms's exhibit *Ruckus Manhattan* and for *Art on the Beach*, both sponsored by Creative Time Inc. He partici-pates in an invitational exhibition at A.I.R. Gallery in New York.

My work at that time was focused mainly on formal issues. The work had bright squares of color superimposed over portraits. This series began during college and many people there were against it. Since I was so maligned at Cooper anyway, I continued to perfect what I was doing. I saw how differently the outside world looked at my work in contrast to the art school atmosphere, and it was very liberating.

1982 Lovell receives a fellowship from the Robert Blackburn Printmaking Workshop. He has his first solo exhibition at the Inter-church Center, New York, sponsored by the A.M.E. Zion Chapter. He also exhibits prints at Cayman Gallery and in *The Beauty Show*

at ABC No Rio, New York. He begins freelance teaching for organizations such as the Printmaking Workshop and the Children's Art Carnival, and various neighborhood centers in New York. He travels to Italy with mentor Randy Williams and his family. While Williams works in his studio at the American Academy in Rome, Lovell explores the city with artist David Hammons and writer Gylbert Coker. Lovell continues on alone to Greece, Egypt, Nigeria, and the Republic of Benin, West Africa.

I went to visit my friend Terry Plater, an African American from Philadelphia, who was teaching architecture at the University of Lagos in Akoka. Some of my well-traveled friends tried to discourage me from going to Nigeria. They felt I wasn't independent enough as a traveler to move about in Africa, and that if I only saw Lagos I would have a devastating impression of what Africa is. After all, many black people do go to Africa looking for their roots, ideally wanting to find the kingdom where their ancestors thrived with dignity before they were "taken over" through slavery. The explanation for why so many of us don't do well in the United States is that we were severed from that land. People wanted to go there and see evidence of such a place. Among my friends at the time, Lagos was known for its poverty, open sewers, corruption, and chaos. Also, young Americans were notorious for getting into trouble in third-world countries, simply because they didn't respect the people and the laws in these countries. It was suggested that I change my ticket and not go into Nigeria this trip, and if I really wanted to go to Africa, I try Morocco or Tunisia. I heard all of the worst stories, and I realized I was developing a pretty bad impression of Africa. It was all secondhand, so I was determined to go and see it for myself. It turned out that Lagos had a rawness and a rhythm that were incredibly beautiful. In spite of the poverty and the other problems, the spirit of the people there was intense. My time there was well spent. Terry and I took a road trip, with some Nigerian friends, to the border and into the Republic of Benin. We stayed in Cotonou, and visited Ganvie, a fishing village built on stilts out in the lagoon, several kilometers from the shore. It is said that the people moved there to hide from the slave traders.

Some Beninois, however, laughed at that idea and claimed that the Ganviens moved there because they believe the water is a deity. It was one of the sights I had seen pictures of and barely imagined I would see on this first trip. Amazing. My first sight of a third-world country had been a month before when I arrived in Cairo. The smells, the movements of the people, and the sounds were amplifications of something I had known from television or from the Bronx or somewhere, but at the same time completely foreign and mesmerizing. So Lagos was the icing on the cake, and I loved every minute of it. I was definitely not considered African, but not an "oibo" (foreigner/white man) either. The Nigerians embraced me as someone who had come back because he was interested enough in knowing how things were for those who had not been "taken over." They are a very dignified people, despite the effects of colonialism, which they equate with slavery in the United States. On the other hand, a couple of people actually expressed regrets over not having been "taken over" because things were so bad for them there. The perception being that Americans are privileged to be born into this country regardless of the means of passage.

The day after I left Lagos, the telecommunications tower was burned down, and there were a succession of coups d'état. I was glad I stuck to my guns and went there, because otherwise I might still have the distortions and fears from friends who were just concerned for my safety. It was not a search for roots, but an important journey all the same.

1983 Lovell moves into a building on Harlem's Manhattan Avenue where he, artist David Hammons, and performance artist Kaylynn Sullivan TwoTrees restore abandoned apartments for living spaces. Lovell begins the *Alva* series, a group of eight 50 x 38–inch pastel drawings based on photo-booth pictures of performance artist/writer and high school friend Alva Rogers. This series is exhibited in the *Transfers* show at the Henry Street Settlement. He also exhibits at Cayman Gallery and Just Above Midtown Downtown Gallery, New York.

1984 Lovell's maternal grandfather Eugene Glover is killed in a mugging outside of his Bronx apartment. Paternal grandmother Mitchell Lovell and maternal great-uncle Johnny Williams die of natural causes. Lovell begins to work from newspaper and tabloid clippings showing people in bereavement. He creates the 50 x 76-inch pastel diptych *Expulsion* for the *Art Against Apartheid* show at Henry Street Settlement, curated by artist Willie Birch. This piece juxtaposes images from Masaccio's *Expulsion from Paradise*, 1427, on one side with images of South African people being arrested and driven from their townships on the other. He also creates the pastel *Scream*, inspired by a *Daily News* photo of a woman who has just learned that her sister had been murdered. He mounts a solo exhibition at East Harlem's Galeria Morivivi. The opening reception features a poetry reading by writer Hettie Jones.

1985 Lovell and his family attend the hearings for the trial of his grandfather's assailants, who eventually plead guilty to manslaughter. Art historian and high school friend Kellie Jones writes the article "Public Personal Portraits / The Art of Whitfield Lovell" for an issue of *Black American Literature Forum* organized by artist Camille Billops and writer James Hatch. Lovell becomes a member of the Friends of Hatch/Billops, an archive of African American culture. He attends the Skowhegan School for Painting and Sculpture where he meets artists Betye Saar, Louisa Chase, Elizabeth Catlett, and Mary Heilmann. While at Skowhegan, his work changes dramatically.

In Skowhegan I had time to really think about what I wanted to do with my work. I felt the formal issues about color were fighting with the narratives I was getting at in pieces like Expulsion and Scream. So I narrowed down the color and began to work monochromatically. I had all of my father's old photographs mailed to me, and I began a process of looking through these images each day before starting to work. The work became more personal and a reflection of the way I saw myself as an artist.

Lovell teaches at the Metropolitan Museum of Art High School Programs. He receives a second fellowship at the Printmaking Workshop. He creates large drypoint portraits and linoleum cuts such as *I Wanted to be a Gardener*, now in the collection of the Library of Congress, Prints Division, Washington, DC.

1986 Lovell travels to Barbados, West Indies, where he stays with his father's sister Ina Clarke and her family. Here he encounters the rich Caribbean culture, which he had always known, albeit secondhand.

When my Barbadian aunt came to visit, I was eight, and we thought she was speaking a different language since her accent was so thick. As we came to know her, we became more aware of the reasons for the different cultural flavors of the two sides of our family. In Barbados I witnessed the place I had heard so much about and known through its food, music, and stories.

Lovell receives a New York State Council on the Arts (NYSCA) grant to be Artist in Residence at the Harlem School of the Arts. He exhibits at the Bronx Museum of the Arts, Jamaica Art Center, and the Queens Museum, New York.

1987 Lovell receives a NYSCA grant to serve as administrative assistant to artist Marina Gutierrez, director of the Cooper Union Saturday Program. He also begins teaching for the Art Education Department at the School of Visual Arts, New York. He moves into an East Village loft with Fred Wilson. The building, owned and occupied by several artists, dancers, and poets, provides ample work space for Lovell to expand his ideas. As a result, his work becomes larger in scale, and his new series develops. Lovell continues to use family photographs as inspiration for his work.

My earliest memories of looking at images have to do with my father's photography. He set up a darkroom in the apartment with lots of impressive equipment. He was self-taught and never really had any formal training. He actually began developing

his own film on his bed, with the blankets over his head, while my mother sat at her sewing machine and kept track of the time for him. He shot many self-portraits, street scenes, auto wrecks, and still lifes. He also loved to experiment with vignetting—exposing several images onto one sheet of paper. But the most memorable are the ones of family and friends. Part of his personality was that he always had a camera; that set him apart from other people and provided a creative outlet. I spent many hours in the darkroom assisting him, which, I realize, plays a great part in my own artistic interests.

1988 Lovell attends the Moussem D'Asilah, an international arts festival in Asilah, Morocco. There, he creates a suite of prints and travels with artists Judy Blum, Krishna Reddy, and Zarina Hashmi. In Morocco Lovell begins collecting "Hands of Fatima" or "Hamsas," metal hand charms that are often symmetrical and have intricate designs carved into them. These objects are traditionally carried to ward off the "evil eye." Lovell's fascination with these amulets is brought on by the fact that he had been using hands in his art as a symbol for power and protection. He later discovers that hand sculptures hold similar meanings throughout Central and South America, the Arab world, and Scandinavia. Further investigation leads to his acquiring bronze Buddhist sculptures of the mudras and Brazilian votive hands carved in wood, as well as American kitsch depictions and household objects with hands. He currently owns a collection of over 200 hands from around the globe. Lovell has a solo show at the Jersey City Museum.

1989 He attends the New York University Graduate Program in Venice, travels throughout Italy with sculptor Helen Ramsaran, and visits the Paris home of Judy Blum and Krishna Reddy. He exhibits at Artists Space and Cinque Gallery, New York.

1990 Lovell receives a Penny McCall Foundation Grant and The Promise of Learnings Inc. Award for Excellence in Education. He designs a poster for the Metropolitan Transit Authority. He travels to Mexico with School of Visual Arts coworker Rose Viggiano and visits the home of Elizabeth Catlett and Francisco Mora in Cuernavaca. He begins collecting ex-votos and retablos. Ex-votos are small antique paintings on tin and copper usually depicting persons in dire situations such as car accidents or grave illnesses. Each gives thanks to a particular saint in cursive text below the images for helping them overcome these tragedies. Lovell's collection of some fifty ex-votos influences his work, particularly Pop/Pistol, created later that year. Lovell also makes the drawing Muerte Florida after seeing Mexican paintings of deceased children in repose.

After looking at European painting for so many years and then the great black painters Jacob Lawrence, Bob Thompson, and Horace Pippin, I looked toward other cultures for inspiration. I found myself more attracted to folk art, which wasn't as concerned with making high art, but with the joy of storytelling. My training, however, was heavily steeped in European artistic values; even the earlier pieces, which had more modernist notions in them, really did come from that tradition. So I also found artists from Latin America to be a very refreshing discovery for me. They seemed to fuse European colonial styles with a different sensibility. I felt they were more passionate about the religious and social narratives and less concerned with skill. Although I didn't grow up Catholic, I was attracted to that symbolism and to certain decorative elements that I feel are part of many images one sees grows up in a place like the Bronx. Rather than returning to Venice to finish my master's degree, I spent a lot of time in Mexico getting an education of a different sort.

1991 Lovell receives a New York Foundation for the Arts Fellowship and participates in numerous group exhibitions including

Interrogating Identity at Grey Art Gallery, New York, curated by gallery director Thomas W. Sokolowski and Kellie Jones. During a one-month residency at Art Awareness, Lexington, New York, Lovell makes an edition of prints with artist Andrea Callard, head of the Avocet water-based silkscreen workshop. He travels throughout Mexico with Rose Viggiano and their friend Hilda Martinez.

1992 Lovell receives a National Endowment for the Arts Mid-Atlantic Fellowship and an Awards in the Visual Arts (AVA) Fellowship. He also receives the American Red Cross Special Service Award for initiating an ongoing arts-and-crafts program for homeless children at a local shelter. He travels to Egypt with Fred Wilson and curator Kathleen Goncharov.

1993 He has a solo exhibition at Lehman College Art Gallery, the Bronx, and receives a Human Resources Administration Award from the City of New York for his work with homeless children. He visits the private artists' retreat Villa Val Lemme in Capriatta d'Orba, Italy, owned by Swedish gallerist Anki Juhanisdottir. The villa had been built by a slave trader who dealt in Africans from Brazil in the early twentieth century. Lovell does site-specific wall drawings using the history of the villa as a theme.

There were grotesque paintings of Africans with nose rings lining the ceilings of some of the rooms. Also, the coat of arms on the front of the building had an African face on it, and a few very elderly locals apparently could remember the blacks who had lived there. The slaver had obviously continued to trade long after it had become illegal, but that was not unheard of in some other countries. It was hard to ignore the background of the place. Ordinarily the experience of being somewhere new would have fermented over time and then become a piece much later. That's how I was used to working. But in this case, I later realized, it was only by leaving my marks in the house itself, giving a voice to those African slaves, that I could truly express what it meant for me—an African American—to be there in the seemingly luxurious environs of an Italian villa.

Artist Robert Kushner recommends Lovell's work to art dealers Bridget Moore and Edward De Luca. Lovell borrows photographs from his grandmother's collection of family members from the 1920s and 1930s. He becomes fascinated with the history and anonymity of these people. Lovell begins to collect (from flea markets and antiques shops) old photographs of African Americans from the first half of the twentieth century. Among these photographs are crayon portrait enlargements, often oval in shape, which were created by making a faint impression from a

negative onto paper and then hand touching with Conté crayon. This was a popular technique before mechanical enlargers were invented.

1994 Lovell travels to Ecuador with artists Philemona Williamson, Emilio Cruz, Donald Locke, and Freddy Rodriguez to participate in the Cuenca Bienal of Painting. The exhibition, *Current Identities*, is curated by Carl Hazlewood of Aljira Gallery, Newark, and includes Lovell's *Dress* and *Our Kiss*, both 1990, and *Head with Flowers*, 1992. After the Bienal, the show travels on to venues in Colombia, Costa Rica, Panama, and Uruguay. Lovell also exhibits *Tree* at Midtown Payson Galleries, New York.

1995 Lovell spends a year in Houston as an artist-in-residence at the invitation of Rice University faculty member and painter Darra Keeton. Lovell quickly meets many who are part of the lively Houston art scene, including Annette Lawrence, Benito Huerta, George Smith, and Virgil Grotfeldt. He creates the installation *Echo* at Project Row Houses, a nonprofit venue where artists are invited to make installations in one of eight abandoned "shotgun" houses.

Villa Val Lemme was the first time I worked directly on the wall. At that time I wanted to explore installation further but wanted the right circumstances to arise. When I was approached to do a row house, it was just the right time. The feeling in the house was ideal for trying new ideas related to my interest in old photographs of "anonymous" people.

Lovell is taken on for representation by DC Moore Gallery, New York.

1996 William Lieberman, chairman of Twentieth Century Art at the Metropolitan Museum of Art, New York, recommends the acquisition of Lovell's *Muerte Florida* for the museum's collection. Lovell returns to New York, resumes his position at the School of Visual Arts, and also teaches drawing at the Fashion Institute of Technology. He receives the Joan Mitchell Foundation Fellowship.

1997 Lovell travels to Havana to participate in the Sixth Havana Biennal. He has solo exhibitions at DC Moore Gallery, New York, and the Southeastern Center for Contemporary Art, Winston Salem, North Carolina, and receives a second New York Foundation for the Arts Fellowship. He visits the Tyler School of Art, Philadelphia, as a guest artist. During a month in Mount Desert, Maine, at the Acadia Summer Art Program, he begins to create

tableaux, which include charcoal drawings on wood and antique objects.

1998 He travels to the University of North Texas, Denton, as a visiting artist at the invitation of faculty member and artist Annette Lawrence. He is approached by the director of the university gallery, Diana Block, to plan an exhibition for the coming year. Lovell has a one-month residency at the Andy Warhol Museum, Pittsburgh, where he presents the exhibition *Collecting Inspiration*, showcasing objects he collects alongside drawings these objects influenced.

Andy was a huge collector of things—everything from vintage photographs to clothing to dishes and folk art. When he died in 1987, it took six months to catalogue the thousands of objects he had acquired. I was given access to the archives where Andy's "time capsules" contained magazines, records, photographs, and anything else he had acquired during a given period, which were just loaded into a box and dated. There are over six hundred "time capsules," and only a hundred of them had been opened and inventoried up to that time. He often used his collections as resource material and drew inspiration from the objects. This was something that Andy and I had in common, though my collections are minuscule compared to his. I began collecting hands after I had already been using hands in my work. The more I learned about the iconography of hands, the more excited I was to continue with the theme. Also, my interest in collecting crayon portraits came simultaneously with the images in the Hand Series, though I didn't consciously think about it at the time. In the exhibition, Pop/Pistol was displayed between the crayon portraits and the ex-votos. There were relationships between all three, with the drawing as the link. Seven choices from the Hand Series were hung, while the hand collection was in a vitrine nearby. There has always been a reason for my wanting to own certain objects more than others. I've tried to be a focused collector, so that I was spending my money on things that fed the work.

With Fred Wilson, Lovell visits Australia and Bali, Indonesia. He does small drawings during this time and studies Aboriginal bark paintings. He also gives a slide lecture for museum professionals at the Ian Potter Museum in Melbourne.

1999 The University of North Texas, Denton, receives funding from the National Endowment for the Arts and the Lannan Foundation for Lovell's exhibit. During a one-month residency he creates the installation *Whispers from the Walls* (pp. 22–23). He completes nineteen tableaux for *Portrayals*, an exhibition organized by the Neuberger Museum of Art, Purchase, New York.

2000 *Whispers from the Walls* travels to the Texas Fine Art Association, the Jones Center for Contemporary Art, Austin, the Seattle Art Museum, and the Studio Museum in Harlem. His exhibition *Recent Tableaux* opens at DC Moore Gallery. The tableaux *Shine* and *Walking Blues* are purchased by the Whitney Museum of American Art and the Seattle Art Museum, respectively.

2001 Lovell resigns from his position at School of Visual Arts. He is a visiting artist at the Skowhegan School for Painting and Sculpture and exhibits *Embers* at the Boston University Art Gallery. He travels to Richmond to create *Visitation: The Richmond Project* (p. 13) at the Hand Workshop Art Center. Made with the assistance of Virginia Commonwealth University students, the exhibition focuses on Richmond's Jackson Ward, the nation's first major black entrepreneurial community.

2002 Lovell spends the summer at the Skowhegan School for Painting and Sculpture as a member of the resident faculty. *Whispers from the Walls* begins its tour of twelve additional venues through ExhibitsUSA. Lovell creates *SANCTUARY: The Great Dismal Swamp* (pp. 151–53) at the Contemporary Art Center of Virginia in Virginia Beach. The exhibition is based on accounts of runaway slaves such as Nat Turner and individuals involved in the Underground Railroad who sought refuge in the Dismal Swamp. The swamp, a nearly 2,200-square-mile area, had been written about by Harriet Beecher Stowe and Walt Whitman. Lovell's installation centers on landscape.

The main inspiration for SANCTUARY: The Great Dismal Swamp, aside from the readings and research I did, was visiting the swamp itself. The people at the Dismal Swamp Wildlife Refuge hosted me for a day of hikes and a boat ride across Lake Drummond, which is in the center of the swamp. Lake Drummond is an egg-shaped pond about three miles across and no deeper than six feet at its center. It was referred to by Irish poet John O'Reilly as "the most wonderful and beautiful sheet of water on the continent." The water is a rich brown color, like tea, the result of the tannin that dripped from the juniper trees over the centuries. That was the inspiration for the pool of water that became the centerpiece for the installation.

Most important for me were the moments when I stood silently in the swamp and just listened to the sounds and felt the ambience.

For the installation we got thirty trees and stood them up in the gallery, with branches, leaves, and vines extending into the space, creating barriers and obstacles for the viewer. The floor was covered with mulch and there were sounds

of crickets, cicadas, and barking hounds throughout. Twelve basins and washboards filled with water were placed around the room, with the faces of people looking out at the viewer. Many of the images and objects that implied human inhabitants and the shingle industry were submerged in water. Somehow the legacy of those who lived hidden in the swamp to avoid slavery seemed to have been nearly lost, buried under that lake.

Lovell creates the print *Chance* to benefit the Skowhegan School of Painting and Sculpture's Committee for the 21st Century Scholarship Fund. He lectures at Princeton University and Carnegie Mellon University and visits the Columbus Art Museum in Georgia, where he lectures during the reception for *Visitation: The Richmond Project.*

2003 Lovell joins the Skowhegan School for Painting and Sculpture Board of Governors. He receives the Richard C. Diebenkorn Teaching Fellowship at the San Francisco Art Institute in California. Lovell creates the installation *Grace* at the Bronx Museum of the Arts.

The exhibition series "Conversations with the Permanent Collection" was curated by Lydia Yee at the Bronx Museum of the Arts. Artists were invited to delve into the artworks in the museum's storage rooms to find inspiration or source material. I chose to work from a collection of vintage photographs donated to the museum by a patron. Lydia allocated a generously sized gallery for me to work with. My preferred drawing surface was vintage lumber, which is rather expensive and not easy to find, so I couldn't cover the whole room with it. Working with a very tight budget, I had to think of ways to utilize the space effectively. It was important to me that I create an installation, an environment that the viewer enters into and becomes part of, as opposed to singular, discreet artworks that hang on the wall and are looked at from a distance. I love having the opportunity to do special works for museum spaces when it allows me to "step out of the box." It's about being able to make things happen that wouldn't be feasible in a commercial gallery situation, such as considering the floor, the ceiling, and perhaps some unusual materials as integral parts of the artwork. It allows me to expand my repertoire and my vocabulary. My decision was to cover only one of the gallery walls with lumber, as a surface for the drawn images, and then work out from there into the rest of the room.

I ordered 4,000 red roses from a Bronx florist, who had them flown in from Peru. They were all hung up to dry from the sprinkler pipes in my studio. Although I had to prepare the components in my studio, I made many planning trips to the museum so the install would go smoothly. The studio itself was brimming with energy and fragrances, and haunted by the characters emerging on the wood.

I wanted the installation to be reminiscent of a church sanctuary, a chapel or a funeral parlor—not to recreate any of these, but to construct an ambience that

combined elements of those settings. *The flowers were placed on the gallery floor in an orderly fashion. They were densely clustered like a thick blanket that came out from the wall panels by seven feet or so, creating a sort of boundary. In the middle of the dried flower bed I placed a book of slave songs called* Negro Workaday Songs, *on a low pedestal, and four silver chalices, one for each of the people drawn on the panels. The church pews brought it all together. Bridget Moore, the owner of DC Moore Gallery, had mentioned having them in the garage at her vacation home years before. As the installation began to take form, I inquired, and was thrilled that she still had them! They occupied the rest of the room just as I had hoped to utilize the space. They also created an effective triangular configuration that steers the eye as well as the movement toward the focal point of the drawings.*

The lighting was set low, with the drawings minimally illuminated. The flowers were highlighted more warmly to allow the texture of the buds to heighten the experience. A recording of Marian Anderson's deep contralto renditions of spirituals played continuously at a soft volume. Songs like "Oh Lord, What a Morning," and "Oh, What a Beautiful City" seemed moody enough to provoke anyone to contemplate the hereafter or the here and now. The pews provided a natural place for the viewers to sit and meditate on the piece, or whatever they were inclined to ponder. The best part for me was watching people wait their turn for a seat on the bench.

Lovell begins teaching at the San Francisco Art Institute as part of his Diebenkorn Residency, which also provides a studio at the Headlands Center in Sausalito. He visits Los Angeles to attend the *Whispers from the Walls* exhibition at the California African American Museum and visits the home and studio of Betye Saar. Together they scour the local flea markets and yard sales for art materials and inspiration. During Lovell's residency in California, his beloved grandmother Mary Jane Glover dies at age ninety-seven. Upon the conclusion of his residency, Lovell returns to New York. He is featured in the exhibitions *African American Masters: Highlights from the Smithsonian American Art Museum* and *Modern Storytellers: Bearden, Birch, Lovell, Ringgold* at the Metropolitan Museum of Art.

2004 Lovell travels to Sydney, Australia, for the exhibition *Witness,* organized by Senior Curator Rachel Kent at the Museum of Contemporary Art. The group exhibition features the installation *Visitation: The Richmond Project.* He participates in several other group exhibitions and mounts solo shows at Olin Art Gallery, Kenyon College, and Arthur Roger Gallery, New Orleans. Lovell creates an installation, *Storyville* (p. 171), for the home of art patrons Sid and Shirley Singer of Mamaroneck, New York.

I was invited by the collector Sid Singer to create an installation in an alcove in his home in Mamaroneck. He had begun collecting artists such as Franz Kline, Louise

215

Nevelson, and Jennifer Bartlett back in the 1970s. He and his wife Shirley had acquired hundreds of artworks over the years, and they also commissioned several site-specific artworks that were custom made for their home. The invitation was a rare opportunity! I was given carte blanche to do whatever I wanted within the 10 x 10 x 10–foot space. Sid is an avid music enthusiast who holds a series of professional classical music concerts in his home every season. Although he didn't want to dictate a theme, he did mention that a musical reference would make him happy if he had a choice.

It took me a while to narrow down the love of music, his and mine, with the issue of "place"—the idea of a shared space where music can be experienced and enjoyed, as well as the implications of the physical limitations of the alcove itself. The space would either be open to viewers passing through, or somewhat restrictive depending on how the area was handled.

So I started looking at speakeasies and loosely derived the composition from some images of them. I was contemplating the power of music as a force, like religion and some other ritual practices, that we can be so moved by that we can sometimes be brought to a higher spiritual state.

I alluded to the power of alcohol by the placement of whiskey bottles and such. Alcohol, for better or worse, holds a fascinating place in this equation. I like to refer to the "medicinal" uses of alcohol as well as the obvious implications of recreational use. Earlier pieces like Bliss, 1999, or Whispers from the Walls and Visitation, which include open decanters of whiskey, sometimes provided potent aromas that can lift installations to other levels through heightened sensory engagement. In Storyville, I wanted to draw a sense of music out of the silence, without the use of recorded sound. I wanted to create an environment where you could hear or feel the music.

The structure of the "room" and the entrance into the installation were inspired by a liquor storage cage I glimpsed in an old movie about Storyville. They were like rooms built within the space of the old speakeasies where the supply of alcohol was kept locked away. The structure was chicken-wired over, so the inventory was visible yet protected from the guests. I was interested in the hexagonal pattern of the chicken wire because of how it created a sort of shroud, when the light hit it, that altered the view of the drawings when one looked through it to the artwork. The chicken wire panels enabled me to create the "passageway" that contained the space, within the alcove, and defined the "composition" (I see the drawings, objects, architecture, and use of physical space as all working together compositionally.) I allowed the piece to develop naturally.

I placed the bottles on the floor and made a point of bringing additional bottles every time I went to his house to keep the process alive. (I haven't been there in several years, though.) With this and other installations I enjoyed creating unique challenges for the viewers as they enter into the piece. In this case not every viewer will want to enter because of the way the chicken wire panels present a narrowed psychological boundary between outside/inside, admittance and non-

acceptance, belonging and not belonging, and the piece may be viewed from outside. When viewers enter it, they have to navigate through the bottles carefully, so they become not only spectators but participants. Everyone has a temporary membership in an exclusive "club," and it is up to them to enter (at their own risk) or not.

2005 Lovell is elected a member of the National Academy of Design. He attends the *Whispers from the Walls* opening at the San Antonio Museum, where he is hosted by art patrons Harmon and Harriet Kelley. He returns to Houston where he is reunited with his friends Rick Lowe, Leaman Greene, and other colleagues at Project Row Houses.

2006 Lovell teaches advanced drawing at Cooper Union. He mounts a solo exhibit at DC Moore Gallery. He visits the Skowhegan School for Painting and Sculpture as a governor. Lovell completes the Card series, his group of fifty-four drawings with individual playing cards attached.

I made my first card piece at Skowhegan in the summer of 2002. I had found a full deck of antique cards with no numerical indices; only the number of symbols (spades, diamonds, hearts, and clubs) indicated which card was which. The Card pieces each consist of the drawn head of an individual and a single vintage playing card. The central positioning of both elements creates a grounded compositional format through which each piece takes on its own unique character. I chose to use a soft tan-colored paper as opposed to the ordinary stark white paper to start with. The act of rendering details was enjoyable in that I had not drawn that way in such a long time. In this regard the card pieces were the most direct precursor to the Kin series. It was relaxing and almost cathartic to make the drawings, but the most exciting part of the process was choosing the one card that best "fit" with the drawn image. The process of making those pairings was intuitive, and so there were no rules. There was, however, much to learn about what kinds of things work well in formal terms. I became conscious of the play between certain geometric forms, the color provided by the cards, the busyness of a card with many markings on it versus the static symmetry of an ace or a deuce. Being mindful of those things helped make each card piece stronger than the one before.

Social and psychological connotations emerged particularly when face cards (kings, queens, jacks) hint at social stations and ranks, especially juxtaposed with heads of "ordinary" African Americans. There is an implication of destiny, of chance, predicament, of one's lot in life.

2007 Lovell is awarded the John D. and Catherine T. MacArthur Foundation Fellowship, often referred to as "the genius award." Lovell begins the Kin series. He is honored by the Bronx Museum

of the Arts at their benefit gala. Lovell and his family go on a cruise to Bermuda to celebrate his father's eightieth birthday.

2008 He is the recipient of the Cooper Union Alumni Association Augustus Saint-Gaudens Award for achievement in art. Lovell mounts the exhibition Kith & Kin at DC Moore Gallery, which includes selections from the first thirty pieces in the series. He has a solo exhibition at the Hudson River Museum in Yonkers, New York. Lovell travels to the University of Hawaii at Hilo, as a visiting artist on the invitation of printmaker Wayne Miyamoto. He travels throughout the Hawaiian Islands with Fred Wilson.

2009 Lovell receives the Nancy Graves Foundation Grant for Visual Arts and the Malvina Hoffman Artists Fund Prize for Sculpture from the National Academy of Art. Lovell is awarded a two-week residency at the Pilchuck Glass School in Stanwood, Washington. He travels to Atlanta to attend the reception for *Mercy, Patience and Destiny: The Women of Whitfield Lovell's Tableaux* at the Woodruff Arts Center. The exhibition, curated by Melissa Messina from Savannah College of Art and Design, is part of Atlanta's National Black Arts Festival. Friend and colleague Carrie Mae Weems conducts a public interview with Lovell. At the reception he is reunited with his cousins Barbara-Ann Maxwell and Jackie Mayes, from whom he learned so much during his childhood summers spent in South Carolina.

2010 The Card Series II: The Rounds, Lovell's second group of card works, is exhibited at DC Moore Gallery (p. 199). The series is purchased by the Smithsonian National Museum of African American History and Culture, Washington, DC.

When I was working on Card Series I, I had decided the natural cutoff point would be the end of the deck. I made fifty-four card pieces, including the two jokers. As I reached the end of the deck, I was saddened because I enjoyed making them so much, as a sort of peripheral thing, not part of the large, ambitious installations or tableaux. I then came across a deck of round cards, which I had never seen before. They were manufactured in Australia, but they had racist "King Coon" imagery on the backs, ace, and joker. I took that opportunity to start an entirely new card series, The Rounds. I made a point of keeping them all together. Card Series I was sold off individually whenever I made ten or so of them, so I never got to see the impact of the full group at once. I was pleased when the Smithsonian acquired the entire Rounds series because although each one could stand alone, there is strength in the series as a unit.

Lovell works with printmaker Judith Solodkin at Solo Impression in New York City. He creates the lithographs *Barbados* and *Georgia*. He attends his opening at Arthur Roger Gallery in New Orleans.

2011 Lovell has a solo exhibition and residency at Smith College Museum of Art, Northampton, Massachusetts. He works extensively in the printmaking studio with master printer Maurice Sanchez. With the help of Smith College students, they make monoprints and edition several lithographs, including *Deuce*. Lovell completes the sixtieth artwork of his *Kin* series.

2012 He visits Chattanooga to plan a major project at the Hunter Museum of American Art.

Nandini Makrandi, curator of the Hunter Museum, invited me to do a project. I began my usual process of reading up on the region to see what might intrigue me about the place's history and its culture. The only reference I ever had for the city was the song "Chattanooga Choo Choo" because of the recordings that I had heard

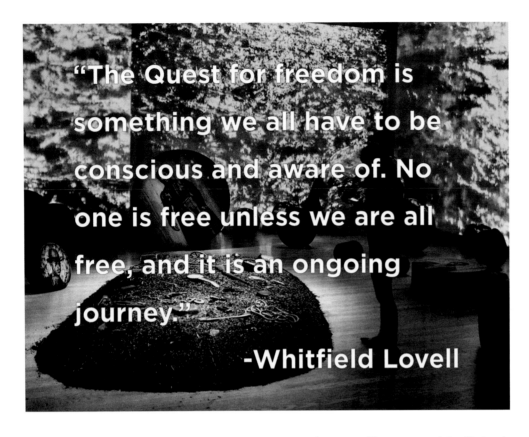

"The Quest for freedom is something we all have to be conscious and aware of. No one is free unless we are all free, and it is an ongoing journey."

-Whitfield Lovell

peripherally all my life, but I certainly didn't know what it was about. I quickly learned that Bessie Smith was born in Chattanooga. She could have provided rich and powerful possibilities for an artwork, yet that seemed obvious—too easy. I tend to shy away from depicting celebrities. I would rather pay homage to great divas like her the way I always had, in pieces like Gin Song, 2004 (p. 195), where the woman is a "Bessie Smith type," and therefore represents all the women who were like her as well. The Chattanooga Choo Choo, which I visited, is also the name of a hotel and restaurant within the old train station, where you can view antique train cars.

What impressed me most about the city was that most of the history, or the physical evidence of the past, had been demolished and replaced by parking lots, shopping malls, and housing complexes. It was so unlike a place like Richmond, where everyone knows about all the historical sites and refers to what happened long ago in locations like Shockoe Bottom or Monument Avenue.

I met two gentlemen who helped me zero in on my inspiration: Mr. White and Mr. Black. Dr. Clark White (aka Deacon Bluz) was an awesome blues singer and sociology professor specializing in the black history of Chattanooga. He took me all over the town and taught me many things. He showed me Bessie Smith's birthplace and the street that once had all the speakeasies and blues bars where musicians such as Bessie got their start.

We took a tram up to a lookout point on a central mountain, and he showed me areas where the black community had lived at various times. Finally, we went into the center of the black neighborhood at the time, which was mostly very depressed. There was something haunting about the absence of surviving traces of black history. One really has to use his or her imagination to conjure up palpable visions of cultural and historical memories.

I visited the office of Daryl Black, who at that time was the executive director of the Chattanooga History Center. He mentioned a monument to the Trail of Tears and the Chattanooga floods, among other important events. Eventually he spoke of Camp Contraband, the site of which was nearly visible from his office window. He

mentioned that blacks who were escaping slavery knew they had to make their way across the Tennessee River because once they reached Camp Contraband they were essentially "free." At that moment I knew what my theme would be. The thought of crossing a river, crossing over to a campground, was so intriguing.

I could not get the old spiritual "Deep River" out of my head. While I didn't want to be too literal, or "recreate" the campground, I knew that song would have to waft through the space. I immediately asked my friend Alicia Hall Moran, a classically trained mezzo-soprano with a soulful, full-bodied timbre, to sing the song. Her husband, the jazz pianist Jason Moran, also helped by engineering the recording and accompanying her with piano chords. I chose a cappella versions she made and arranged them so they would play at fifteen-minute intervals. There were also natural sounds such as crickets, rustling water, and birdsong, which emanated from suitcases, as if about to burst free.

2013 Deep River (pp. 176–79) opens at the Hunter Museum of American Art.

2014 Lovell receives the National Academy Award for Excellence. He travels to Savannah, Georgia, to install Deep River at the Telfair Museum. He is hosted by art patrons Walter O. and Linda Evans.

2015 Lovell's exhibition Distant Relations: Selections from the Kin Series opens at DC Moore Gallery. Deep River is presented at the Cummer Museum in Jacksonville, Florida. While the exhibition is on view, a young white gunman massacres black members of a bible study group at the Emanuel African Methodist Episcopal Church in Charleston, South Carolina. In response to this tragedy, the Cummer Museum's director, Hope McMath, offers free admission to the exhibition as a place of reflection and healing. More than three thousand visitors attend the exhibition that weekend.

Whitfield Lovell, 2001,
photographed by Sandra Paci

Page 220: **Kin V (Thou
Dark One),** 2008 (Detail).
Conté on paper, rhinestone
broach; 30 x 22 ¹/₂ x ⁷/₈ inches.
Columbus Museum of Art,
Ohio: Museum Purchase
with funds provided by Loann
Crane in honor of Ray Hanley
and his passion for the arts in
Columbus

In times of senseless manifestations of racial hatred, it is important to remember how vital awareness and consciousness of history is. We have to acknowledge how we've come to where we are now, and how treacherous the journey was for some. We have to realize how pointless the hostility and violence are. In order to evolve as a society, we must teach every generation about what happened. You cannot teach one generation and assume or hope the problems of racial animosity will disappear. One would like to think that each generation would teach their children and pass along a tradition of tolerance. But there is no such thing as "post-racial times," at least not yet. Those of us who grew up in the 1960s and 1970s thought things were changing and it would be a better world. The disappointment for me was seeing how racial friction reemerges again and again among young people as well as older ones.

After a lecture I gave for patrons of the Phillips Collection, I was approached by a group of young museum members who wanted to know what I thought of the Black Lives Matter movement and the kinds of atrocities that are taking place today. As young, progressive whites, they felt they were becoming sensitized to the different realities that people of color have to deal with. I reflected momentarily and told them that whatever Black Lives Matter is fighting for has been going on for many years. I am glad they are empathetic, but it is so much a part of my psyche that it is not news. I probably try not to think about it, generally, to make it through a given day.

Of course, I am encouraged by all of the progress we have made, whether brought on by government legislation or by the rejection of hatred brought on by the evolution of the human spirit over time. Many positive strides have been made toward civil rights and equality in my lifetime, so as drops of water turn a mill, I do believe the world will continue to improve. But again, each generation has to be taught. It is an ongoing process, and we have a long way to go.

As an artist, my priority is the art. I'm not trying to change the world, and I don't generally approach my work as protest pieces. However, I recognize that in many ways to be an African American artist at this point in time is unavoidably a political statement. As a black male, the very symbols of my heritage, my culture, are laden with sociopolitical content.

If my work can help raise consciousness in any way, I am grateful, and I consider it time well spent. I was pleased to learn that the success of Whispers from the Walls helped broaden the dialogue about Quakertown's legacy in Denton, Texas. Some public officials were not thrilled, at the time, about implications of racial injustices occurring there, yet it became an acknowledged episode in Denton's history. They recently placed a commemorative stone marker and museum in Quakertown Park in honor of the community that once thrived there. I was also glad to hear that the rangers at the Dismal Swamp State Park acknowledged the legacy of the maroons who lived there for hundreds of years by including a mention of them in their guided tours. I'm not sure if they continued with that, but it was a great response to what they learned from the show.

Lovell is included in the exhibition, Modern Vision: American Sculptors' Drawing from the Linda Lichtenberg Kaplan Collection, presented at The Phillips Collection, Washington, DC. Lovell's father Allister Lovell dies in September at age eighty-nine. Lovell and Wilson depart for a tour of Havana designed for MacArthur Foundation award recipients. The Cummer Museum purchases Pago, Pago, 2008.

2016 The Card Series II: The Rounds is featured in the opening exhibition of the National Museum of African American History and Culture, Washington, DC. A solo exhibition of Lovell's work opens at The Phillips Collection.

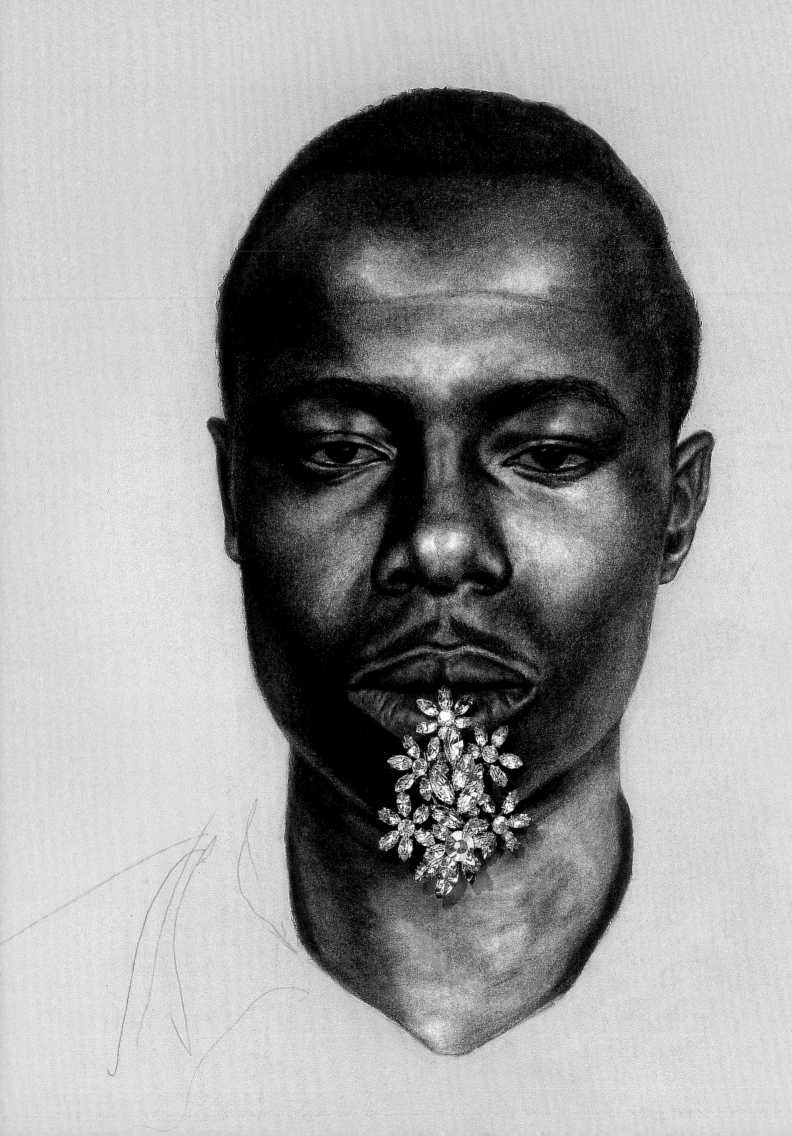

Selected Bibliography

2016 South, Will. "Themes and Variations: It's What Artists Do," in *Remix: Themes and Variations in African American Art* (exhibition catalogue). Columbia, SC: Columbia Museum of Art, pp. 12, 13, 66.

2015 Della Monica, Lauren P. *Bodies of Work: Contemporary Figurative Painting*. Aglen, PA: Schiffer Publishing, pp. 100–1.

Hampton, Karen. *The Journey North* (exhibition catalogue). Clinton, NY: Wellin Museum of Art, Hamilton College.

2014 Bindman, David, and Henry Louis Gates Jr. *The Image of the Black in Western Art*. Cambridge, MA: Harvard University Press, pp. 241–42.

2013 Hayes, Jeffrey M., *Etched in Collective History* (exhibition catalogue). Birmingham, AL: Birmingham Museum of Art.

Lampe, Lilly. "Whitfield Lovell: Hunter Museum of American Art," *Art in America*, October.

Makrandi, Nandini. *Whitfield Lovell: Deep River* (exhibition catalogue). Chattanooga, TN: Hunter Museum of Art.

2012 Quashie, Kevin. *The Sovereignty of Quiet (Beyond Resistance in Black Culture)*. New Brunswick, NJ: Rutgers University Press, cover, pp. 6–8, 110–11.

2011 Jones, Kellie. *Eye Minded, Living and Writing Contemporary Art*. Durham, NC: Duke University Press, pp. 12, 31.

2010 Franks, Pamela, and Robert E. Steele. *Embodied: Black Identities in American Art from the Yale University Art Gallery* (exhibition catalogue). New Haven, CT: Yale University Art Gallery, p. 45.

Griffin, Farah Jasmine. "Whitfield Lovell," in *RE:COLLECTION: Selected Works from The Studio Museum in Harlem*. New York: The Studio Museum in Harlem.

McGee, Julie L. "Whitfield Lovell: Autour du Monde," *NKA Journal of Contemporary African Art*, no. 26 (Spring), cover, pp. 48–59.

Sims, Lowery Stokes. *Threads: Textiles and Fiber in the Works of African American Artists* (exhibition catalogue). Beijing, China: EK Projects, pp. 2, 16–18, 34–43.

United States Mission to the United Nations, New York: ART in Embassies Exhibition (exhibition catalogue). Washington, DC: Art in Embassies.

2009 Carson, Charles D., and Julie L. McGee. *Sound:Print:Record: African American Legacies* (exhibition catalogue). Newark, DE: University Museums, University of Delaware, cover, p. 46.

Kim, Linda. "Distant Relations: Identity and Estrangement in Whitfield Lovell's Kin Series," in *Distant Relations* (exhibition catalogue). Mahwah, NJ: Ramapo College.

Lewis, Sarah, and Melissa Messina. *Mercy, Patience and Destiny: The Women of Whitfield Lovell's Tableaux* (exhibition catalogue). Atlanta, GA: The ACA Gallery of SCAD.

2008 Genocchio, Benjamin. "Intimate Views of Anonymous African Americans," *The New York Times*, November 13.

Heartney, Eleanor. *Art and Today*, New York: Phaidon Press, p. 412.

Lovell, Whitfield. "Rummaging and Working with Betye Saar," in *Betye Saar: Migrations/Transformations* (exhibition catalogue). New York, NY: Michael Rosenfeld Gallery, p. 9.

Sims, Lowery Stokes, and Bartholomew Bland. *Whitfield Lovell: All Things in Time*. Yonkers, NY: Hudson River Museum.

2007 Reynolds, Jock. *Art For Yale: Collecting for a New Century* (exhibition catalogue). New Haven, CT: Yale University Art Gallery, pp. 23, 334, pl. 319.

2006 Cotter, Holland. "Art Review: 'Legacies: Contemporary Artists Reflect on Slavery' at Historical Society, Emancipation Remains a Work in Progress," *The New York Times*, June 20.

2005 Lovell, Whitfield. *John Biggers: My America* (exhibition catalogue). New York: Michael Rosenfeld Gallery.

Yee, Lydia, and Marisol Nieves. *Collection Remixed* (exhibition catalogue). Bronx, NY: The Bronx Museum of the Arts, pp. 15–16, 54–55.

2004 Brookman, Philip, ed., with Merry Foresta, Julia J. Norrell, Paul Roth, and Jacqueline Days Serwer. *Common Ground: Discovering Community in 150 Years of Art* (exhibition catalogue). London: Merrell Publishers.

Princenthal, Nancy, et al. "Whitfield Lovell," in *+Witness* (exhibition catalogue). Sydney, Australia: Museum of Contemporary Art, pp. 42–49.

2003 Everett, Gwen. *African American Masters: Highlights from the Smithsonian American Art Museum.* New York: Harry N. Abrams; Washington, DC: Smithsonian American Art Museum.

Gerdts, William H., et al. *American Art at the Flint Institute of Arts.* Flint, MI: Flint Institute of Arts, pp. 260–61.

Lapcek, Barbara. "Whitfield Lovell: Visual Artist," in *Hatch-Billops Collections, Inc.: Artist & Influence,* Vol. XXI. New York: Hatch-Billops Collection, pp. 175–92.

Lippard, Lucy R., Carla Hanzal, Leslie King-Hammond, and Jennifer Ellen Way. *The Art of Whitfield Lovell: Whispers from the Walls* (exhibition catalogue), 2nd. ed. San Francisco: Pomegranate.

2002 Hanzal, Carla. *SANCTUARY: The Great Dismal Swamp, An Installation by Whitfield Lovell* (exhibition brochure). Virginia Beach: Contemporary Art Center of Virginia.

Nahas, Dominique. *Whitfield Lovell: Embers* (exhibition catalogue). New York: DC Moore Gallery.

"Whitfield Lovell," *The New York Times,* April 12.

"Whitfield Lovell," *The New Yorker,* May 6.

2001 Fairbrother, Trevor. "Going Forward, Looking Back," in *Words of Wisdom: A Curator's Vade Mecum on Contemporary Art.* New York: Independent Curators International, pp. 56–58.

Kushner, Robert. *Beauty Without Regret* (exhibition catalogue). Santa Fe, NM: Bellas Artes Gallery.

Makrandi, Nandini. *Beyond the Frame: Whitfield Lovell* (exhibition brochure). Knoxville, TN: Knoxville Museum of Art.

Princenthal, Nancy. "A World in One Room," *Art in America,* April, pp. 150–53.

2000 Foster, Carter E., and Stephan F. F. Jost. *Drawing on Language* (exhibition catalogue). Cleveland: SPACES.

Hills, Patricia. *Whitfield Lovell: Recent Tableaux* (exhibition catalogue). New York: DC Moore Gallery.

Nadelman, Cynthia. "Whitfield Lovell," *ARTnews,* October, p. 181.

Wei, Lilly. *Portrayals* (exhibition catalogue). Purchase, NY: Neuberger Museum of Art.

1999 Hertz, Betti-Sue. *Urban Mythologies: The Bronx Represented Since the 1960s* (exhibition catalogue). Bronx, NY: The Bronx Museum of the Arts.

Lippard, Lucy, and Jennifer Ellen Way. *The Art of Whitfield Lovell, Whispers From the Walls* (exhibition catalogue). Denton, TX: University of North Texas Press.

1998 Taha, Halima M. *Collecting African American Art: Works on Paper and Canvas.* New York: Crown Publishers.

1997 Llanes, Llilian. *Sexta Bienal de la Habana, El Individuo y Su Memoria* (exhibition catalogue). Havana, Cuba: Centro Wilfredo Lam, p. 152.

1996 Cappellazzo, Amy. *Real* (exhibition catalogue). Miami, FL: Bass Museum of Art.

Chin, Mel. *Scratch* (exhibition catalogue). New York: Thread Waxing Space.

1995 de Larrazabal, Eudoxia Estrella. *IV Bienal International de Pintura, Cuenca, Ecuador* (exhibition catalogue). Cuenca, Ecuador, p. 134.

Yau, John. *Murder* (exhibition catalogue). Santa Monica, CA: Smart Art Press.

1993 Hazlewood, Carl E. *Current Identities: Recent Painting in the United States* (exhibition catalogue). Newark, NJ: Aljira Center for Contemporary Art.

Yau, John. *The Bronx Celebrates Whitfield Lovell* (exhibition catalogue). Bronx, NY: Lehman College Art Gallery.

1991 Bellamy, Peter. *The Artist Project, Portraits of the Real World/ New York Artists 1981–1990.* New York: IN Publishing.

Jones, Kellie, and Thomas W. Sokolowski. *Interrogating Identity* (exhibition catalogue). New York: Grey Art Gallery and Study Center.

Long, Richard, and Judith Wilson. *African-American Works on Paper from the Cochran Collection* (exhibition catalogue). Atlanta: Double Density.

1990 Georgia, Olivia. *Family Stories* (exhibition catalogue). Staten Island, NY: Snug Harbor Cultural Center.

Stanislaus, Grace. *New Perspectives: Colin Chase and Whitfield Lovell* (exhibition catalogue). Miami, FL: Wolfson Gallery, Miami Dade College.

1989 Smith, Valerie. *Selections from the Artists File, Artists Space* (exhibition catalogue). New York: Artists Space.

1988 Jones, Kellie. *New Visions: James Little, Whitfield Lovell, Alison Saar* (exhibition catalogue). Queens, NY: The Queens Museum.

Other Countries: Gay Black Voices. New York: Cultural Council Foundation/Management and Resources for the Arts.

1987 Bibby, Diedre. *Who's Uptown: Harlem '87* (exhibition catalogue). New York: Schomburg Center for Research in Black Culture.

1986 *Black Visions '86* (exhibition catalogue). New York: Tweed Gallery.

Verre, Philip. *Curator's Choice II* (exhibition catalogue). Bronx, NY: The Bronx Museum of the Arts.

1984 *Artist in the Marketplace* (exhibition catalogue). Bronx, NY: The Bronx Museum of the Arts.

Selected Public Collections

Arkansas Arts Center, Little Rock
Art in Embassies, Lusaka, Zambia
Asheville Art Museum, North Carolina
Baltimore Museum of Art, Maryland
Bass Museum of Art, Miami
The Bronx Museum of the Arts, New York
Brooklyn Museum, New York
Chrysler Museum of Art, Norfolk, Virginia
Cochran Collection, Atlanta, Georgia
Columbia University, New York
Columbus Museum of Art, Ohio
The Cummer Museum of Art & Gardens, Jacksonville, Florida
Davison Art Center, Wesleyan University, Middletown, Connecticut
Deutsche Bank, Frankfurt, Germany
Flint Institute of Arts, Michigan
Greenville County Museum of Art, South Carolina

Hampton University Museum, Virginia
Harvard Business School, Cambridge, Massachusetts
High Museum of Art, Atlanta, Georgia
Hunter Museum of American Art, Chattanooga, Tennessee
Jule Collins Smith Museum of Fine Art, Auburn University, Alabama
Kalamazoo Institute of Arts, Michigan
Library of Congress, Division of Prints and Photographs, Washington, DC
Los Angeles County Museum of Art, California
McNay Art Museum, San Antonio, Texas
Memphis Brooks Museum of Art, Tennessee
The Metropolitan Museum of Art, New York
Microsoft Corporation, Seattle, Washington
The Mint Museum of Art, Charlotte, North Carolina
Montclair Art Museum, New Jersey
Morris Museum of Art, Augusta, Georgia
Muskegon Museum of Art, Michigan
National Gallery of Art, Washington, DC
Neuberger Museum of Art, Purchase, New York
New Orleans Museum of Art, Louisiana
The New School University Collection, New York
Palmer Museum of Art, Pennsylvania State University, University Park
Pennsylvania Academy of the Fine Arts, Philadelphia
The Phillips Collection, Washington, DC
Promise of Learning Collection, New York
Seattle Art Museum, Washington
Smith College Museum of Art, Northampton, Massachusetts
Smithsonian American Art Museum, Washington, DC
Smithsonian National Museum of African American History and Culture, Washington, DC
Spiritmuseum, Stockholm, Sweden
Springfield Art Museum, Missouri
The Studio Museum in Harlem, New York
Telfair Museums, Savannah, Georgia
Wake Forest University, Winston-Salem, North Carolina
Whitney Museum of American Art, New York
Wieland Foundation, Atlanta, Georgia
Williams College Museum of Art, Williamstown, Massachusetts
Yale University Art Gallery, New Haven, Connecticut

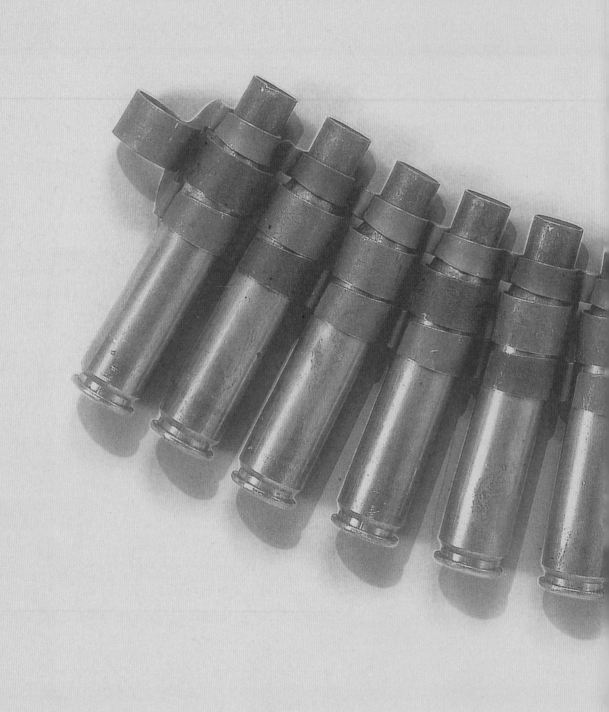